Andrew Wilton is Keeper and Senior Research Fellow at the Tate Gallery
in London, where he was the founding Curator of the Turner Collection,
and subsequently Keeper of the British Collection. Before joining the
Tate, he worked in the Department of Prints and Drawings at the
British Museum and in the Yale Center for British Art at New Haven.
His many publications include *British Watercolours 1750 to 1850*
and *Turner in his Time*.

Thames & Hudson world of art

This famous series provides the widest available
range of illustrated books on art in all its aspects.

If you would like to receive a complete list
of titles in print please write to:

THAMES & HUDSON
181A High Holborn
London WC1V 7QX

In the United States please write to:

THAMES & HUDSON INC.
500 Fifth Avenue
New York, New York 10110

Printed in Singapore

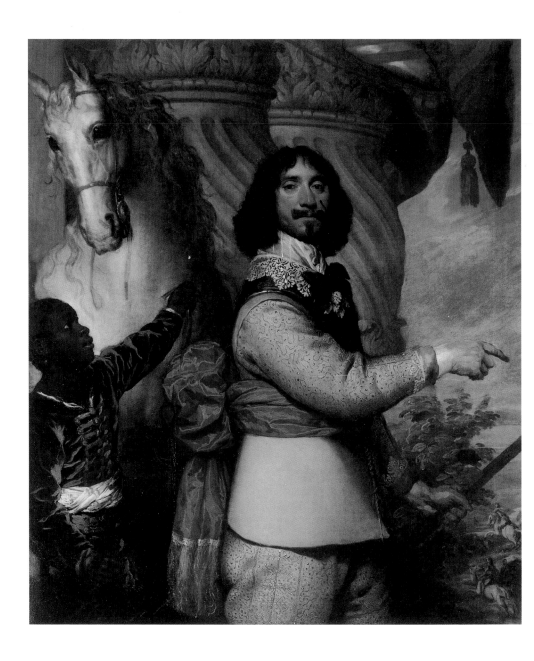

1. **William Dobson**, *John, 1st Baron Byron*, c. 1643

Andrew Wilton

Five Centuries of British Painting
From Holbein to Hodgkin

183 illustrations, 71 in color

Thames & Hudson world of art

Acknowledgments

I am grateful, as always, to the numerous scholars whose books, articles and talks have over the years stimulated and developed my understanding of British art. In addition to these, several people have helped me assemble, check and organize the facts and illustrations in this book; I am particularly grateful to Tim Barringer, Kevin Driscoll, Adrian Glew, Karen Hearn, David Fraser Jenkins, Emily Lane, Christopher Newall, Nicholas Serota, Robert Upstone, Simon Wilson and Christina Wilton for assistance in many different ways.

In the hope that they will one day develop an interest in the painters of the British School, I dedicate this book to my god-son, George Newall, and my god-daughters Emily Knight and Sarah Richards, who are approaching the age at which I first opened Roger Fry's 'Reflections on British Painting'.

A.W.

First published in paperback in the United States of America in 2001 by Thames & Hudson Inc., 500 Fifth Avenue, New York, New York 10110

thamesandhudsonusa.com

Library of Congress Catalog Card Number 2001087396
ISBN 0-500-20349-0

Designed by John Morgan
Typeset by Omnific
Printed and bound in Singapore by CS Graphics

Contents

Foreword

There are many ways to write a book on British painting nowadays. Scholars have approached the subject from angles economic, social, political, and feminist, among many; and there has been much to say from each point of view. But there has been a tendency for writers of different interests to concentrate on different parts of the story. Feminists have found the Victorian period particularly rewarding; socio-economists have explored the landscape painting of the Romantic period; political philosophers have found the Augustan Age a rich seam. If a survey like this one is to incorporate the insights of so many recent researchers, its perspective will tend to shift markedly from period to period. It may also, perhaps, lose sight of the paintings themselves as works of art, rather than as documents of their time. This account, then, is an aesthetic history rather than a social or political one, though it aims to place artists and works in their broad historical context.

We are now able to view the 20th century in deeper historical perspective. Stanley Spencer, until recently regarded as a quirky Academician, is now recognized as a major figure of his time, and artists of many different traditions can be similarly reassessed as having contributed in their own ways to the aesthetic and social texture of a complicated period. Throughout, some of the decisions as to whom to include and whom to leave out have been subjective; but there is such a thing as a generally recognized canon of critically important figures, however loosely defined, and these, especially in an introductory survey, need to be in their places. If the book fails to do justice to all the various emphases of recent interpretation, I hope that it will at least provide a working overview of the subject, and a stimulus for those readers with more specific interests, whether aesthetic or social, to make further enquiry.

The narrative has been conceived of as continuous, divided into chapters which cover more or less defined historical periods. These inevitably flow into one another, and some major figures belong to more than one period. I have chosen to group Crome with a discussion of the Picturesque because he seems to me to spring from, and crown, that tradition; William Blake is best understood in the context of history painting;

just as Francis Bacon belongs in an important sense in the context of post-war Existentialism.

During almost the whole of the period covered by this book, the cultural centre of the British Isles was London. It was in London that artists from abroad usually settled, and in London that the Royal Academy was established. Many regional centres produced artists and art institutions – Dublin, Cork, Edinburgh, Liverpool, Bristol, Norwich, to name only some – but the English capital exercised a magnetic effect on everyone, and few artists of importance failed to gravitate there. 'London' therefore stood for Britain even at a time when, say, Edinburgh was at its cultural zenith. The British School was, in practical terms, based in London, and most British artists – as well as many who came from abroad – thought of themselves as English. I apply the two labels, as far as possible, to indicate real differences, but make no apology for using them interchangeably at times.

The term 'painting' can be defined broadly or loosely. I have chosen to concentrate on work in oil, but no history of the visual arts in Britain can ignore watercolour, which played a central role in the development of the Romantic vision in the late 18th and early 19th centuries; and there have been some important artists since who have made significant use of the medium. Miniature, too, has been a vital expression of the British sensibility; I have sketched its impressive origins in the 16th and early 17th centuries, but have not attempted a detailed survey of its later development.

I referred above to 'the British sensibility', but do not want that to be taken as prescriptive, or delimiting. In practice, there are as many reasons for denying a unifying national aesthetic as for identifying one, and much ink has been spilt on the question whether such a thing exists. There are qualities in British art that people, both indigenous and foreign, notice as distinctively 'of' these islands, and some of them – the love of portraiture and landscape, for instance – have persisted over centuries. Others, like a preference for the small-scale or the linear, are more difficult to substantiate in practice. It is better, perhaps, to proceed with no assumptions of this kind; but it can be said with some certainty that British art, taken all together, is not quite like that of other countries, and has some special qualities, not always obvious ones, that shine in any international context and make the subject extraordinarily rewarding.

Chapter 1 The Renaissance Princes: The Tudors 1500–1603

For most of the 15th century, England had been riven by the squabbles of the Wars of the Roses. Only with the able administration of the first of the Tudors, Henry VII, did the kingdom achieve some degree of unity and stability. His son Henry VIII, eighteen when he attained the crown in 1509, proceeded to make his court one of the most splendid in Europe. He began as a model Renaissance prince: scholar, poet, musician and swordsman. His legendary meeting with the King of France, François I, at the Field of Cloth of Gold in 1520 identified him as the equal of one of the most cultured of European kings, the builder of the châteaux of Fontainebleau and Chambord, patron of Leonardo da Vinci and an army of Italian artists.

Henry too built extravagant palaces for himself, at Whitehall, Hampton Court and Nonesuch, filling them with artefacts by skilled craftsmen from all over Europe. He employed the Italian sculptor Pietro Torrigiano to create the effigy on his father's tomb in Westminster Abbey, and was lucky enough to have one of Europe's greatest artists, the German Hans Holbein (1497/98–1543), to immortalize him and his court in paint.

Holbein, born in Augsburg but established in Basel, belonged to the international circle of humanist scholars and artists who epitomize the northern Renaissance. He had been introduced to Henry's adviser Sir Thomas More by the Dutch scholar Erasmus, who lived in England between 1509 and 1514. Holbein designed illustrations to Erasmus's most famous book, *The Praise of Folly*, earning his commendation as 'a wonderful artist', and executed two grand allegorical processions, *The Triumph of Wealth* and *Triumph of Poverty* (now lost), for the Hanseatic merchants' London headquarters, Steelyard Hall. These were in the florid Mannerist style of northern Europe, an ebullient variant of the new Italian art with its classically inspired figures and architecture.

Shortly after Holbein's arrival in London in 1526 More commissioned from him a large portrait of himself surrounded by his family. The picture no longer exists, but is recorded in copies, and Holbein's pen drawing of the composition survives. It treats all the individuals in the group on more or less equal

2

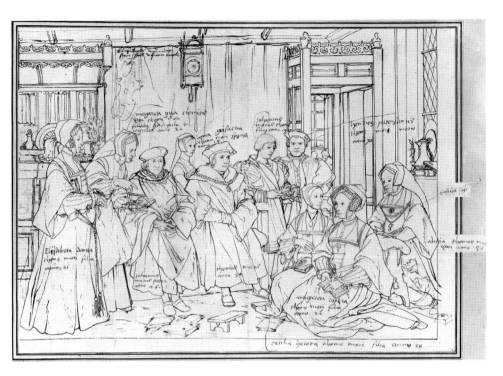

2. **Hans Holbein the younger**, preparatory drawing for *Thomas More and His Family*, 1526 Sir Thomas More (1478–1535) was a supporter of the new humanism, and was greatly admired by Erasmus, who dedicated his book *In Praise of Folly* to him. More's neo-Platonic political fantasy *Utopia* (1516) became the model for many subsequent visions of the future of society. A superb portrait by Holbein of More alone is in the Frick Collection, New York.

terms, setting them in what seems to be the carefully observed interior of More's house. With its grand scale and brilliant characterization it initiates the genealogy of British portrait painting.

Holbein returned to Basel in 1528, and came back to London in 1532 to find the country on the brink of radical change. During the 1530s Henry inaugurated a cultural revolution more far-reaching than anything since 1066. His assumption of control over the Church and suppression of the monastic orders that had sustained it effectively destroyed the medieval civilization the Tudors had inherited. Rich ecclesiastical and monastic establishments were emptied and in due course despoiled, iconoclastic mobs tearing down Popish images, defacing sculptures and obliterating wall-paintings. In England, the new Protestant religion had little use for visual representation. Henry reconstructed the arts of his country as a system of propaganda for himself as 'Defender of the Faith', a monarch occupying an imperial throne. Painters would no longer depict the Virgin Mary and the Christ Child: they would henceforth paint him and his dynasty. His palaces embodied his power and wealth; his portraits showed him as king 'in this world present the person of God'. Portraiture, which had existed in the late 15th century and

under Henry VII as a feeble provincial reflection of current practice in the Low Countries, was propelled into a central role.

That role was proclaimed in a huge picture that Holbein created at Whitehall in about 1537, the supreme statement of Tudor dynastic ambition. Wholly secular yet with a quasi-theological message about the divine right of kings, it was a symbolic portrait of Henry with his parents, Henry VII and Elizabeth of York, and his third wife Jane Seymour, mother of his son and heir. The figures stood like saints in an altarpiece, against a richly decorated background of shell-headed niches and pilasters ornamented with arabesques, linked by a frieze of mermaids and mermen. Sumptuous carpets covered the floor at their feet, and the ceiling was painted in trompe-l'oeil suggesting a balustrade supported by writhing nude figures. This great work was lost in the fire that destroyed all of Whitehall Palace except the Banqueting Hall in 1698, but there survive copies, and Holbein's full-size working drawing for the figures of Henry VII and Henry VIII himself, four-square, arms akimbo, tremendous.

But Holbein's court portraits often strike a surprisingly intimate note. The small head of the King that he painted in about 1536 preserves the majesty of the man, but presents him as a palpable human being. Like the Whitehall whole-length, it was probably transferred to the panel from a careful drawing. Many such drawings have come down to us, so that we can follow Holbein's process of looking and understanding at close quarters. An initial lead-point drawing on paper delicately washed with pink colour is strengthened with a fine pen or chalk outline. Coloured chalks are used to add flesh tints, golden hair or the brown of a fur collar. The searching gaze, the intensely moulded features are observed with dispassionate care. Holbein traced the outline to transfer it to the panel on which the finished painting was to be executed. When he paints, his technique is of such refinement that we forget the membrane of pigment by which the illusion of actuality is achieved. Working in oils on wooden panels, he followed a tradition that had been perfected in the Netherlands and Germany in the previous century. The use of canvas as a support was beginning to come in, and he occasionally painted in tempera on cloth, though no examples have survived.

The small likeness of Henry has the quality of a miniature, and indeed Holbein was a master of this form too. He may have been taught to paint 'in little' on vellum by Henry's 'pictor-maker', the Fleming Lucas Hornebolt or Horenbout (*c.* 1490–1544), whose superior position at court Holbein never

3

usurped. His miniatures excel Hornebolt's in every respect, though they adopt Hornebolt's standard background of brilliant blue, which set off the head of the sitter with charm and force. This blue was usually either azurite or smalt, a pigment made from powdered blue glass. From Holbein's example there sprang a noble tradition of miniature painting in England, which flourished especially in the reigns of Elizabeth and James I, but was to continue impressively until the early 19th century.

Holbein's miniature likeness of *Anne of Cleves* (1539) stands as a kind of emblem of his gifts as a portrait painter. Its purpose was simply to inform Henry of Anne's appearance. Holbein could perform that task with uncanny truth and immediacy. When tackling great men like More, he brings his penetrating

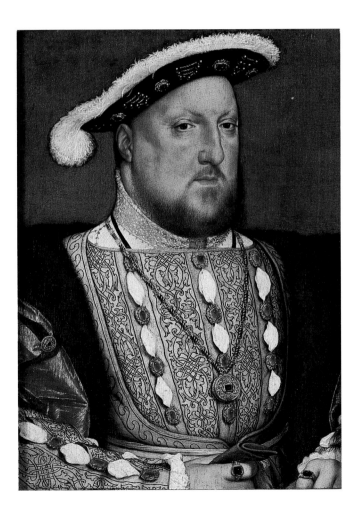

3. **Hans Holbein the younger**, *Henry VIII*, *c*. 1536
Henry VIII (born 1491, reigned 1509–47) was around forty-five when Holbein painted this intimate likeness of him, at the moment when the dissolution of the monasteries was about to be implemented. It exemplifies the artist's ability to present the sitter both as a wholly convincing individual and as public symbol. Unusually, Henry is shown three-quarter-face, as he is depicted in Holbein's cartoon for the great mural in Whitehall Palace. The blue background was to become almost a trademark of the miniature.

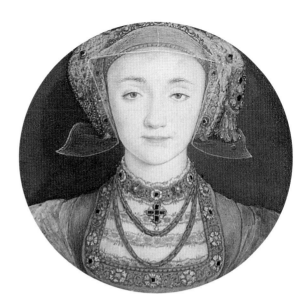

4. Hans Holbein the younger,
Anne of Cleves, 1539
After Jane Seymour's death, Anne (1515–57), daughter of the Protestant Duke of Cleves, was proposed as Henry's fourth wife. The Ambassador to the Low Countries wrote, 'I hear no great praise neither of her personage nor beauty'. On the strength of Holbein's picture, however, she was summoned to England, and married the King in 1540; but he was soon disgusted with his 'Flanders mare', and the marriage was annulled.

eye to bear directly on face and character, and makes us feel we know them personally. It is as though we had interrupted them in private, surrounded by objects characteristic of them: the pen and papers of the writer, the books in which the scholar is absorbed, the measuring implements of the mathematician. These are the equivalent of the attributes that would accompany the portrayal of a saint in any religious picture, and they have a symbolic as well as a literal function. They denote the sitter's role in life, point to his claim to fame, round out his character. Holbein's great double portrait of Jean de Dinteville and George de Selve, Bishop of Lavour, known as *The Ambassadors* (1533), incorporates an array of symbolic objects representing the four humanist arts of astronomy, music, mathematics and geography, laying out for us, as it were, the cultivated and inquiring minds of the two men. The strangest item is an elastically stretched, anamorphic skull at the sitters' feet that only assumes its proper shape when we view the picture from the side. Dinteville's motto was '*memento mori*' – remember that thou shalt die – and when we contemplate this skewed perspective of Death, everything else in the picture goes out of focus.

Holbein created models of state and private portraiture that remained influential for a century, though his legacy was more to do with calm and dignified presentation than with his refined analysis of character. A few artists learned something of this: the Englishman John Bettes (fl. *c.* 1531–*c.* 1570) produced at least one

5. John Bettes the elder,
An Unknown Man in a Black Cap,
1545
Bettes probably trained under
Holbein (compare ill. 7). He
may also have studied on the
Continent: this picture is signed
in French on the back of the
panel 'faict par Jehan Bettes
Anglois' ('made by John Bettes,
Englishman'). Bettes worked on
decorative schemes at Whitehall,
and also produced miniatures
and wood-engravings.

6. Guillim Scrots, *Edward VI,*
1547
Scrots created the standard
portrait type of the new young
king, which was repeated by
numerous hands. Edward (born
1537, reigned 1547–53) was
Henry's son by his third wife, Jane
Seymour, and Scrots's design
suggests the direct continuation
of the royal line by imitating
Holbein's most familiar
likenesses of Henry.

highly accomplished likeness that reflects Holbein's example. Guillim Stretes or Scrots (fl. 1537–53), the Fleming who succeeded him at court from about 1545, tried to invest Henry's young heir, Edward, with his father's dignity, and in doing so borrowed heavily from Holbein as well as from the painters of the Habsburg court he had served in Brussels. Scrots is one of several Continental painters who secured important commissions at this time. A large portrait, once attributed to him and traditionally showing Henry Howard, Earl of Surrey, is now thought to be possibly by an Italian hand; it is indeed reminiscent of the work of the north Italian painter Giovanni Battista Moroni. At all events it illustrates the most sophisticated work of the time: dated 1546, it is painted, most unusually, on canvas. The elaborate background is derived from an engraving of the 1540s by an artist of the School of Fontainebleau, demonstrating the high Mannerist style of that moment.

Henry's dynastic ambitions were quashed when his son died in the seventh year of his reign, aged fifteen. The crown passed to Edward's elder sister Mary, a devout Catholic, who in 1554 married Philip II of Spain, son of Charles V, Holy Roman Emperor. The English throne was more closely united than ever with the great Continental houses. But Mary was largely subservient to

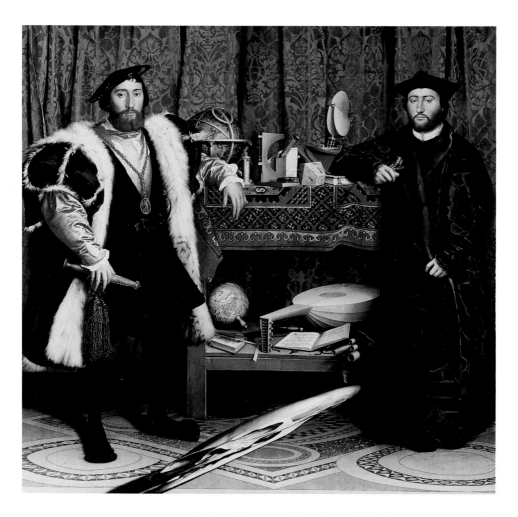

7. **Hans Holbein the younger,**
The Ambassadors, 1533
The sitters are Jean de Dinteville,
aged twenty-nine, French
ambassador in London, and
George de Selve, aged twenty-five,
Bishop of Lavour. Their poses are
similar to those of Henry VII and
Henry VIII in Holbein's great
dynastic painting for Whitehall
Palace, but instead of the splendid
Mannerist setting in which the
Tudors are placed, these two
scholars form an intimate group
with their mathematical, scientific
and musical instruments.

the family of her powerful in-laws. With their support she tried
to revoke the Reformation, to reinstate the Church of Rome in
an England where Protestantism was becoming steadily more
entrenched. Her efforts, involving the burning of many
Protestants, brought on her the obloquy of the nation. Charles
and Philip were patrons of one of the greatest painters of any
age, the Venetian Titian, to whom they often sat. Behind all the
portrait painting of the later 16th century there looms the
achievement of this subtle and majestic artist.

Perhaps fortunately, Mary died in 1558, and her younger
sister Elizabeth ascended the throne, to become the last and
greatest of the dynasty. After the disasters of Mary's reign she
recognized the urgent need to create an iconography of herself

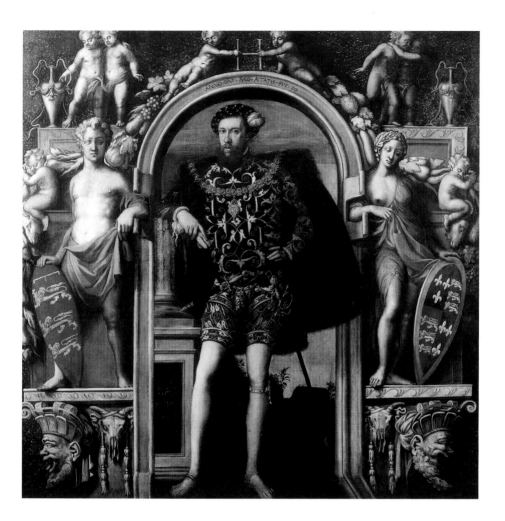

8. **Unknown artist, possibly Italian**, *Portrait of a Man thought to be Henry Howard, Earl of Surrey*, 1546

that demonstrated her uncompromising control of the kingdom. This aim became a formative influence on the development of painting in England over the rest of the century. It brought together all the strands that had been present in the work of the previous reigns: the flamboyant Mannerism that had served as background to state portraits, the stern, unflinching majesty of official likenesses, the singleness of purpose and clarity of design that had distinguished Holbein's achievement.

An artist who had risen to prominence in Edward's and Mary's reigns, having come to England from Antwerp in the late 1540s, was Hans Eworth (fl. 1540–74), who reinvigorated Holbein's legacy in an output of characterful portraits not only of the nobility but also of the landed gentry. His picture of the

soldier Sir John Luttrell (1550) is an imaginative Mannerist allegory of the Treaty of Boulogne, in which the naked Luttrell, submerged to his waist in the sea, is sustained by a personification of Peace, with Venus and other figures occupying a cloudy compartment above his head. Another allegory almost certainly by Eworth (it is signed with the monogram 'HE') celebrates the new Queen in a composition which gives the classical story of the Judgment of Paris a modern political twist. Elizabeth, holding her orb of state as though it were the golden apple of the Hesperides, seems to be weighing the merits of Venus, Juno and Minerva. Rather than awarding it to one of them, she confounds all three by outshining them in their respective qualities: the beauty of Venus, the wisdom of Minerva and the strength of Juno. Here is the beginning of that 'cult of personality' so important in Elizabeth's battle for the control of her nobles and the country as a whole. The portraits painted of her from this time on all have the aim of reasserting the message. We can still feel the force of her ministers' propaganda campaign, and the effectiveness of her painters, in our own very clear idea of what she looked like.

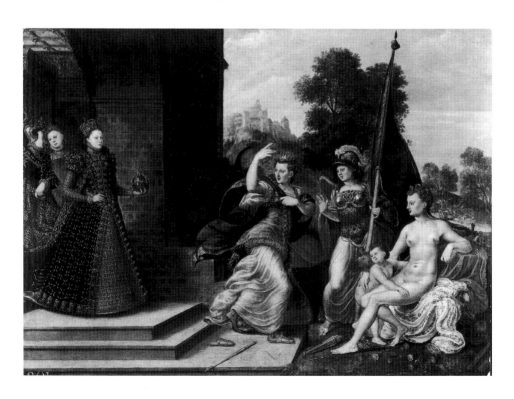

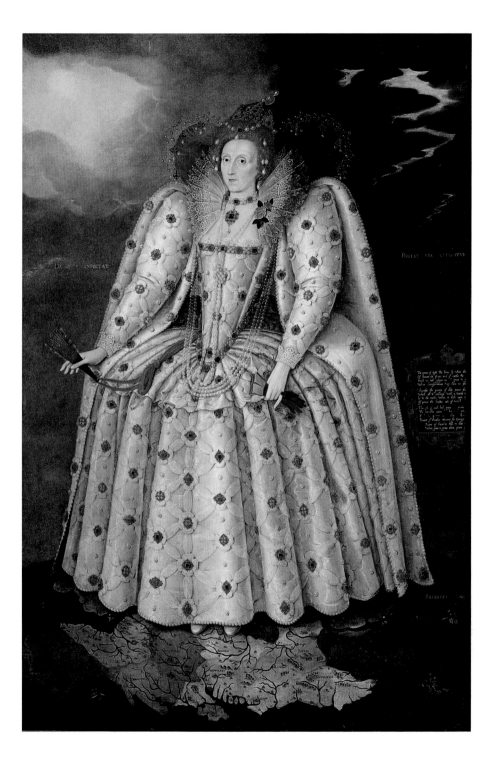

Although they vary in size and complexity of design, the portraits of Elizabeth as Queen tend to present her uniformly. They are notably static, and the sitter's immobility seems to be enforced by the weight and richness of her apparel. Above all, the face is stylized; there is none of the individualized scrutiny of Holbein. Even the refined Nicholas Hilliard (1546/47–1618), whose miniature portraits preserve with exquisite immediacy the characters of the Elizabethan age, presents his Queen in an oil painting of *c.* 1575 as a distant, generalized figure – a figurehead almost literally: she is carved from seasoned timber, painted of course, but immovable and fit to brave every gale. 13

Fifteen or twenty years later, a very different artist painting an entirely different kind of picture could still present Elizabeth in the same stylized way: the head turned slightly to our left, framed in jewelled wig and lace ruff, the shoulders stiff, the body straight. But in his 'Ditchley Portrait' Marcus Gheeraerts the younger (*c.* 1561–1636) gives us Elizabeth from head to toe, not against Hilliard's plain background but planting her feet firmly on England itself, a map spread out on a globe that hangs beneath a sky both sunny with her splendour and menacingly stormy with her authority. She wears an ornate white dress: still, aged about sixty, the diplomatically Virgin Queen. Sir Henry Lee of Ditchley probably commissioned the portrait from Gheeraerts to celebrate the Queen's arrival as his guest for an entertainment in 1592. The unchanging image of the monarch could be endowed with many attributes. Gheeraerts used the whole panoply of the earth and heavens to celebrate Elizabeth. Other artists gave her varying symbolic accessories: a rainbow, an ermine, even a sieve, betokening both chastity and the refining faculty of critical judgment. 10

Born in the Netherlands, Gheeraerts had spent nearly all his life in England. Two years after the Ditchley Portrait he painted Sir Henry Lee's cousin Thomas as an Irish soldier, bare-legged, standing in a rolling landscape no doubt intended to suggest Ireland. Thomas Lee was something of a rough diamond, part hero, part outlaw; he was executed at Tyburn in 1601. Gheeraerts beautifully balances these *farouche* qualities with Lee's pretensions to military status in the long-running struggle to colonize Ireland, creating an image of almost romantic eccentricity. The picture has an experimental quality, a sense of responding slightly tentatively to special circumstances, giving it a nervous vitality that is recognizably a characteristic that would develop distinctively in English portraiture over the next century or so. 11

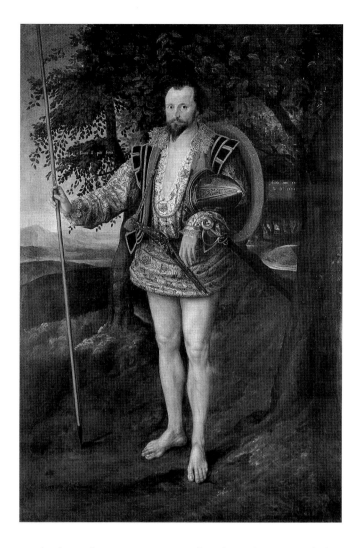

11. **Marcus Gheeraerts the younger,** *Captain Thomas Lee*, 1594
In contrast to his iconic portraits of Elizabeth (ill. 10), Gheeraerts can be seen here introducing a new naturalism into portraiture, incorporating a fluidly painted landscape and presenting his sitter with engaging informality and directness.

As the 16th century progressed, native painters were being steadily trained in practices new to the English. But the list of good native-born artists in the reign of Elizabeth is not a long one. Apart from Hilliard, who was primarily a miniaturist, one of the more conspicuous is George Gower (d. 1596), whom Elizabeth made her Serjeant Painter in 1581. Gower was that typically English character, the gentleman amateur, but it is also typical that he took his art seriously enough to become wholly professional. He never achieved the greatest heights, but produced competent, somewhat stiff but characterful heads that proclaim the honesty of his approach. His

Self-portrait (1579) is a fair example of what he could do, and emblematically proclaims his devotion to his art by showing a pair of scales in which the dividers of the draughtsman outweigh the gentleman's coat of arms. Furthermore, he depicts himself holding the palette and brushes of his trade.

As Serjeant Painter Gower was an innovator: he was the first portraitist to hold the post, which was more usually a decorator's appointment. He was paid to undertake a fair amount of ornamental work for royal festivities, painting the panels of coaches or ceremonial rooms in a style derived from the Mannerists of Fontainebleau and Brussels. The great houses of the period – country seats like Lord Burghley's at Stamford, or London palaces like the Earl of Northumberland's at Charing Cross, displayed the aristocratic version of that style. Cornelis Ketel (1548–1616) could bring to such commissions the full panoply of Mannerism, which he had learnt at first hand in Fontainebleau: elaborate allegories with contorted nude figures and a good deal of eroticism that native artists would have been unlikely to

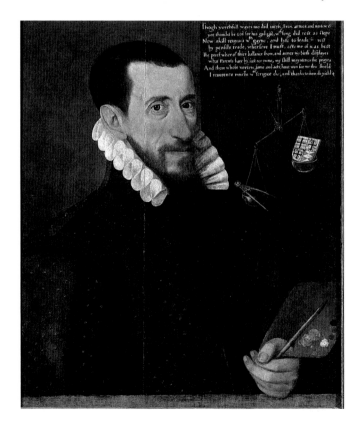

12. **George Gower**, *Self-portrait*, 1579

promulgate. Ketel returned to the Netherlands in 1581; it has been suggested that his style was too free for English tastes. Clearly, many of the English-born painters who tried their hand at this complicated idiom were hardly up to the technical standard it demanded. Gower may well have supplied such works, and there is no reason to suppose that he fell short of his royal patroness's expectations.

Nevertheless, it was as a portrait painter that he was most valued, and in 1584 it was proposed that he should be granted a monopoly on all royal portraits, both painted and engraved. The

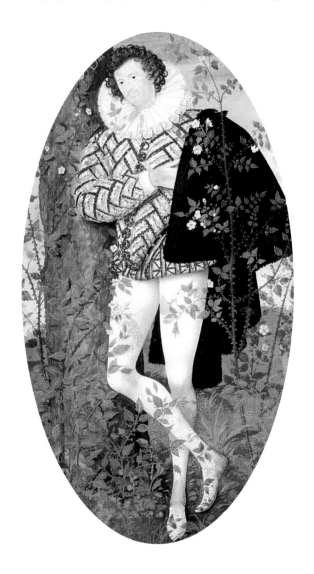

13. **Nicholas Hilliard**, *A Young Man among Roses, probably Robert Devereux, Earl of Essex*, *c*. 1587 (actual size)

clause about engraving was important, for prints were beginning their long history as vital adjuncts to painting, the means by which images could be reproduced in quantity and made available to the public as paintings never could be. Hilliard's monopoly was probably never ratified; another was drafted for him to paint portraits 'in little', though his miniatures were rarely reproduced as prints. In many respects they represent the supreme achievement of the Elizabethan visual arts.

The son of an Exeter goldsmith, Hilliard had been trained in the shop of the Queen's jeweller, Robert Brandon, and his skill as a miniaturist grew naturally from this soil. During Mary's reign he lived in Switzerland where he may have had opportunities to admire Holbein. 'Holbein's manner I have ever imitated, and hold it for the best', he said. Hilliard's work is of ravishing delicacy and precision, enhanced by rich colour. While his portrayals of Elizabeth preserve her whitened, flat, 'official' visage, his likenesses of others present fully convincing characters. Their features and costumes are rendered with a refinement more self-conscious than Holbein's, glittering against plain backgrounds, often the brilliant blue set off by an elegant inscription in gold. Hilliard's whole-length miniature of *A Young Man among Roses* 13 (*c.* 1587) has become an epitome of the age. It has been supposed to represent one of the most romantic figures of the time, Robert Devereux, 2nd Earl of Essex. He leans against a tree, the embodiment of pensive, pleasurable melancholy. The intermingling of exquisitely painted sprays of wild roses with a strikingly patterned black and white costume is unforgettable.

At the end of the century Hilliard wrote (but never published) a *Treatise Concerning the Arte of Limning*, propounding a subjective, instinctual view of his art, emphasizing the genius of the draughtsman and the 'polite' nature of miniature painting. Gower had successfully combined other sorts of painting with being a gentleman, but the civilized art of the miniaturist was a 'a thing apart from all other Painting or drawing, and tendeth not to comon mens usse . . .' Hilliard's approach marks an advance in the recognition of the artist as someone more than a mere artisan.

His treatise was written at the prompting of Richard Haydocke, who had recently translated a famous Italian essay on the art of painting by Giovanni Paolo Lomazzo. Its appearance in 1598 marked the arrival of Italian Renaissance ideas as part of the theory, as opposed to distantly derived practice, of painting in England.

Hilliard's successors join his refinement and directness to a more opulent sense of decoration. His pupil Isaac Oliver (*c*. 1565–1617) was the son of a Huguenot immigrant, and possessed an innate feeling for Continental Mannerism. Some of his miniatures are quite large, with elaborate compositions of whole-length figures and carefully wrought backgrounds. In some instances he borrowed a compositional idea from Hilliard, as when he showed Lord Herbert of Cherbury (*c*. 1613) reclining full-length in a wooded landscape. But in due course, Hilliard would himself be influenced by his younger colleague, who could design in a full-bloodedly Continental style. Oliver's *Portrait of a Lady in Masque Costume* (*c*. 1610) is pervaded by sinuous rhythms that mark a departure from the formalities of Elizabeth's reign. In the hands of his son Peter the style was taken on into the period of the high Baroque, of which, on its jewel-like scale, it was a quintessential expression.

15

14

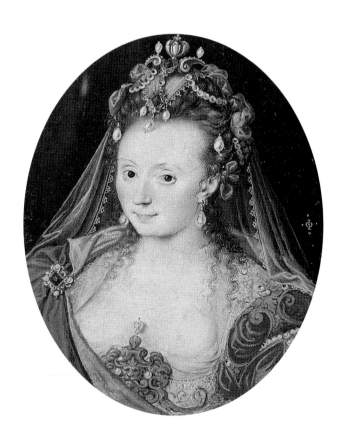

14. **Isaac Oliver**, *Portrait of a Lady in Masque Costume*, c. 1610
This is evidently the likeness of a lady of James I's court, dressed in a costume which may have been designed by Inigo Jones for a masque, perhaps representing the character of Flora, goddess of flowers. Oliver was appointed 'painter for the art of limning' to the Queen, Anne of Denmark (ill. 18), in 1605.

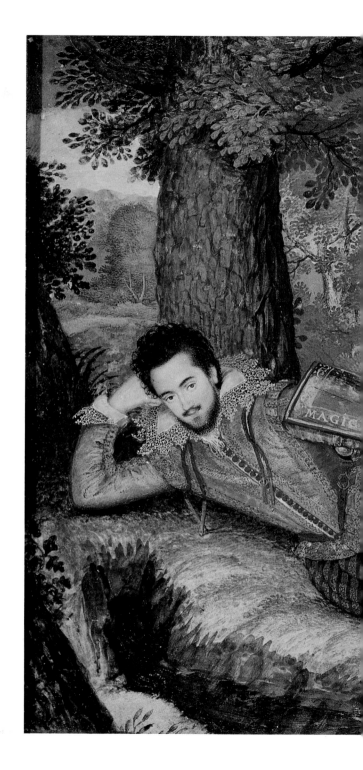

15. **Isaac Oliver**, *Edward
Herbert, 1st Baron Herbert
of Cherbury, c.* 1613
(actual size)
Edward Herbert (1583–1648),
soldier, courtier and diplomat,
was also, like his more famous
younger brother George, a
metaphysical poet. Impetuous
and darkly handsome (the
antiquary John Aubrey called
him 'a black man'), he was
addicted to 'chivalrous' quarrels
that often resulted in duels.
Oliver depicts him here resting
after one of these encounters, in
heraldically brilliant colours that
recall the imagery of medieval
tournaments, while his pose,
derived from that of the Earl of
Northumberland in a Hilliard
miniature of *c.* 1590, is that of
the meditative philosopher-poet.

Chapter 2 The Renaissance Princes: The Stuarts 1603–1688

Elizabeth died in 1603, and her Scottish successor, James I, inaugurated a new dynasty. His court was a less sober place than Elizabeth's, and became the meeting-point for many arts. By this time the lessons of the Italian Renaissance were beginning to be absorbed in England. The great men of Elizabeth's day – men like Burghley and Northumberland – were scholars and travellers, and had encouraged their artist protégés to travel likewise. The Earl of Arundel was another of their number, and brought home from Italy a collection of ancient marbles that was to be the model for many a connoisseur over the next two centuries. His travelling entourage included scholars and artists, and, on his journey to Italy in 1613–14, the architect Inigo Jones, who was to transform architecture in England. He introduced a strict classical style based on the ancient Roman theoretician Vitruvius and his 16th-century interpreters Serlio and Palladio.

Jones was employed at James's court as a designer of spectacular entertainments or masques. From 1605 on, in collaboration with the playwright Ben Jonson he devised wonderful settings and costumes, creating fantasy worlds for the pleasure-loving King and Queen and their court. There is an element of fantasy, too, in the portraiture of the new reign. The sitters are often presented as if they were taking part in some splendid masque or ballet, and stand against backgrounds that might have been designed by Jones. Often these are representations of the exotic houses and gardens they had created for themselves, or would have liked to create, in real life.

The paintings of William Larkin (*c.* 1580–1619) are full of brilliant colour and gorgeous details, each a little pageant in itself. It is a measure of how undeveloped the role of the painter still was in England that Larkin's works cannot be certainly ascribed to him. The group of sumptuous portraits we call his have long been separated from any record of their creator. But if their authorship is shadowy, they themselves certainly are not. They represent the climax of the style that had been developing through the last fifty years or more, incorporating all the elements of a standard Elizabethan portrait but with heightened

brilliance and clarity. Costume becomes a vital index of status: its every fold, slash and pearl acquires prominence and meaning. Pattern and colour – the intricacy of a Turkey carpet, the swag of a red curtain, the embroidery of a doublet or an underskirt – present a richly varied surface texture out of which the intelligent, expressionless faces peer with disconcerting realism.

The contrast between the extreme stylization of drapery and the fine modelling of the faces prompts the question whether more than one artist was involved. That would not be unlikely. It was common practice for portrait painters to distribute different aspects of a picture to specialized assistants: face and hands by the principal, landscape, drapery, or still life by others. But there is also the question of what these portraits were intended to do. The stylization, as we have seen in the case of Elizabeth, is used deliberately to create a distancing effect, to transform the sitter into an 'icon'. But the increased sophistication in the rendering of likeness marks a shift of mood that was shortly to make itself apparent in portraiture of a very different kind. The paintings of 'Larkin' are both a climax and a transition to a new age.

We can compare them with contemporary works by the Dutch painter Daniel Mytens (c. 1590–1647), first recorded in England working for Arundel in 1618. About that year he painted two whole-lengths, of Arundel and his wife Alatheia, both seated, with noticeably softer and gentler furnishings than Larkin's. The oriental carpet has a flowing pattern; there is no discrepancy between stiff fabrics and soft flesh: everything works harmoniously together. Behind Arundel is a long gallery containing his classical sculptures; his wife sits before a similar perspective lined with paintings – mostly rigid whole-length portraits, in plain black frames, of the type still to be seen in the long galleries of English country houses. This is a rare contemporary record of the way portraits were used at the time. 17

Despite a certain repetitiousness in his presentation, with predictable poses and turns of the head, Mytens was an acute observer of his sitters and their habits. He could be adventurous, devising bold patterns of strong colour, as in his striking *James Hamilton, later 1st Duke of Hamilton* (1623) which has a Spanish air about it, or his scintillating portrait of *The Earl of Baltimore* with its wonderfully painted, gently iridescent costume.

He was not the only Dutch painter working in London in the early decades of the 17th century, but he was the most various and ambitious. Another, Paul Van Somer (c. 1576–1622), sometimes worked on a larger scale, and his grand likeness

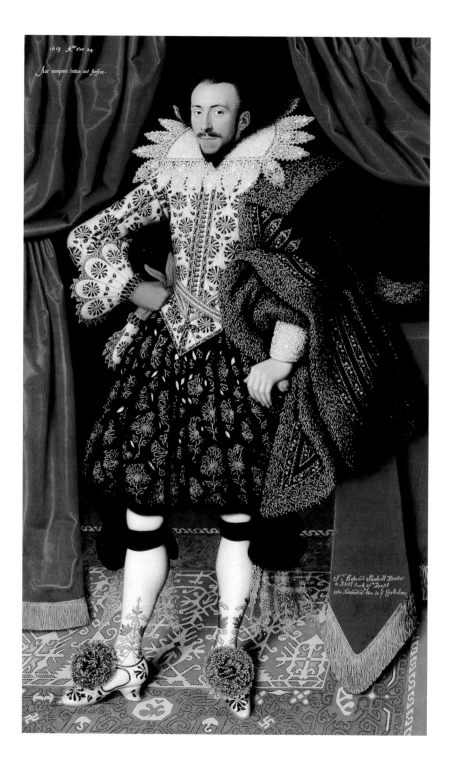

16. **William Larkin** (attr.),
Richard Sackville, 3rd Earl of Dorset, 1613
Richard Sackville (the inscription is incorrect) was born in 1589, and succeeded to the title in 1609. Like Lord Herbert of Cherbury (ill. 15), he was a courtier with a high opinion of his own appearance, a penchant for the ladies and a passion for clothes, as this portrait testifies. The costume shown here, with a cloak 'of uncutt velvet blacke laced . . . and lined with shagg of black silver and gold' over a 'doublett of Cloth of silver embroidered all over in slips of sattin black and gold', is recorded in a surviving inventory.

17. **Daniel Mytens**, *Alatheia Talbot, Countess of Arundel*, c.1618
Mytens painted a pair of portraits showing Arundel and his wife each presiding over a portion of their art collection. Arundel invites us to admire his Roman sculpture, while his wife presides over an equally important group of portraits in plain ebonized frames, trimmed with narrow gilt slips – a Northern rather than an Italian style. Arundel collected Italian and Flemish paintings, and owned work by Holbein. Mytens's treatment of the couple as equal and separate reflects their marriage, which was not entirely happy. From the late 1630s Alatheia – as much a *virtuoso* as her husband – spent much time travelling in Europe on her own account. She eventually settled in the Low Countries, and died in Amsterdam in 1654.

of *Anne of Denmark* (1617) suggests his former employment as a history painter in Amsterdam. Its combination of landscape and figures, with a black servant holding a horse, anticipates the compositions of 'grand manner' portraits in the 18th century. But Van Somer's known output in London is meagre. More prolific was Cornelius Johnson or Janssens (1593–1661), German-Flemish by parentage but born in England. He spent the latter part of his career in Holland, but his early portraits, on a modest scale, often simple head-and-shoulders, are distinguished for their gentleness and muted pearly colour.

Mytens and his Netherlandish colleagues were a formidable body of professionals before whom the native English artists of the time could put up little show. Of these, the most distinguished representative was Robert Peake (*c.* 1551–1619), whom James I made his Serjeant Painter in 1609, jointly with John de Critz (*c.* 1551/52–1642), who had held the post since 1603.

18

De Critz, born in Antwerp, was brought to London in infancy; he specialized in ephemeral decorative work, and little that can be confidently attributed to him has survived. We know more about Peake's output. It displays all the panache of the best work of the foreigners, with a freshness of vision entirely English. His portrait heads are both delicate and forceful, staring out from inventive backgrounds sometimes stylized like Larkin's, but often much more imaginative. His portrait of Henry, Prince of Wales, with a young friend, Sir John Harington, killing a deer (1603) is one of the most swagger of the period, with its lively poses and sense of narrative. Similar devices are used in another portrait of Henry (*c.* 1605–10), and one of his sister the Princess Elizabeth. He draws his sword with a heroic gesture, to enact the Prince of Wales's motto 'Ich Dien' (I serve). She stands tranquilly in a green garden full of delights, while in the deer park beyond a hunt is taking place.

18. **Paul Van Somer**, *Anne of Denmark*, 1617
Anne (1574–1619) had married James VI of Scotland in 1589, and after her husband's accession to the English throne as James I became a leading figure in the cultural life of the court, commissioning plays, poetry and masques, in which she also took part. She is seen here standing in the grounds of her palace at Oatlands, near Weybridge in Surrey. For her Inigo Jones designed the Italianate gateway in the wall to the right. The motto on the scroll above her, '*La Mia Grandezza dal Eccelso*' ('My greatness is from above') signals her learning in matters Italian. She collected works of art and was a keen sportswoman, as this portrait of her with five Italian greyhounds shows.

Some of the same inventiveness is to be found in the work of an artist who was not a professional but a dedicated amateur. Sir Nathaniel Bacon (1585–1627) seems to have taught himself by a steady process of application, beginning by imitating the still life paintings he had seen in the Low Countries, which he often visited. His series of 'ten great peeces in wainscot [i.e. set into panelling] of fish and fowle' have not all been traced, but it seems that they began rather hesitantly, and gained in confidence until he had evolved a remarkable personal style. At first sight the subjects look entirely Flemish or Dutch; on closer inspection we see that the technique quite lacks the bravura effects of thick paint (impasto) we find in Continental work. The surface is flat, the pigments applied thinly and evenly. It is a very English, pragmatic way of going about things. Everything is described in meticulous detail, one thing after another. Bacon loves to pile his observations up in heaps: fruit and vegetables, game and fish, stones in a wall. In his *Self-portrait* of about 1620, it is books that he assembles one on top of another, a still life that tells us much about him. He leans back in his chair, displaying an elegant leg in

21

20

31

a stocking of bright yellow, a particular shade that he developed (known at the time, like some other yellows, as 'pinke').

Bacon had clearly seen the work of Mytens when he painted this self-portrait. The relaxed yet formal pose, the thoughtful use of accessories to amplify our knowledge of the sitter, the very presentation of the three-quarter face, all echo Mytens's characteristic methods. In this and the tiny handful of works that we know of his Bacon shows himself worthy to be classed with the Dutch professional. He takes the efforts of Gower a stage further in the story of English artists' determined self-tuition in the ways of the European masters.

This increased proficiency was no flash in the pan. The wider learning of the new aristocrats, who used the Italian word *virtuosi* to describe themselves, meant that an altogether more knowledgeable dialogue was beginning to take place between

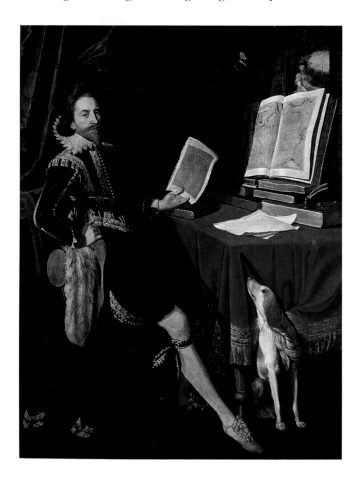

20. **Sir Nathaniel Bacon**, *Self-portrait*, c.1620
Bacon was one of the *virtuosi* of his time; his abilities as a painter were matched by wide-ranging interests in contemporary culture and science. He came from a distinguished family: his grandfather had been Lord Keeper under Queen Elizabeth, and Sir Francis Bacon, the philosopher and statesman, was a kinsman. He was appointed Knight of the Bath in 1626. Here, he displays his erudition and taste: a pile of books is surmounted by a large atlas open at a map of Europe, and on the wall behind them is a painting of Minerva, goddess of wisdom. He is holding a drawing, and on the wall, along with the sword which signals his social standing, hangs a palette: like Gower (ill. 12) and Hilliard, Bacon lays stress on the gentlemanly merits of the painter's art.

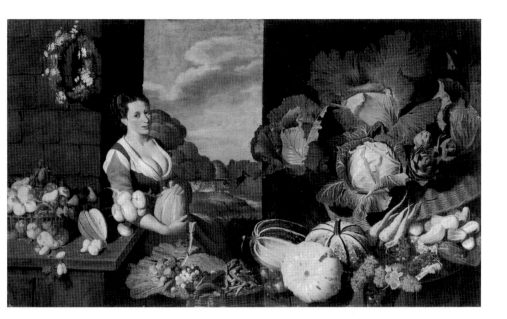

21. **Sir Nathaniel Bacon**,
A Cookmaid with Vegetables and Fruit, c. 1620–25
Bacon was a pioneering gardener and probably grew many of the fruit and vegetables he records so carefully in this picture. We know, for instance, that he cultivated the melons that harmonize so suggestively with the *decolletée* cookmaid, and the landscape background shows a cabbage garden that is presumably his own. This recently rediscovered picture adds substantially to the small number of works that can be identified as his.

London and the Continental centres on the subject of art. For instance, while the Countess of Arundel was passing through Antwerp on her travels she commissioned the great Peter Paul Rubens (1577–1640) of that city to paint her. Then Prince Charles asked Rubens to paint a picture for him, and in the 1620s the artist worked on decorations for the London house of the Duke of Buckingham, another knowledgeable collector. Rubens was interested in the new palace that Inigo Jones was planning for the King at Whitehall, and when he came to London in 1629 on a diplomatic mission he took up negotiations already begun abroad for a commission to decorate the ceiling of the Banqueting House. Charles had ascended the throne in 1625 and was building up one of the most important collections of paintings ever assembled. Rubens added to it a most unusual view of the Thames with St George and the Dragon (1629–30), in which the saint is a portrait of the young King and the princess he rescues is his Queen, Henrietta Maria of France. Groups of allegorical figures in the foreground, among the foliage and in the clouds invoke the tradition of grand subject painting as it had evolved in Venice and Flanders over the past hundred years.

With the accession of Charles I the English court attained its apogee of Renaissance splendour. Rubens called the King 'the greatest amateur of paintings among the princes of the world'. Charles's collection of works by Italian and Flemish masters

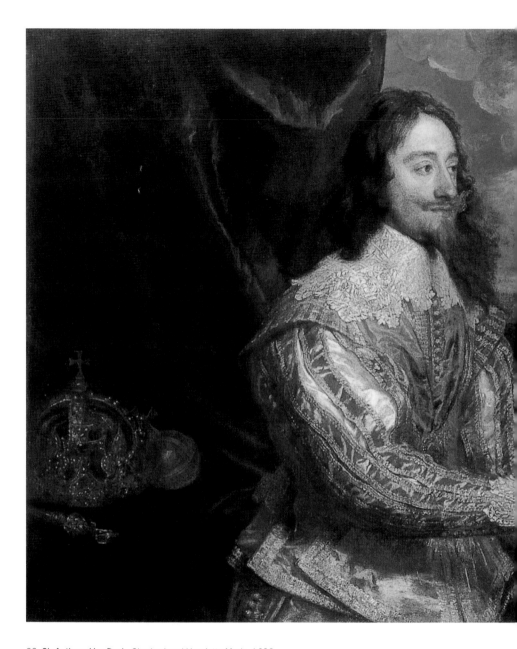

22. **Sir Anthony Van Dyck**, *Charles I and Henrietta Maria*, 1632
Just as Holbein formed the image of Henry VIII and his court, so Van Dyck
crystallized that of Charles I (born 1600, reigned 1625–49), Henrietta Maria
(1609–69) and their circle. This is one of the first pictures of the King and Queen
that the artist painted after his return to London in 1632, and it establishes their
humanity as decisively as, in their tender exchange of olive spray and laurel wreath,
it does their stable relationship as the father and mother of a peaceful nation.

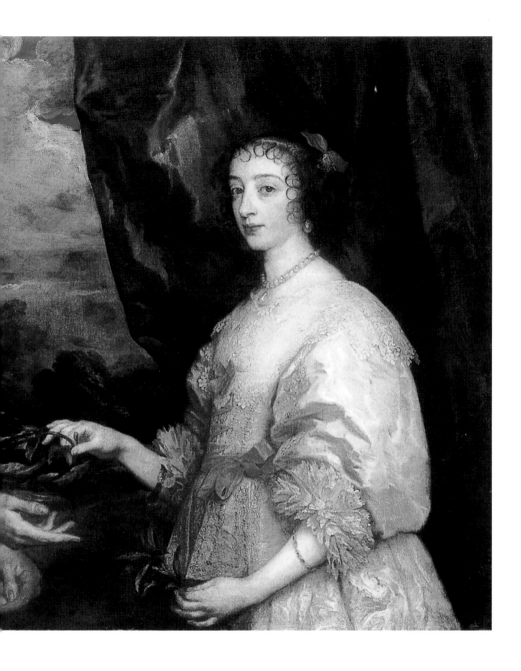

was the achievement of a man much more interested in the arts than in government. He was to pay the price for that preference with his head in 1649. Then his collection was broken up, and its masterpieces now grace the great galleries of Europe and beyond: St Petersburg, Vienna, Munich, Berlin, Paris, Madrid, Washington – all possess jewels from Charles's treasure-house.

The court continued to be the setting for elaborate entertainments, with Inigo Jones and Ben Jonson, and later Sir William Davenant, in charge. The 'Cavalier poets' flourished: Traherne, Suckling and Herrick composed lyrics to their mistresses' clothes and eyebrows. To this splendid court came, from Antwerp in 1632, Anthony Van Dyck (1599–1641). He had already visited London briefly in 1620–21, probably at the behest of either Arundel or Buckingham. Now he returned to set up his practice, unable to do so in Antwerp because his old master Rubens was firmly established there. He had developed precociously into a virtuoso painter in a manner that was a distinct variant of Rubens's, and recently travelled in Italy, combining with his Flemish style the richness of Venetian colour and a profound admiration for Titian. Executed with sweeping brushstrokes and overlaid touches of warm, semi-transparent pigment (glazes), his portraits were destined to have an impact on British art that would last until the 20th century.

Almost immediately he established his mastery by painting a 'Great Peece' of Charles, Henrietta Maria, and their two eldest children (1632), on a large scale. The picture achieves a sophisticated equilibrium that knocked the existing court painters, even Mytens, into the shadows. The Baroque grandeur of the presentation is balanced by a fluent design underpinning a gentle, one may say loving, understanding of these people as human beings, a family that had established for the first time in England a 'domestication of majesty', as it has been called.

Like Holbein, Van Dyck knew how to adapt his manner to the requirements of the English. Charles's court was very different from Henry VIII's. The stiff formality of those days had disappeared, and a much freer, almost bucolic elegance held sway. Van Dyck made this informality the keynote of many of his English portraits. Compared with the sturdy burghers of Antwerp, his English lords and ladies seem on the whole a trifle effete. Pale, slender-wristed and melancholy, they do not give an impression of worldly know-how. Van Dyck has somehow caught the mood of a court that, whatever its creative endowments, was doomed to a violent end. But the intuition of the artist is submerged in a

tactful flattery that has preserved these unrealistic men and women as the embodiment of aristocratic ease and elegance.

They are posed with relaxed grace in settings that sometimes suggest nature in quite wild moods. A whole-length portrait of the poet *Sir John Suckling*, for instance, shows the sitter in an invented costume that makes him look something of a brigand, amid overhanging, weed-grown rocks. Suckling holds a folio of Shakespeare, as though interrupted while reading from it. He might be taking part in one of the court masques: a fictional character who remains his real self. This idea of the superimposition of two identities in one portrait was to become important later on. Van Dyck produced a particularly striking example in his dramatic portrait of *The Countess of Southampton as Fortune* 23

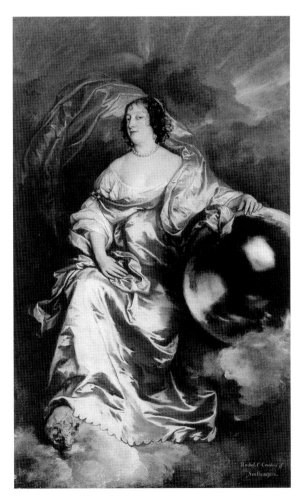

23. **Sir Anthony Van Dyck**,
The Countess of Southampton as Fortune, c. 1638
Rachel de Ruvigny (1603–40) met her second husband, Thomas Wriothesley, Earl of Southampton, in France and married him in 1634. Her reputation as 'la belle et vertueuse Huguenotte' may have suggested to Van Dyck this representation of her as an all-victorious goddess. The conceit of presenting a lady as an immortal borne aloft on clouds was to inspire Reynolds to some of his most splendid inventions.

24. **Sir Anthony Van Dyck**,
*Sir Endymion Porter and
Van Dyck, c.* 1632
A scholar and connoisseur, Porter
(1587–1649) was among the first
to give Van Dyck employment in
England, and the two men were
close associates. This double
portrait exemplifies the 'friendship
portrait' that Van Dyck introduced
and which later artists, notably
Reynolds, were to adopt as a
favourite format.

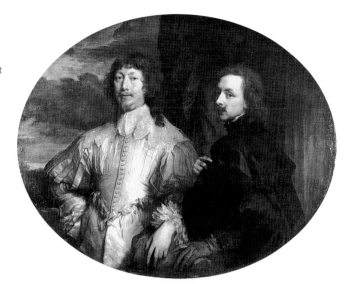

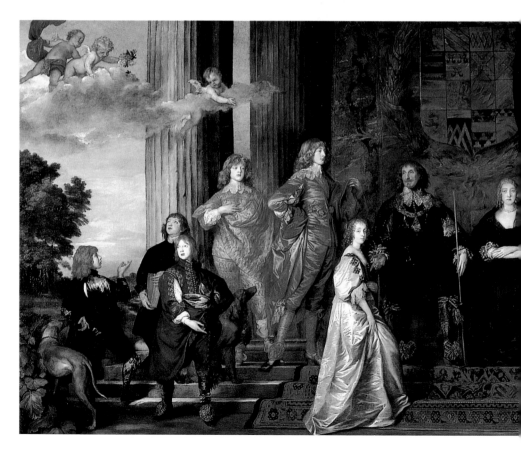

(*c.* 1638). She is a divinity straight out of a court masque, enthroned among clouds, holding a sceptre and leaning on an enormous globe which has the appearance of a bubble. Her foot rests on a human skull. Casting a glance of alluring disdain at the spectator she rules all mankind, a *Dea ex machina* of superhuman grandeur and aplomb.

The portrayal of an individual as a 'character' from mythology or literature chimed well with the acting proclivities of the King and Queen. Like the complicated sets of Jones's masques, the portrait of the Countess is an echo of the elaborate compositions of the Baroque religious painting Van Dyck practised in Catholic Antwerp. He was rarely required to execute religious or mythological subjects in England. The *Rinaldo and Armida* (1629) that he painted for the King on commission from his friend Endymion Porter, a Groom of the Bedchamber, is a magnificent exception, as sumptuous a tribute to Venetian art as he ever painted. In his images of Porter himself, Van Dyck developed Holbein's notion of the portrait of the cultivated friend into an intimate genre that was to have long-lasting appeal. At the opposite end of the scale, he could apply the grandest Baroque ideas to portraiture when a number of figures were to be painted together. His most influential essay in this vein is the huge group of the Earl of Pembroke and his family (*c.* 1634) in the Double Cube Room at Wilton (a house designed by Inigo Jones). The cast of characters is deployed across an imposing stage of colossal columns, steps and drapery, and the solemn moment is blessed by hovering cherubs. The design is both monumental and natural, easy and grand at once. Many large-scale family groups painted for English country houses in the ensuing two centuries would find inspiration in this splendid model.

There was so much variety in Van Dyck's work that his influence remoulded almost every aspect of painting in England. No portrait painter could ignore what he had done. His effect on the work of William Dobson (*c.* 1611–46) is obvious at once. A second glance, though, reveals a very different artistic temperament, and one decidedly English. Patrician elegance is replaced by matter-of-fact earthiness. Dobson was trained in the studio of Frans Cleyn (1582–1658) of Rostock, who had worked extensively in Denmark, and lived mostly in England from 1623. Cleyn is particularly associated with the decorative borders for the famous tapestries woven after Raphael's designs at the Mortlake tapestry works, set up in 1619. He also designed book illustrations and schemes for house interiors. Dobson assisted

him in some of these projects, but took up portraiture, stepping into the breach as court 'face-painter' after the death of Van Dyck, when Charles was conducting the Civil War from his base at Oxford. It is he who defines for us the image of the loyal Cavalier, hearty, cultured, proud of the crimson sash announcing his allegiance.

Dobson's sitters are usually men, and he presents them surrounded by evidence of their broad interests. He is at his most flamboyant depicting *John, 1st Baron Byron* (*c.* 1643), three-quarter-length in an authoritative pose, pointing forward into a landscape where a battle is taking place. Behind him a black servant holds his white horse. The rich golds and reds of the costumes are echoed by the banners and twisted Baroque columns against which they stand. There is a Venetian opulence that comes from Van Dyck, as do its patrician poise and theatricality.

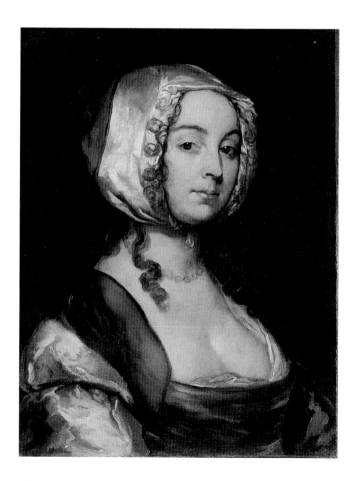

26. **William Dobson**, *Portrait of the Artist's second Wife, Judith*, *c.* 1640

But Dobson paints quite differently from Van Dyck. The smooth, fluent brushstrokes have given way to an altogether coarser, though none the less effective, technique. However noble the figure, Dobson's powerfully applied paint brings to life a personality more impetuously energetic than refined. It is the vivid, pragmatic use of paint that signals the experimental cast of the English mind. Passages of Dobson's work anticipate that of Hogarth a century later. And there is a certain Hogarthian awareness of the human vulnerability of these apparently confident men. We catch Dobson at a more intimate moment in the lovely study that he made of his second wife, Judith. With its direct gaze out at the spectator – or rather, at the artist himself – this likeness evokes the warmth of the relationship between husband and wife, tenderly expressed by means of Dobson's lively handling.

It is usual to see Dobson's achievement as something of a dead end. He naturalized Van Dyck's style, as it were, and after him came the Commonwealth, when painting suffered an eclipse. But there were other worthy followers of Van Dyck. Henry Stone (1616–58) – 'Old Stone', as he was called to distinguish him from his younger brothers – produced some able portraits, including a dignified full-face half-length of Charles I, unexpectedly in circular format. And Oliver Cromwell was not indifferent to the arts. Several painters flourished during his Protectorate, although the expansive patronage of royalty was incompatible with his style. His 'court painter' was Robert Walker (d. 1658), a dour, dry imitator of Van Dyck who was well aware of his own limitations. 'If I could get better I would not do Vandikes', he said, and a contemporary remarked, 'He would not bend his mind to make any postures of his own.'

But there were others who continued the tradition established by Dobson. Samuel Cooper (1608–72) trained as a miniaturist with his uncle, John Hoskins (c. 1590–1664/65), whose livelihood derived largely from copying Van Dyck portraits in little. Cooper developed into one of the most accomplished miniature painters of his or any age. His exquisite draughtsmanship and refined technique possess a forthright verve that makes him the small-scale equivalent of Dobson. Cooper was one of the first British artists to work in pastel, a medium that became common for small-scale portraits in the late 17th century, and continued in use throughout the 18th.

It was during the Commonwealth that another native artist of the younger generation established himself in London.

27. **Samuel Cooper**, *A Lady, possibly Barbara Villiers, Duchess of Cleveland*, *c.* 1670 Cooper's miniatures have been rated by some even higher than those of Hilliard. Renowned all over Europe, he was so successful that his career survived the fall of Charles and the Commonwealth, so that, at the Restoration, he was able to take his place as a celebrated master.

26

27

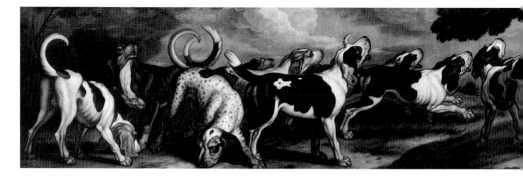

28. **Francis Barlow**, *Southern-mouthed Hounds*, c. 1665
Barlow was probably trained under a London portrait-painter, William Sheppard (fl. 1650–60), but early on turned to the depiction of animals. He was, in the words of one commentator, 'the most English of seventeenth-century painters in his understanding of country life.' His skill in integrating sporting events and animals with landscape foreshadows the achievements of the British School in the next century, and he was the first to publish the representation of a horse-race, which would be a fruitful subject for painters for over two hundred years.

Francis Barlow (?1626–1704) seems to have trained as a portrait painter, but devoted his career to very different subjects. He was the first native painter of animals of any distinction since the medieval illuminators, and provides more evidence that painting in England was developing in new directions. His work suggests that he had close acquaintance with contemporary Dutch and Flemish animal painters like Jan Weenix, Frans Snyders and Melchior d'Hondecoeter. At Ham House near London the Duke of Lauderdale employed him to paint decorations alongside a group of Netherlandish artists and later, after the Restoration, he worked on large friezes of foxhounds for a house in Surrey. Their flowing rhythms of linked animal forms foreshadow the compositional subtleties of George Stubbs a century later. Barlow was also a prolific illustrator of books and is probably best known for his lively designs for Aesop's *Fables* (1666). Once Barlow had established it, many artists took up animal painting and by the early years of the 18th century the horse or dog portrait was almost as common as the human likeness.

28

Barlow often presents his animals against spirited landscape backgrounds, and alongside sporting painting, landscape began to emerge as an independent form. The Netherlanders had developed a school of landscape painters early on. By the end of the 16th century artists from the Low Countries were influential in Italy, and when Charles I was making his great collection a few years later their work figured in it. As in other areas, the painters who came to England were not necessarily of the highest calibre. Adriaen Van Stalbemt (1580–1662) and Alexander Kierincx (1600–1652) did not produce inspired work. But the taste for representations of landscape was growing. The jewel-like theological library of Sir John Kederminster, installed at Langley Marish in Berkshire in 1631, contains among its painted decorations thirty small landscapes, including marines and storm subjects as well

as views of buildings and pastoral scenes, evidently derived from Netherlandish originals, some perhaps from prints. The impression is of an individual artist, perhaps a court painter, working to standard formulas from a well-stocked professional repertoire.

In 1636 the Earl of Arundel brought to England the Bohemian draughtsman Wenceslaus Hollar (1607–77), whose prolific output included a quantity of topographical views, many of which he issued as etchings, introducing that flexible medium into the country for the first time. The market for views grew, and there began to be a stream of pictures showing panoramas of towns and cities, country houses and their estates often seen in bird's-eye view. Jan Siberechts (1627–1703) exemplifies the genre at its best. Coming from the Antwerp of Rubens, he was an accomplished painter of natural effects who could combine them

29

29. **Jan Siberechts**, *Wollaton Hall and Park, Nottinghamshire*, 1697
Siberechts was a leading exponent of the Dutch tradition of 'bird's-eye view' house-portraiture that remained popular in England through most of the 17th and early 18th centuries. This view of Wollaton, outside Nottingham, the 'prodigy house' that Robert Smythson built for Sir Francis Willoughby in the 1580s, demonstrates the careful enumeration of every aspect of house and grounds, the total economy of the estate, which such pictures were intended to provide. It is an artificial mode that contrasts with Siberechts's more realistic work as one of the first landscapists to show English scenery and English climatic conditions together as fit subject matter for a picture.

with views of places, or with excellent figures that remind us of the country folk who people the foregrounds of Rubens's own landscapes.

Among the natives, Nathaniel Bacon was again a pioneer. A tiny fantasy of about 1620, on copper, is attributed to him: with its weird rocks and trees it borrows style and subject matter from the Low Countries. It was characteristic that 'pure' landscape, unconnected with topography, should be explored by a gentleman amateur. Robert Aggas (*c.* 1619–79), by contrast, was probably the grandson of a cartographer. The relationship embodies the historical development of landscape drawing and painting from such drily descriptive occupations. Aggas, who lived at Stoke-by-Nayland in Suffolk, is known only from one

work, which could hardly be farther removed from map-making. His *Landscape – Sunset* (1679) is an ambitious essay in purely imaginative nature-painting, conceived on a grand scale, and full of close observation, though clearly not intended to present a specific view. Henry Anderton (*c.* 1630–65) is likewise known for only one landscape painting, *Mountain Landscape with dancing Shepherd* (1650s), a work of high quality, with tender golden light derived from the work of Italianate Dutchmen like Nicolaes Berchem. Anderton also practised as a portrait painter.

These artists painted landscape for its own sake, with a sophisticated awareness of Continental precedents. Not only the Dutch but the French landscapists working in Italy, Claude Lorrain and Gaspard Poussin, were vital influences, with their development of the 'ideal' landscape. The imaginative leap from landscape painting as record to landscape as abstract meditation on nature – and indeed on art itself – is a crucial one. It is a stage in the psychological growth of the British School, by which artists in Britain apprehended new purposes for painting, new relationships between viewer and object. Before the early 18th century the abandonment of the topographical principle is rare. 'Abstract' landscape was to become so important later that its hesitant beginnings in the 17th century are worth saluting.

The Commonwealth period (1649–60) saw the rise to prominence of a new portrait painter, the Dutchman Peter Lely (1618–80), who had arrived in the early 1640s. To begin with he produced pictures that reflected his Dutch Baroque background – classical landscapes peopled by naked nymphs, executed in resonant browns and flesh tones, which he painted alongside rather sombre portraits of military personnel. His portrayal of *The Children of Charles I* (1646/47) is entirely Dutch. He readily absorbed the Flemish-cum-Venetian influence of Van Dyck, and it was as Van Dyck's natural successor that he became Principal Painter to Charles II at the Restoration in 1660. In that capacity he presided over, and largely set the style for, the last great ebullition of princely magnificence of the English Renaissance.

The seeds sown by Inigo Jones in the earlier part of the century bore fruit now in the wealth of fine classical buildings that went up all over the country. Jones's successors, above all Christopher Wren, established an authoritative classicism that set the course of architecture in England. After the Great Fire in 1666 Wren was charged with the reconstruction of London and

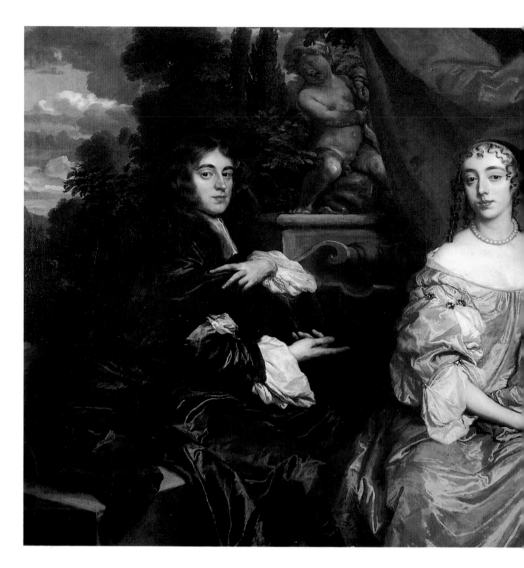

31. **Sir Peter Lely**, *Henry Hyde, Viscount Cornbury, and his Wife, Theodosia Capel*, 1661–62
Henry Hyde (1638–1709) was the son of the Earl of Clarendon and brother of the poet Earl of Rochester. This picture must have been commissioned as a wedding portrait; tragically, Theodosia died of smallpox early in 1662. Their interrelated gestures depend on such models as Van Dyck's *Charles I and Henrietta Maria* (ill. 22).

his new cathedral of St Paul's rose out of the ashes as a mighty statement of the classical aesthetic. New palaces were built, and artists were brought in from abroad to cover acres of wall and ceiling with allegory in the high Baroque style. An Italian, Antonio Verrio (?1639–1707), was one of the first. He arrived from France in about 1671, working for the Duke of Montagu, and remained much in demand, though he was later rivalled in technical ability by the Frenchman Louis Laguerre (1663–1721), with whom he collaborated, for instance at the Duke of Devonshire's grand house at Chatsworth in Derbyshire.

Into these splendid palaces Lely introduced portraits that are an interesting blend of the swagger of Van Dyck with Dutch solidity. His court beauties are decidedly graspable, his gentlemen vigorous personalities. The faces are plumper, less poetic than Van Dyck's, and the ladies subscribe to a somewhat uniform style of beauty. But many of Van Dyck's stage props remain in place. There are columns and draperies, or the suggestion of a rocky outdoor setting creating a romantic wildness against which the lustrous artificiality of the sitters stands in suggestive contrast. Above all, Lely's sense of colour is ravishing. His autumnal golds and browns slide one above another in exquisite cascades of satin and velvet, from which a white hand or a swelling bosom emerges with a seductive glow. Van Dyck's way of presenting his sitters as historical characters becomes a standard device. Lely painted the Duchess of Cleveland, for instance, in roles as various as Minerva, Venus, the Magdalen and the Virgin Mary herself.

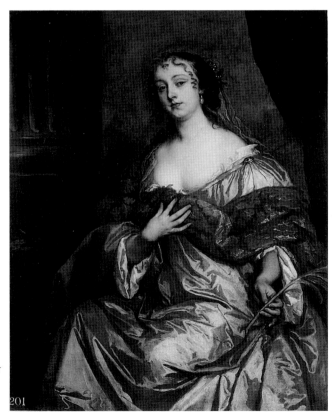

32. **Sir Peter Lely**,
Elizabeth Hamilton, Comtesse de Gramont, c. 1663
Elizabeth Hamilton (1641–1708) was apparently never Charles II's mistress, but her beauty and intelligence qualified her for a place among the 'Hampton Court Beauties'. The martyr's palm that she holds in her left hand endues her with an aura of saintliness that is belied by her languorous expression and reluctantly concealed bosom.

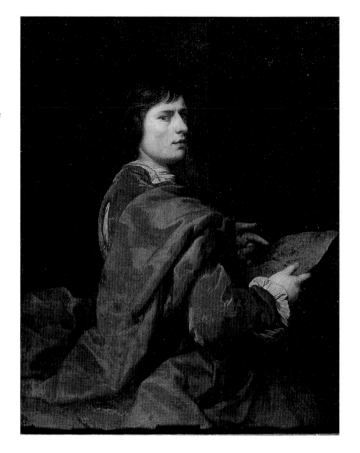

33. John Greenhill, *Self-portrait*, 1665

Greenhill was a gifted draughtsman as well as painter, and his pose in this self-portrait, pointing at a drawing, may allude to that talent. Several of his chalk drawings survive. His career was relatively short, owing to his 'loose and unguarded manner of living', which led to a drunken accident that proved fatal. An early influence on him was Gerard Soest (*c.* 1602–81), a Dutchman who came to England in the 1640s; but it was Lely who supplied the dominant characteristics of his style.

But these tricks are no longer the means by which a simple portrait is raised to the plain of a grander, more conceptual art. They are the armoury of Venus, adding to the titillation of partly disclosed flesh a hint of saintliness that everything else in the picture deliberately belies. Lely's series of 'Hampton Court Beauties' is a harem-full of gorgeous creatures whose coy glances and assumed piety only emphasize that they are all too available. It is an embodiment in warmly applied paint of the very apparent lasciviousness of Charles II and his entourage.

Lely's success was founded on a sure talent as draughtsman that reveals itself in his beautiful chalk drawings, which betray a careful study of Van Dyck's methods. Similar work was produced by some of his pupils, notably John Greenhill (?1640–76), perhaps his most adept native follower. A convincing application of fluent impasto gives Greenhill's best work

its own distinctive life. The celebrated woman novelist and playwright Aphra Behn wrote of him:

> *So bold, so soft, his touches were,*
> *So round each part, so sweet, so fair,*
> *That as his pencil mov'd, men thought it press'd*
> *The lively imitated breast,*
> *Which yields like clouds where little angels rest.*

Although Greenhill mainly produced heads or half-lengths, he occasionally explored more ambitious compositional types with allegorical accessories.

Aphra Behn was one of many women who were now beginning the centuries-long progress to professional independence. Mary Beale (1633–99) is unusual in having been a fully professional woman painter, with a flourishing London practice. Her formal portraits are somewhat stolid, but she could deploy Lely's expressive free brushwork when she was at her ease with family, friends and children.

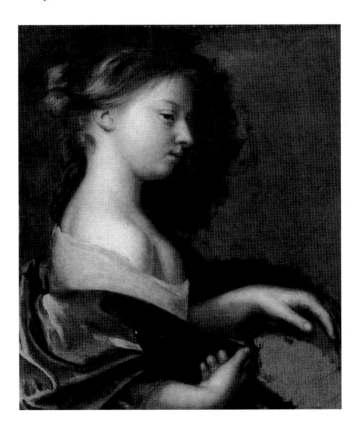

34. **Mary Beale**, *Study of a Young Girl, c.* 1681

Lely was a Protestant, and Charles II's Queen, Catherine of Braganza, was Catholic. Charles himself secretly converted to Catholicism, though he knew it would be unwise to let this become public. It was the suspicion of Catholicism that had sealed Charles I's unpopularity, and James II was later to bring the Stuart dynasty to an ignominious end by insisting on the restitution of Romish practices. In the last decades of the dynasty several Catholic painters flourished. The portrayals of Charles's mistresses by Lely's Papist rival the Antwerp-trained Jacob Huysmans (*c.* 1633–96) are lush, dense images of theatrical overstatement, extravagant in setting and ornamental detail.

Less extreme but also capable of rich effects of colour and atmosphere is the work of a Catholic Scot, John Michael Wright (1617–94). After his training in Edinburgh as a portrait painter with George Jamesone (1590–1644), Wright travelled in Europe, studying in Rome, and probably in France and the Low Countries. He could sometimes achieve wonderfully showy effects reminiscent of contemporary French painting, in his portraits of gentlemen in densely curled wigs and silver-embroidered coats, but there is a characterful seriousness about

35. **John Michael Wright**, *The Family of Sir Robert Vyner*, 1673 Stylistically, the picture blends features from contemporary Dutch and French painting. Sir Robert Vyner (1631–88), from a family of Warwickshire gentry, was a banker and goldsmith. In 1665 he married Mary Whitchurch, and in 1666 he was made a Baronet. In 1674, the year after this portrait was painted, he became Lord Mayor of London. But in the same year his wife died, and his financial standing was ruined when the Dutch wars, combined with court extravagance, threatened Charles II with bankruptcy. Their son Charles lived only to the age of twenty-two, leaving his father to die of a broken heart.

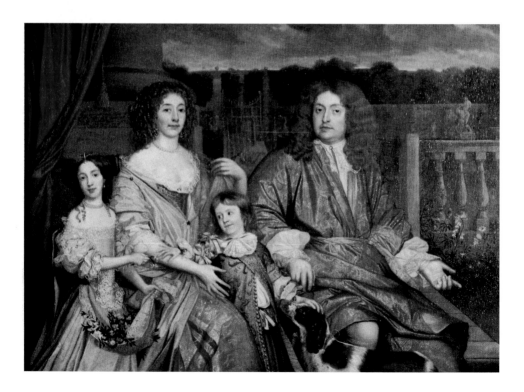

his women in their finely pleated, shot mauve and pearl silks that is at the opposite pole from Lely. He is particularly poetic in his handling of the wistful sunset landscapes that frequently feature in the backgrounds of his portraits.

Wright might have dominated painting in late 17th-century Scotland; instead he went abroad, and later worked in England. His place was filled by an immigrant Dutchman, Jacob de Wet (1640–97). De Wet created Baroque decorative schemes for Scottish houses, including Glamis Castle, and portraits like the outrageous whole-length of *John, 1st Marquis of Atholl* (*c.* 1680) at Blair Atholl. With his contorted pose and absurd Roman armour the Marquis exemplifies an extreme of theatricality that portrait painters were to react against in the coming decades.

36

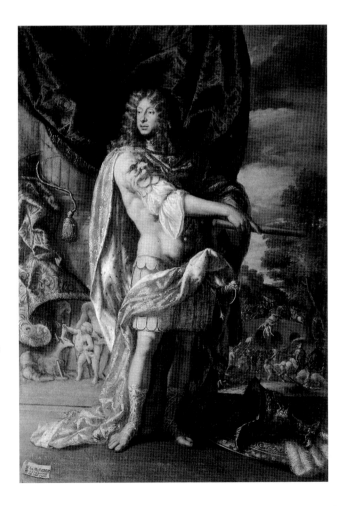

36. **Jacob de Wet**, *John, 1st Marquis of Atholl*, *c.* 1680 John Murray, 2nd Earl and 1st Marquis of Atholl (1631–1703), could never be relied on to remain on the same side in any dispute. The historian Thomas Babington Macaulay called him 'the falsest, most fickle, the most pusillanimous of mankind.' This fantastic portrait shows him as one of the victorious generals of the battle of Bothwell Brig, at which the Covenanters were defeated. He wears the ceremonial armour of an ancient Roman, with all the paraphernalia of the grandest Continental Baroque portraiture. Although in some ways a curiosity, it foreshadows the splendidly rhetorical Highland portraits of Raeburn a century later (ill. 105).

Chapter 3 The Age of Improvement: 1688–1750

When William of Orange came from Holland in 1688 with his Stuart Queen, Mary, to take the throne so precipitately vacated by James II, there was perhaps no great change in national sentiment. The public wish was carried out when James was sent packing. But the quality of court life, and the flavour of life in high places generally, underwent a radical transformation. The Catholic leanings of the Stuarts were definitively replaced by William's committed Protestantism. The opulence of the Renaissance courts gave way to a sober preoccupation with parliamentary government, the concerns of a burgeoning mercantile class, and a new sense of the responsibilities of high position. Science attained new prestige, marked by the burgeoning of the Royal Society, which had been formally instituted in 1660. Painting too was a branch of learned enquiry. New markets for art were beginning to emerge, and new requirements were made of artists.

Portraiture, for instance, changed notably. It lost much of its theatricality and became serious, almost staid. Lely's successor as court painter, Godfrey Kneller (1646–1723), was a native of Lübeck in the mercantile heart of northern Germany, perfectly cut out to express the new attitudes. He had trained in Holland under Ferdinand Bol, and must have learnt, too, from Rembrandt. He then travelled to Rome, and was well versed in modern painting by the time he came to England in the early 1670s under the patronage of a Hamburg merchant, John Bankes. He was appointed Principal Painter to the new King in 1688, along with an Englishman, John Riley (1646–91).

Although Kneller's approach derives from Lely's, his style is stripped of lubriciousness. His ladies do not pout at us, exposing plump flesh: they gaze with a cool, grave regard, like monuments to ancient virtues. The standard poses become stiffer, more predictable. The rhetoric of power shifts key from the self-consciously erotic to the self-consciously respectable. The technique is noticeably dryer, too. Gone are the liquid glazes and sensuous impasto: Kneller's preferred manner, which at his best is very expressive, involves a dry scumble of highlight over a flat, sombre colour, devoid of sensuality. In his more intimate portraits, usually half-lengths of male friends, his freedom of touch

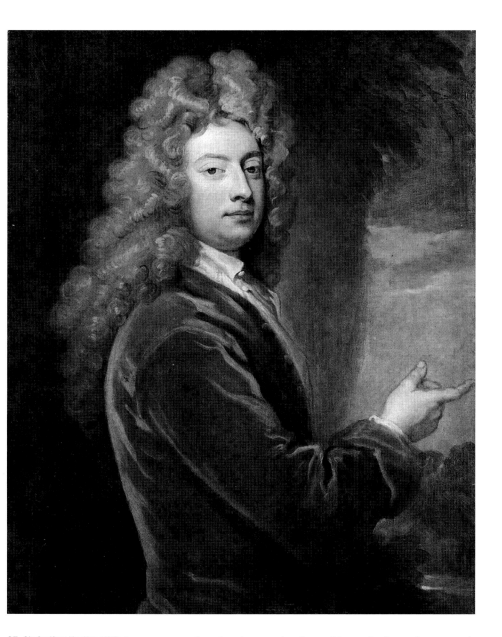

37. **Sir Godfrey Kneller**, *William Congreve*, 1709. By the time Kneller painted him as a member of the Kit-Kat Club, Congreve (1670–1729) had given up writing plays as an ungentlemanly activity (his best-known, *The Way of the World* was his last, in 1700).

approaches the virtuoso; but it would smack of paradox to speak of virtuosity in reference to such direct, unaffected painting. He is most himself with the members of the Kit-Kat Club, that informal group of public men, politicians and literati who imparted their dynamism to the high-minded 'Augustan' age of Queen Anne and George I. In these modest half-lengths, executed

37

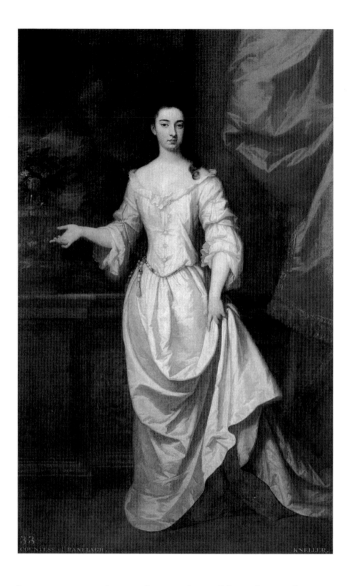

38. **Sir Godfrey Kneller,**
*Margaret Cecil, Countess
of Ranelagh*, 1691

between 1701 and 1721, the trappings of formal portraiture are dispensed with. Physiognomy alone becomes the subject.

On the grander scale of court portraiture, Kneller's set of whole-length 'Hampton Court Beauties' contrasts sharply with Lely's series (which were all three-quarter-lengths). *The Countess of Ranelagh* (1691) confronts us with great poise, making a generous gesture with her right hand, and holding up her dress, though she does both without the least coquetry. Rather she engages us in intelligent conversation, undistracted by

39. **John Closterman**,
Anthony Ashley Cooper, 3rd Earl of Shaftesbury, c.1701
Shaftesbury (1671–1713) was educated under the tutelage of the great philosopher John Locke. As a serious Whig he endorsed progressive measures for the improvement of conditions for the disadvantaged. His *Characteristicks* (1711) – which gave currency to the phrase 'moral feeling' – link Locke and Descartes with later developments in British, German and French philosophy. Closterman's portrait shows him informally attired, his loose dressing gown and open shirt immediately evoking the philosopher's life of thoughtful retirement. He leans on a plinth with volumes of Xenophon and Plato to hand.

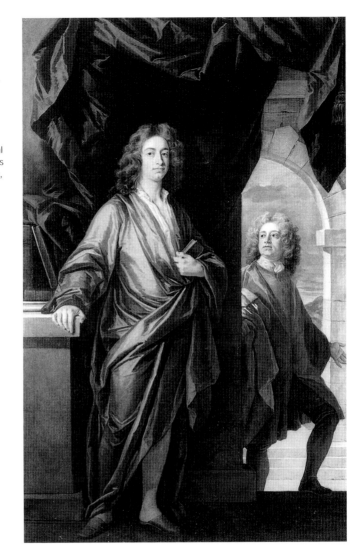

emblems or symbols. The curtain and tapestry behind her provide the soberest of backdrops to this civilized invitation.

It was of course in portraits of men that the new seriousness was most forcibly embodied. The Baroque pyrotechnics of de Wet and Huysmans now seem frivolous. But if the military might of Imperial Rome was invoked to give the Marquis of Atholl a veneer of heroic splendour, so now the more earnest virtues of the Roman Republic could suggest a weightier value. Men of substance must also be men of integrity in matters affect-

36

39

ing the public realm. The *locus classicus* of the idea is provided by another north German, John Closterman (1660–1711), from Osnabruck, who had come to England, after a period of study in Paris, in 1681. His likenesses of bewigged dignitaries, often in fictitious armour, apparently continue the Baroque conventions unchanged. But there is an undercurrent of increased seriousness, and when we come to *Antony Ashley, 3rd Earl of Shaftesbury* (*c.* 1701) we find ourselves in an atmosphere of earnest philosophy that is palpably new.

Shaftesbury gained a reputation as a thinker, his *Characteristicks of Men, Manners, Opinions, and Times*, published in 1711, being one of the definitive documents of the new aristocracy. It defined the 'Well-Bred Man' in terms that included an informed appreciation of the fine arts, which in their turn have a refining effect on the intellect and the emotions, and become part of the mechanism of civilized discourse. Here are the origins of the 18th century's high valuation of ancient Roman culture, and of Italian art, especially historical or literary subject paintings dealing with noble moral ideas. The work of the Rome-based French painter Nicolas Poussin, with its seriousness and learned classicism derived from the sculpture and architecture of Antiquity, was a vital point of reference.

Shaftesbury must have collaborated closely with Closterman in the conception of his portrait. Although it harks back in some ways to literary images like Van Dyck's of Suckling, this is a new notion of the portrait as icon of power. Influence is no longer simply a matter of birth or social standing: it must be earned by worthy behaviour, by 'politeness' in all its senses: good manners and good taste united to express the very fabric of civilization. A fresh link has been forged in the chain that binds the various layers of society together: the link of high ideals based on a notion of common humanity.

To encounter the movement for moral improvement at its most attractive we must read the magazines that were beginning to be popular, *The Spectator* and *The Tatler*, written by Joseph Addison and Richard Steele, whose journalism conveyed lessons in politeness in the most digestible and entertaining forms. With these moral and social imperatives in place, portraiture settled into a steady, comfortable role reiterating well-understood assumptions with a broad homogeneity of style. Kneller provided a reliable formula; Riley too had some lasting influence. His sober approach anticipated the new ideas already in Charles II's reign, and his full-length portraits of servants suggest an

endearing humanity. Kneller had a substantial rival in the Danish painter Michael Dahl (*c.* 1659–1743), who worked in a very similar idiom, though with a greater overt delight in the Baroque accessories of full-bottomed wigs and flowing draperies. A little later, the sparkling, broadly handled whole-lengths of John Vanderbank (1694–1739) brought a certain Rococo ebullience to the type. The practice not only of portraiture but of painting in general as a serious art – and one that ought to be admitted to the ranks of gentlemanly pursuits – was given a verbal formulation in the writings of another artist in this mould, Jonathan Richardson (1665-1745). His *Essay on the Theory of Painting* was first published in 1715 and remained in print for most of the century.

The most spectacular works of art in the period were celebrations of national and public success as much as individual. The triumphs of the Duke of Marlborough in the European wars

40

41. **Sir James Thornhill**, detail of the ceiling of the Painted Hall of the Royal Naval Hospital, Greenwich, 1707–27

were recognized by the gift of a vast palace near Oxford, Blenheim, commissioned in 1706 and planned as one of the most splendid buildings in Europe. It was 'a house but not a dwelling', in the phrase of the satirical poet Alexander Pope, and was duly decorated with sumptuous paintings by Laguerre, dense with allegory derived from the illusionistic ceilings of Roman churches of the Counter-Reformation.

In the grand schemes of the politically ambitious aristocracy, art could again perform its function as propaganda. High-minded themes were cast as masque-like presentations in which gods and goddesses represented abstractions among putti-infested clouds. Occasionally the results were more than simply overpowering: they could be beautifully invented and elegantly realized. Laguerre and Verrio served as adequate models for their only serious native English rival, James Thornhill (1675–1734). It was Thornhill who was entrusted with the decoration of another huge public enterprise, the great 41 Painted Hall of the new Royal Naval Hospital at Greenwich.

The project occupied him for twenty years from 1707. The space follows, on a huge scale, the pattern of Oxford and Cambridge college halls: a long room between high windows, with anteroom, and a transept at the far end. Thornhill covered walls and ceiling with sprawling allegories glorifying William and Mary and their successors, and the triumphs of the Royal Navy, supported by giant trompe-l'oeil pilasters and architectural ornament. Their sheer scale makes these decorations an extraordinary achievement for a native British painter. Thornhill went on to decorate the dome of Wren's new St Paul's, another vast project, and houses in London and round the country. But this overweening style of decoration did not really suit the English temperament. Few followed Thornhill's example, though an exception was William Kent (1685–1748), architect and designer of furniture and gardens, who created mural paintings at Hampton Court and Kensington Palace, where he worked from 1723.

Thornhill's designs were not merely decorative: they carried with them the sense of civic responsibility celebrated in the portraiture of the period. There is therefore more of a link than we might at first suppose between Thornhill's work and that of his son-in-law William Hogarth (1697–1764). Hogarth is associated first of all with his 'modern moral subjects', satires dissecting the vices of the age in small-scale scenes derived from Dutch genre painting of the previous century. But these too are concerned with the responsibility of the citizen, seeking to teach not through high-minded allegory but through easily accessible comedy.

For by this time there existed an increasingly rich and ambitious middle class, establishing itself in genteel surroundings, and emulating the aristocracy in buying art. This is the period when paintings for the first time in England become 'collectibles' – desirable chattels in a wealthy man's household.

The situation had existed for most of the previous century in Holland; now it was the turn of the English, and the Dutch were to have an important effect on what they bought.

While the Dutch 'little masters' had woven into their scenes of modern life a texture of ulterior meaning using individual symbolic details, Hogarth sought to tell extensive stories. He begins a tradition that was to become characteristic in England: the tradition of the literary picture. His scenes of everyday life are chapters of novels, tracing the lives, rise and fall of types – the Rake, the Harlot, the Industrious and Idle Apprentices. Each type is made thoroughly individual as in a novel, surrounded by a cast of believable, if Dickensian, characters and the crowded paraphernalia of a contemporary drawing-room or bawdy-house, London street or prison. The series *Marriage A-la-Mode* 43 (*c.* 1743) traces the tragi-comedy of a marriage of convenience in which bride and groom go their separate ways to destruction. A later set, containing only four scenes rather than the six of the earlier series (or indeed the twelve that tell the contrasting stories of *Industry and Idleness*), deals not with private but with public life. The suite *An Election* (1754) is a product of Hogarth's later years, and its complex subjects are presented with devastating wit and compositional authority: a panorama of contemporary life is presented with an all-encompassing fascination for vernacular detail and the foibles of humanity that recalls Brueghel.

Hogarth realized that such works could never reach their market in their original form as oil paintings. He had been trained as an engraver, initially on silver, and had quickly entered the arena of popular satirical engravings, which were much in demand. This too was a fashion that had come over from Holland. It was a natural step for him to translate his paintings into prints. He engraved his 'moral subjects' and sold them by the thousands to a public newly eager for prints of all kinds. The great age of the reproductive print in England was beginning, and Hogarth was entrepreneur enough to capitalize on the technology and the fashion. In 1735 he lobbied for Parliament to pass a Bill outlawing the piracy of prints and establishing a principle of legal copyright (literary copyright had existed since 1709) that was to survive until the demise of the reproductive print a hundred and fifty years later.

Hogarth's moralities were imitated repeatedly in the 18th century, though rarely with so acute a satirical edge. The idea of the narrative series was taken over literally by Joseph Highmore (1692–1780), who painted a set of scenes illustrating Samuel Richardson's novel *Pamela, or Virtue Rewarded* (1740). In these the intention is less to convey a moral lesson than to retell in visual terms a popular sentimental romance, though Richardson's novels exemplify the spread of a general moral consciousness in the period. Highmore was well qualified: he specialized in gentle, faintly Rococo portraits which at their best are among the most distinguished successors to Kneller.

42

When Hogarth first made his mark as a painter, in the 1720s, it was with a new style of portrait: the small-scale family group or 'conversation'. Again, the inspiration was largely Dutch, and a number of artists from Holland practised the form in England: Pieter Angillis (1685–1734) and Joseph van Aken (1699–1749) are representative. But there was another important strain in its parentage: a French tradition that owed its vitality to Jean-Antoine Watteau (1684–1721).

42. **Joseph Highmore**, *Scene from Samuel Richardson's 'Pamela': Pamela tells a Nursery Tale*, 1744
Richardson's epistolary novels mark a high point of the new bourgeois civilization flourishing in mid-18th-century London. His first, *Pamela*, was a story of 'moral feeling', about an innocent young woman beset by the wiles of predatory men. It was an international success. In this episode from his series of twelve scenes from *Pamela*, Highmore depicts the heroine as a model of domestic virtue.

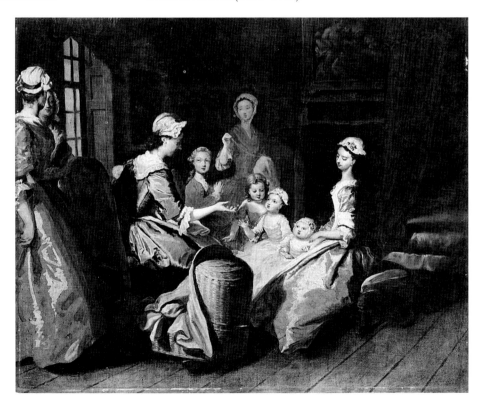

43. **William Hogarth**,
*Marriage A-la-Mode, Scene IV:
The Toilette, c.*1743
The foppish, pox-ridden heir to
the profligate and snobbish Lord
Squanderfield has married the
daughter of a rich London
Alderman. Here, as Countess,
she holds a fashionable levee,
surrounded by hairdresser,
musicians (including a castrato,
left foreground), black servants,
and her lover the lawyer
Silvertongue (far right). The floor
is littered with invitations and on
the walls hang pictures that
comment ironically on the
situation.

44. **William Hogarth,**
A Performance of 'The Indian Emperor or the Conquest of Mexico by the Spaniards',
1732–35
Hogarth's love of theatre is combined here with his practice as a painter of conversation pieces. To achieve the combination of subjects he deploys perspective ingeniously so that both elements of the group, actors and audience, are allowed space in which to develop their separate and mutual interrelationships.

Watteau visited England only briefly, in 1720, but the influence of his elegant *fêtes galantes* – courtly and flirtatious picnics – was immense. They were imitated by such immigrant artists as the German-trained Frenchman Philippe Mercier (?1689–1760) and the Fleming Joseph Francis Nollekens (1702–48). Watteau's brand of frivolity is shot through with an almost elegiac sense of the evanescence of pleasure; but in the hands of his imitators it became simply charming, with much play of the sheen of rich fabrics and the coy glances of pretty women. Mercier, who became Principal Painter to Frederick, Prince of Wales, supplied him and the court with conversations and 'fancy pieces' – decorative figure subjects – showing young women in domestic settings or allegories of the senses. The fancy picture, consciously avoiding the moral weight of historical subjects, was to be a popular type throughout the century.

The conversation piece began rather staidly in England, with Dutch influence more in evidence than French. In the work of Gawen Hamilton (c.1697–1737) gentlemen and ladies are grouped in interiors that suggest sober wealth, occupied rather desultorily with whatever objects and activities suitably indicate their claims to fame or simply individuality. These conversations remain formal, dominated by that sense of public virtue we have so often noticed.

Hogarth was quite capable of producing works like these. But with his vivid sense of fun and of the innate drollness of humanity he often subverted decorum by introducing a more personal note. He came to the conversation-piece by way of theatrical subjects: in the late 1720s he painted several versions of a scene from John Gay's famous musical comedy *The Beggar's Opera*. In these he explored the dramatic rapport of characters on stage, refining both his psychological insight and his technique as he proceeded. The formula of a group of small-scale

45. **Philippe Mercier**, *Hearing*, 1743–46
This is one of a set of pictures representing the five senses. The subject, a version of Watteau's musical gatherings, is presented as a charming comedy of manners, with emphasis on the charm.

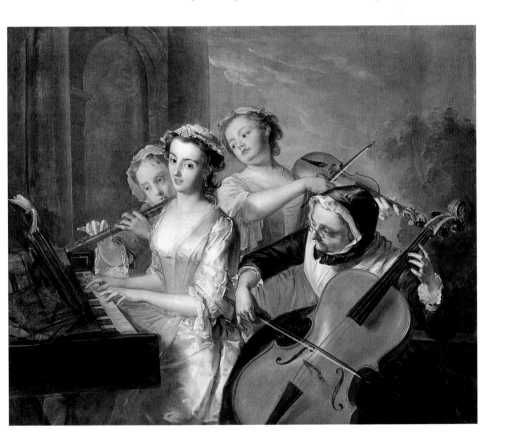

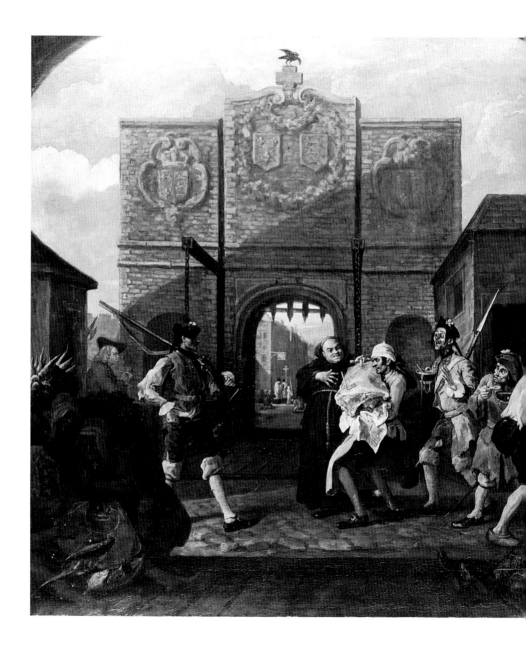

46. **William Hogarth**, *Calais Gate: O the Roast Beef of Old England!*, 1749
Hogarth's skill in telling a story is not only a matter of humorous characterization
and droll contrasts: it is bound up with his ability to paint with a fluent descriptive
ease that creates figures and forms in convincing and vital three-dimensionality.
His use of light and shade as an aid to narrative is also well illustrated here.
The Highlander hunched miserably in the right corner is a member of the
Young Pretender's defeated army, who has followed him into exile.

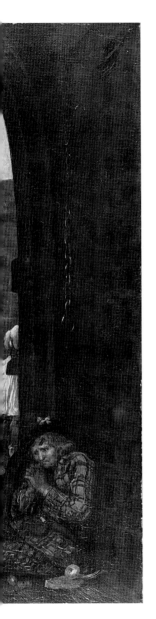

figures, connected by some narrative situation and seen through a curtained proscenium arch, was taken up in his purely social group portraits. Even the draped curtain remains in some of them. In the most ambitious of all, *A Performance of 'The Indian Emperor or the Conquest of Mexico by the Spaniards'* (1732–35), the social event is a session of amateur theatricals. The children of grandees perform for the benefit of a royal prince and princesses and several eminent adults, at the house of the Master of the Mint, John Conduitt. Hogarth dwells with delight on the children's engaged faces, on their glittering finery, and on the stage scenery with its awesome prison set. The interrelationship of actors and audience is cunningly contrived in the picture space, each participant given prominence without detracting from the coherence of the composition as a whole.

44

Hogarth rarely emphasizes the grandeur of his sitters. He is more interested in them as ordinary people. His debt to the French tradition is apparent only in odd touches – the lustre of a dress, the delicacy of some of his colour – but he was not one to paint children as though they were adults, or dogs, for that matter, as though they were posing for the artist (except in a self-portrait in which his own pug comically replicates his expression). He doesn't mock his sitters – that would not be in any portrait-painter's interests – but he makes the most of their humanity. The comic touches are a compliment to their broad-mindedness and liberal opinions: they draw attention to precisely the mental attitudes that these 'polite' people cultivated.

Hogarth's aim was to portray the English as more human and at the same time more civilized than any other nation. His view of Calais Gate, which he titled *O the Roast Beef of Old England!* (1749), is a parable of his feelings on the matter. The scrawny French soldiers, fed on thin gruel, stare longingly at the sirloin being carried to the English inn, and a fat friar prods it appreciatively. Hogarth himself sits at the left sketching the gate, which he admired as it had been built by the English, and is about to be 'carried to the governor as a spy' for doing so: a soldier's hand descends on his shoulder as he draws.

46

He could be offensively chauvinistic, fulminating against the imposition of foreign models on English art. His energetic style of applying paint is itself almost a patriotic statement, ostentatiously free of the constraints learnt in foreign academies. 'Going to study abroad', he wrote, 'is an errant farce and more likely to confound a true genious than to improve him.' With these views it's not surprising that Hogarth campaigned for the

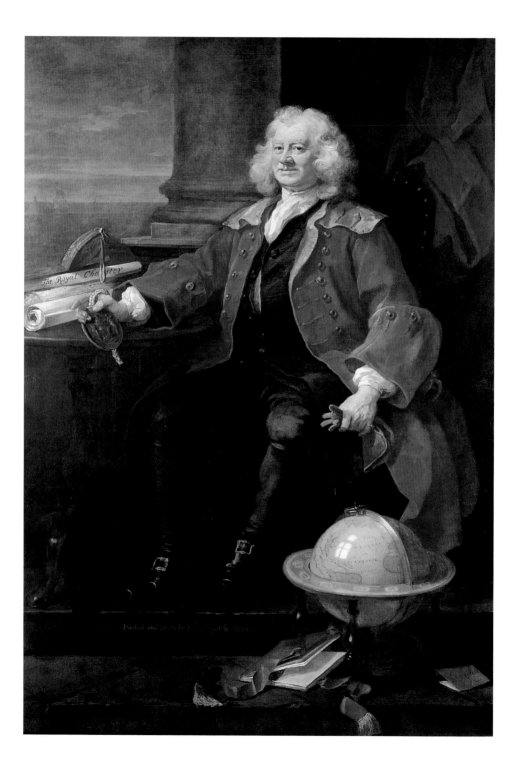
The Royal Charter

Painted and engrav'd by Wm Hogarth 1740

recognition of a national school of painting. When a friend, Captain Thomas Coram, established a home for foundling children in London he availed himself of an invitation to paint for it, and encouraged Coram to commission other artists too. With work by him and several contemporaries the Foundling Hospital's collection became a sort of embryonic National Gallery, long before such an institution was ever formally set up. For Coram, too, Handel composed music: painting was to be encouraged in a context of general cultural improvement.

47

Hogarth's portrait of Coram himself, executed for the inauguration of the Hospital in 1740, is highly innovative. A large whole-length, it shows the bluff merchant-philanthropist seated, with the ships that made him wealthy afloat on a distant sea beyond a column and heavy curtain. The trappings are those of the full-blown Baroque state portrait; but this is not a king, nor even a nobleman, but the honest, downright commercial man with a strongly developed social sense, towards whom the whole period since the Glorious Revolution of 1688 had been tending. Hogarth was the painter to do him – and the period – exact justice. The improvised touch of his luscious paint reflects the self-made man. The still life of globe and books in the foreground is a *tour de force* of crisp, bravura illusionism. Nevertheless, just as Coram is quintessentially English, so Hogarth's technique belongs to a native tradition. We are reminded of the earthy quality of Dobson's handling, and there is a Dobsonian delight in the red-faced, hearty English character of the sitter. After two centuries of fascinating but, it must be admitted, spasmodic development English painting and English subject matter have at last converged, in the hands of a master.

Coram's art collection was intended to show what English painters could achieve. If he despised Continental pretensions, Hogarth nevertheless tried his hand at grand subjects. For Coram he painted *Moses brought before Pharoah's Daughter*, a Biblical illustration of the Foundling Hospital's mission, and for the church of St Mary Redcliffe at Bristol he produced an enormous triptych, centred on the *Ascension of Christ* (1755–56). Such ambitious exercises were not his natural metier, but they are given life by his innate energy of invention and freshness of handling.

Hogarth brought artists of very different interests to Coram's attention. A series of roundels depicting landscapes and townscapes includes work by three of the key figures in the development of landscape at a critical moment in its history. Richard Wilson and Thomas Gainsborough are the first undisputedly great masters of

47. **William Hogarth**, *Captain Thomas Coram*, 1740
In this picture Hogarth stakes out new ground for himself as a painter in the grand manner, perhaps consciously borrowing the composition of a French portrait that he could have known from an engraving. This was a gesture not only of self-promotion, but of propaganda for a new kind of painting for a new English class: Coram is presented as an English archetype, a successful merchant entitled to see himself depicted with the swagger usually reserved for the aristocracy.

the school, while George Lambert (1700–1765) illustrates the growing diversity and flexibility of the painter of nature. Lambert absorbed the two traditions of topographical and ideal views into one practice and established the versatility of his profession. He could compose a 'Classical Landscape' as an exercise in the abstract idealism of Gaspard Poussin, with balancing groups of trees and light-filled distance, or an imaginary woodland scene in the style of Meindert Hobbema. In a different vein, his view of *Box Hill* (1733) 48 is free from all the formalities of picture construction, an apparently objective record of the scene before him. Lambert sometimes collaborated with Hogarth, who would paint the figures into his subjects.

Coram also patronized the talented but short-lived sea-painter Charles Brooking (1723–59), acquiring a huge canvas 49 by him in the generally accepted style of such works, that is, imitating the Dutch marine artist Willem van de Velde the younger (1633–1707) who had come to England with his father

48. **George Lambert**, *A View of Box Hill, Surrey*, 1733
This view of a famous beauty spot south of London does not render it as an equivalent of the idyllic Italian landscape of Claude: the unemphatic features are allowed to be beautiful in their own English way. Lambert's delicate, soft light unifies the scene in a way that was 'Claud de Lorain's peculiar excellence and is now Mr Lambert's', in the words of Hogarth.

(1611–93) in 1672. Between them the Van de Veldes established a pattern of depicting ships and the sea that would be increasingly important in a society whose wealth and influence were largely founded on sea power.

Another of Coram's painters, the youthful Thomas Gainsborough (1727–88), also combined Dutch and French ideas in his work. In him culminates the Watteau-inspired tradition that had subsisted through the first third of the century. He had been taught by an émigré Frenchman, Hubert Gravelot (1699–1773), who came to England in 1732 and practised mostly as an illustrator, in a delicate Rococo style of sinuous curves and courtly elegance. This, it should be said, was not an entirely foreign idiom. Hogarth formulated his own idea of the 'line of beauty', the serpentine double curve that is the foundation of Rococo design, in *The Analysis of Beauty* (1753), a work of aesthetic theory that stands with the best 18th-century writing on the subject.

49. **Charles Brooking**, *A Man of War firing a Salute, c.*1750–59

Schooled by Gravelot, Gainsborough evolved a Rococo distinctively his own. His country gentlefolk are posed comfortably in attitudes distantly evocative of the languor of Watteau's courtiers, in landscapes that transmute the Holland of Jan Wynants or Philips Wouwermans into Gainsborough's native Suffolk. The parallelism of portrait and landscape in these sturdy yet delicate works is prophetic of his later pursuit of both forms. As with Lambert, landscape is nurtured in a dual relationship that enriches and develops it. In a pure landscape like *Cornard Wood* (1753) Gainsborough at a stroke translates the Dutch tradition into something unmistakably East Anglian. These are domesticated scenes: characterful oaks glint against storm-darkened skies alight with plump clouds, countryfolk drive carts or cattle along winding lanes. Into such settings the small whole-length portraits fit naturally. Mr and Mrs 50 Andrews, whom Gainsborough painted about the time of their marriage in 1748, are clearly proud of a fertile and well tended estate. But their casual poses and frank expressions do not ask us to stand in awe of them, or to admire them for any special

50. **Thomas Gainsborough**, *Mr and Mrs Andrews, c.* 1748–50 Gainsborough's early portraits are the true English counterparts of Watteau's *fêtes galantes*: the sitters are idle, not in some dream landscape, but in real-life parkland, with a well-defined economic relationship to their surroundings. There are practical hints of the Rococo 'line of beauty' in the wrought-iron seat, the curving hoop of Mrs Andrews' skirt, and even in the neatly turned calves of her nonchalant husband.

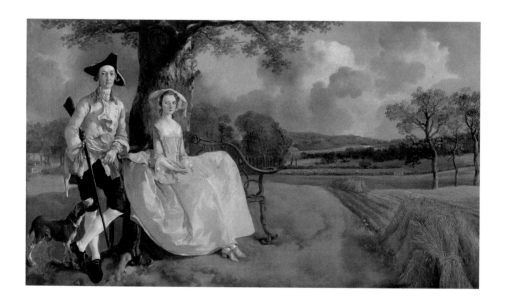

accomplishments. Even the partridge that Mr Andrews might be supposed to have shot never got painted in on his wife's blue taffeta lap.

Gainsborough sometimes collaborated on conversation pieces with Francis Hayman (1708–76), whose genial groups in the open air or conversing in an alehouse influenced his own. Hayman's work was 'easily distinguishable by the large noses and shambling legs of his figures,' as Horace Walpole said, and he was more admired for his historical subjects. He executed a *Finding of the Infant Moses in the Bulrushes* (1746) for the Foundling Hospital, and painted other histories. Genial, cheerful and decorative, Hayman's style was just right for a series of pictures commissioned in the early 1740s for the supper-boxes at Vauxhall Gardens. His theme was English games and pastimes – subjects in which he could display his gift for lively Rococo composition. Like Hogarth, he was a pioneering theatrical painter, an exemplar of the new genres now emerging from the ferment of commercial prosperity that was making England the most dynamic country on earth.

51. **Francis Hayman**, *The Play of the See-Saw*, c.1741–42 The pleasure gardens for Londoners at Vauxhall were developed in the early 18th century by Jonathan Tyers, who added numerous buildings, statues and a cascade. The supper-boxes were decorated by Hayman and his assistants with panels illustrating sports and pastimes which have a moral subtext, going some way, perhaps, to counteracting the licentious reputation of the gardens. The theme was the transience of human pleasure. Many depict children's games, and were intended to instruct the young. Here, the see-saw becomes an emblem of the precariousness of happiness.

51

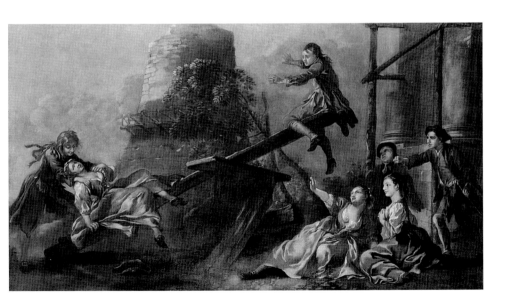

Chapter 4 The Age of Industry: 1750–1800

In 1712 Thomas Newcomen in Dartmouth developed the first steam pump, and in 1733 John Kay of Bury in Lancashire patented the fly-shuttle. The technological and social upheaval of the Industrial Revolution was under way. Radical change affected the arts too. If Hogarth invented a way of painting to suit his own patriotic aims, almost every painter of significance in the generation after him was a technical innovator one way or another.

It was an age when theory was revered. Newton had shown that the universe could be ordered and measured; Descartes in France and Locke in England demonstrated that mental processes could also be described and categorized. The 18th century saw a succession of philosophers and aesthetic theorists propounding their views as to the effect of experience on our thoughts and emotions. Our experience of reality was naturally extended to include our experience of art. Shaftesbury had attempted such an analysis in his *Characteristicks*. Hogarth, too, as we know, was moved to order his ideas on art into a work of theory.

The scientific spirit permeated all fields of endeavour, and artists came to see their occupation as a kind of science: a process of analysis, categorization and reduction. At one end of the scale, they sought to rationalize their professional existence, forming societies in the capital to facilitate training. These culminated in 1768 in the founding of the Royal Academy, which provided training and exhibition facilities for a professional body of artists in London, under royal patronage. Its first President, Joshua Reynolds (1723–92), who was to be the definitive aesthetic theorist of his time, painted an allegorical figure of *Theory* (*c.* 1779) for the ceiling of the Academicians' new library.

Reynolds's own art was a blend of theory and opportunism; he made it work by binding the ingredients together with a wonderful wit. In his field of portraiture an admixture of wit was urgently needed. Up to the time of Reynolds's master, Thomas Hudson (1701–79), face-painting remained largely dependent on well-tried formulas. Hudson's studio turned out glossy, prepossessing likenesses, standard half-, three-quarter- and whole-lengths showing off fine satin dresses and embroidered

waistcoats adorning flushed, successful men and pale, compliant women.

Already, Hudson's Scottish rival Alan Ramsay (1713–84) was showing a way forward. Ramsay studied in Italy in the 1730s, and came to London in 1738 armed with a subtler, more poetic style than anyone could boast in the capital at the time. He was widely regarded as a beacon of the Scottish Enlightenment; James Boswell remarked on his 'very lively mind'. Appropriately, he created a classic likeness of the French Enlightenment philosopher Jean-Jacques Rousseau (1766). His early work is like Hudson's, but his handling of flesh is another matter. His female portraits glow with an inner radiance, his male heads have a warmth that exudes humanity. All are perceived as individuals, colleagues, as it were, in the Enlightenment debate. As he matured, Ramsay's textures softened and his colour became

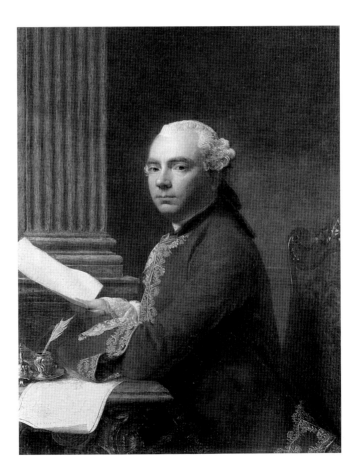

52. **Allan Ramsay**, *Robert Wood*, 1755
Wood was a scholar of ancient literature and civilization, and was famous as one of the discoverers of the ancient city of Palmyra in Syria. His *Essay on the Original Genius of Homer* was published in 1769, and Ramsay seems to have read and been impressed by it. He paints Wood here very much in the manner of contemporary French artists, with an animated presentation of character and attention to the refinements of a handsome costume.

more idiosyncratic, his vibrant, sweet pinks and blues reminiscent of French pastel painters of the period. His style of the 1750s and '60s seems especially apt to the depiction of beautiful women arrayed in silk and lace. It was Ramsay, not Reynolds, who painted, in 1762, the most enduring official images of George III and his Queen, Charlotte.

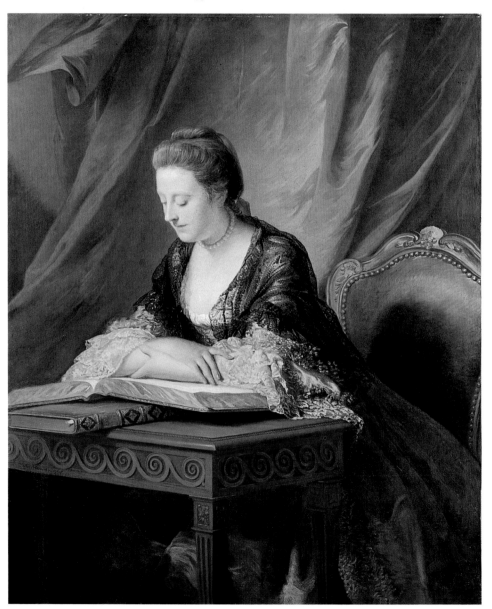

54. Sir Joshua Reynolds,
Self-portrait, shading the eyes,
c. 1747–48
This is Reynolds's first mature self-portrait, the forerunner of many. It is the only one in which he shows himself in his own role as a practising painter, holding brush and mahl-stick, and in the act of looking intently – the artist's fundamental occupation. It is therefore a kind of manifesto of the dedicated artist. The motif of the face half in shadow was one to which Reynolds would return in many works during his career.

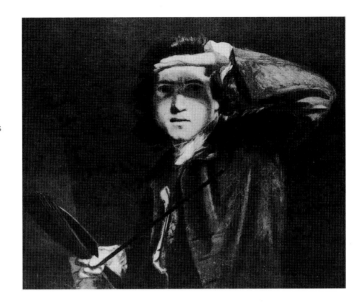

opposite
53. Allan Ramsay, *Emily, Countess of Kildare,* 1765
As Ramsay's career progressed his style became softer and more atmospheric; he abandoned the crisp finish of his early work in favour of a more delicate manner characterized by gentle lighting and pastel colours. Emily Lennox (1731–1814) was one of the three daughters of the 2nd Duke of Richmond (Canaletto's patron: see ill. 77), who married James Fitzgerald, Earl of Kildare, later Duke of Leinster, by whom she had nineteen children. She was painted by numerous artists, from Arthur Devis to Sir Joshua Reynolds.

Reynolds too visited Italy, not to enter an artist's studio like Ramsay, but to study the works of the masters. When he returned to London in 1753 he was a changed artist. Hudson, finding nothing of his own style left in his pupil's work, exclaimed 'By God, Reynolds, you don't paint so well as when you left England!' He was now Ramsay's chief rival, and established himself as a natural leader of artists. His many self-portraits show us a man passionately concerned with his identity as an artist, modelling himself on Rembrandt, aware of his humanity, yet vividly conscious of his technical powers. His election as the Academy's first President was inevitable. The annual lectures or Discourses that he delivered to the students (and many others) became a kind of Bible for artists that would remain in use for nearly a century.

54

As a thinker, Reynolds descends directly from Shaftesbury (see pp. 55–56). He inherited Shaftesbury's sense of the social responsibility of art. He believed in the primacy of serious subject matter, and the duty of the artist, if he could, to pursue 'history' – subjects taken from the Bible, classical mythology or literature. Other 'branches' of the business were necessarily inferior: portrait, landscape, genre (scenes of everyday life), animal painting and still life were progressively less capable of seriousness. This hierarchy was dependent on a concept, derived from literary criticism, that certain works of art embodied supreme spiritual grandeur, and could raise the mind to

contemplate things far above the mundane. The 18th century defined this, the Sublime, in endless ways. Edmund Burke in a famous *Philosophical Enquiry* of 1757 contrasted it with the Beautiful, but attributed our awareness of both to psychological states: we find beautiful what we desire, sublime what is life-threatening. 'Whatever is in any sort terrible, or is conversant about terrible objects, or operates in a manner analogous to terror, is a source of the sublime; that is, it is productive of the strongest emotion which the mind is capable of feeling.' Burke's theory opened up the discussion of Beauty and Sublimity to the consideration of natural as well as human phenomena. In the course of the 18th century, despite Reynolds, landscape painting gradually asserted itself as a primary expressive form.

Central to Reynolds's thinking was the idea that great art must generalize. 'The most beautiful forms [in nature] have something about them like weakness, minuteness, or imperfection', he said; 'by a long habit of observing what any set of objects of the same kind have in common . . . the painter . . . learns to design naturally by drawing his figures unlike any one object. This idea of the perfect state of nature, which the artist calls Ideal Beauty, is the great leading principle, by which works of genius are conducted.' Reynolds faced a dilemma: for what was his chosen profession of portraiture if not the representation of the particular? The key to an understanding of his achievement is an appreciation of his stratagems for resolving this puzzle.

He believed that the Old Masters were an infallible source of inspiration. This was the antidote to Hogarth's chauvinism: the artist must not be insular, but feel himself part of the broad international current of art. Reynolds would take a figure from Correggio or Raphael and present it with a clever twist as the portrait of a contemporary. This process invested portraiture with a dignity it couldn't otherwise aspire to. A naval commander like *Commodore Keppel* (1753–54) was all the more imposing if he reminded the viewer, subliminally, of the Apollo Belvedere or a Roman senator. Reynolds tried his hand at history, but was not cut out for it, as he well knew. But by importing historical ideas into portraiture his sitters were flattered, and his work gained in intellectual weight.

There was further reason for the stratagem. While his male sitters could very well be presented in their own personas as statesmen, lawyers or generals, with the paraphernalia of their rank or office, women enjoyed no self-evident standing. Their role was largely passive, to bear children and to be social ornaments.

55. **Sir Joshua Reynolds**, *Georgiana, Duchess of Devonshire, with her Daughter, Lady Georgiana Cavendish*, 1784 Georgiana, Duchess of Devonshire (1757–1806), was renowned as 'The Beautiful Duchess', though it was her ebullient personality rather than her looks which earned general admiration. This unexpected portrait presents that personality as it manifested itself in private: Reynolds typically allows his subjects to adopt their own natural poses, and by inspired choice of moment and deft composition transforms a fleeting instant into a formal, even a monumental, statement.

Mythology and history provided a wonderful dressing-up box with which they could be disguised as goddesses, nymphs or vestal virgins. So Mrs Musters becomes Hebe, the actress Sarah Siddons the Tragic Muse. This was a development of Lely's system of presenting court beauties as saints, but in Reynolds's hands the idea takes on genuine seriousness. At the same time, he could deploy an enchanting sense of humour. In his picture of *Georgiana, Duchess of Devonshire, with her Daughter, Lady* *Georgiana Cavendish* (1784) the interplay of mother and infant is captured with relaxed indulgence; splendid as it is, the portrait presents the sitters as though Reynolds were a doting godfather, delighted by their mutual happiness. A childless bachelor, he was inspired by children to some of his most attractive work.

True to his time, and to his exploratory cast of mind, he was given to technical experiment. His enthusiastic use of bitumen and other untested substances has resulted in the wreck of many fine works. But when he abjured 'patent' recipes or the assistance of his band of drapery-painters and other helpers, he could produce portraits of a wonderful immediacy and verve. Then, even

56. Sir Joshua Reynolds, *Colonel George Coussmaker*, 1782
Coussmaker is shown in his uniform as colonel in the Grenadier Guards, his red coat trimmed with gold braid. From the evidence of an unusually large number of sittings, even for the horse, it is likely that Reynolds painted this portrait entirely himself, unaided by the usual team of assistants. Every portion of the design is executed with painterly verve and fluency, while the composition as a whole is integrated into a single bold and easy rhythm.

57. Francis Cotes, *Lady Stanhope and Lady Effingham as Diana and her Companion*, c.1765
This picture may be a celebration of the marriage of Catherine Proctor, the right-hand young lady, with Thomas Howard, 3rd Earl of Effingham. The vaguely classical costumes are very much those that Reynolds recommended, but there is a suggestion that the young ladies are taking part in amateur theatricals. He reinforces the light tone with a palette of soft colours and a composition built on gently flowing rhythms. Cotes had begun his career as a capable portrait draughtsman in pastels.

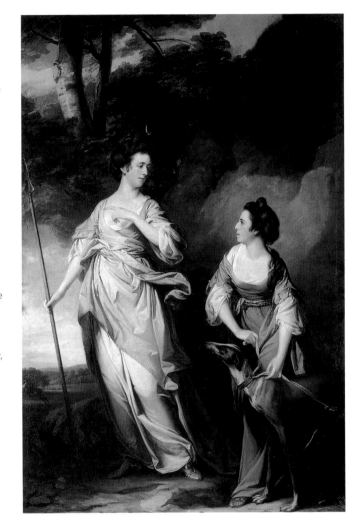

grand set-pieces like his *Colonel George Coussmaker* (1782) have a 56
sparkle and imaginative power that mark them out as among the first genuinely Romantic statements of character.

The draperies he devised as appropriate clothing for his exalted sitters are generalized too: neither classical nor modern, they seem designed specifically to serve the purposes of painting, and to give maximum scope for swags, folds and long sweeping lines, enhanced by great loops of pearls. 'Ancient dresses,' he thought, had the advantage of 'simplicity ... without those whimsical and capricious forms by which all other dresses are embarrassed.' The fashion for dressing sitters in 'Vandyck'

costume was the means by which 'very ordinary pictures acquired something of the air and effect of the works of Vandyck'. Other portrait painters adopted this pictorial tailoring: Francis Cotes (1726–70) is one. An accomplished follower of Reynolds, he stamped his own personality on his work by a happy combination of the informal with the formal. He adopted a distinctive palette of pastel colours derived from the influential 17th-century Bolognese master Guido Reni.

The decorative quality of such colour schemes was of particular value to those painters who were employed to adorn the newly built of houses of the nabobs, returned from India laden with wealth. Into restrained, Pompeian interiors designed by Robert Adam, Antonio Zucchi (1728–95) and Angelica Kauffmann (1740–1807) brought sweetly coloured lunettes and roundels in which allegorical figures grouped themselves in tasteful attitudes, recreating the elegance of ancient Rome. Kauffmann, a Swiss, spent several years in England, and became one of two women founder-members of the Royal Academy before marrying Zucchi and moving to Italy. In addition to her decorative work, 'Mrs Angelica' produced portraits and a body of highly serious history painting, for which she was considered to have 'a peculiar turn'.

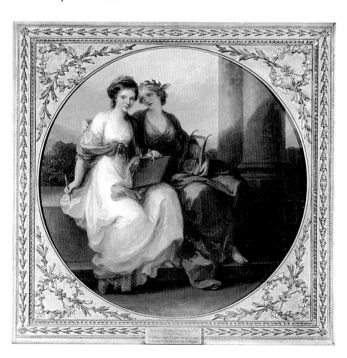

58. **Angelica Kauffmann,**
Self-portrait in the Character of Painting embraced by Poetry, 1782
This allegorical presentation of the artist as a personification of the art of painting is typical of the decorative roundels and ovals that Kauffmann produced to enliven the interiors of Robert Adam, where the colours are derived from Adam's experience of ancient Roman painting, as recently excavated in Italy. It is interesting to compare the subject with Reynolds's more immediate likeness of himself as a painter (ill. 54).

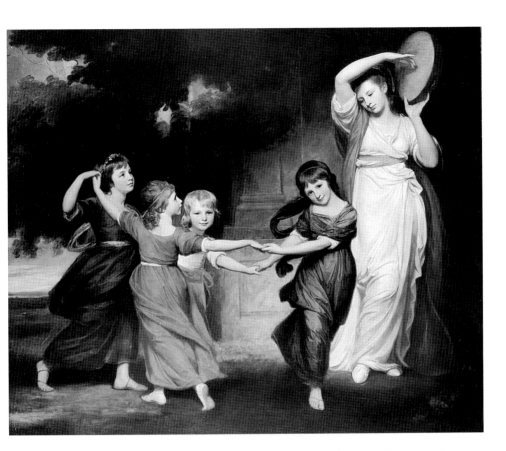

59. George Romney, *Children of the Gower Family*, 1776–77 Just as Kauffmann borrowed colour schemes from ancient Roman painting, so many artists used classical relief sculptures as sources for their compositions. This motif of figures linked in a dance was to be found in friezes on Roman sarcophagi and elsewhere, and had been used by Nicolas Poussin in some celebrated works, including the *Bacchanal before a Herm of Pan*.

Reynolds had a profound influence on all the succeeding generation of portraitists, most noticeably on William Beechey (1753–1839) and John Hoppner (1758–1810), both of whom were appointed painters to members of the royal family. George Romney (1734–1802) evolved a more distinctive style. Born in Lancashire, he studied in Italy in the mid-1770s, and developed a Reynoldsian sense of seriousness. He lacked Reynolds's witty inventiveness when it came to adapting the poses of the old masters to new uses, but painted with suave panache, handling pigment broadly and subordinating detail to a bold general effect. John Wesley admired Romney's facility: 'He struck off an exact likeness at once, and did more in an hour than Sir Joshua did in ten.' At its best Romney's work is both monumental and human, with a classical clarity of statement that outdoes Reynolds. He sometimes incorporated historical ideas into his portraits, painting a family of children as though they were Arcadian nymphs, for instance; or a model he was besotted with,

59

Nelson's mistress Emma Hamilton, as Cassandra, a Bacchante or 'Hope'. He also had ambitions to paint large-scale historical subjects, most of which never got beyond the stage of rapid, often very exciting, pen drawings.

Reynolds's practical sense is well illustrated in his realization of the benefits to be gained from the engravers. The reproductive print was now a vital part of the art economy, and Reynolds made sure that his pictures were regularly and well engraved. The method was usually the tonal medium of mezzotint, brought to new perfection by a skilled group of Irishmen working in London. Thanks to their sensitive translations of oil painting into rich black and white, the work of Reynolds and his contemporaries was widely familiar.

An obvious example of the scientific spirit at work in this period is George Stubbs (1724–1806). His reputation was made as a painter of racehorses and other domestic animals; he also painted lions, tigers, monkeys, a cheetah, even a zebra. He dissected horses and made meticulous drawings of their anatomy, issuing the results in a magisterial publication, *The Anatomy of the Horse* (1766). He was closely involved with the early Industrial Revolution in the Midlands, experimenting with techniques for painting in enamel colours, first on copper, then in

60. **George Stubbs**, *A Cheetah and Stag with Two Indians*, 1765
The world-wide explorations of British merchants, soldiers and scientists in the 18th century brought many novel species of animals to the United Kingdom, and Stubbs was uniquely fitted to record the exotic creatures. This cheetah, the first to reach England, was given to George III with two Indian handlers. Stubbs shows them restraining it with hood and collar. The men are painted with the compassionate objectivity that Stubbs brought to all his subjects.

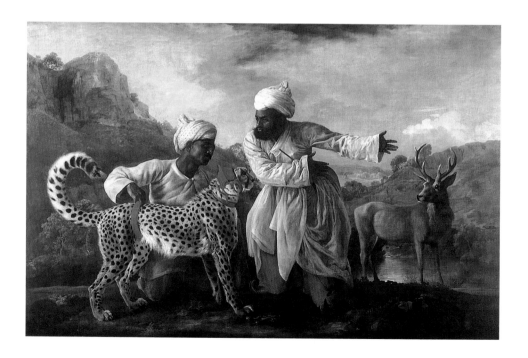

collaboration with the experimental potter Josiah Wedgwood, 61 who fired his paintings on ceramic plaques.

Stubbs built on a well-established tradition. The British had been commissioning pictures of horses, hunts and other equine events since the late 17th century. The field had been pioneered by a Dutchman, Jan Wyck (1652–1700), and his English pupil John Wootton (1682–1764), who between them had greatly refined the desired blend of animal painting and landscape. Stubbs took the form to new levels of subtlety, composing his groups of figures and animals with the grace and delicacy of a sporting Raphael. He makes us aware of the flow of line, the rhythm of curves along a horse's back, the linking movement of a groom's arm or swaying body. A few brood mares in a field are related to each other like a row of Raphael's angels or Muses. These harmonious structures are underscored by Stubbs's refined sense of colour, the realistic sheen of his animals' coats, the soft and silvery perspectives of his landscape backgrounds. *Hambletonian, Rubbing Down* (1800) is a work of typical compo- 63 sitional subtlety: it is a monumental image dominated by the quivering energy of the horse, triumphant but exhausted from a taxing race, whose body, framed by a man and a stable-lad, almost fills the large canvas.

61. George Stubbs, *Reapers,* 1795
Stubbs's work for Wedgwood included making paintings in enamels on ceramic plaques, which involved much research into the properties of pigments subjected to great heat. The results are remarkable, and in a subject such as this the character and palette of the oil painting from which it derives are perfectly preserved. This subject is one of a pair, the other design showing haymaking.

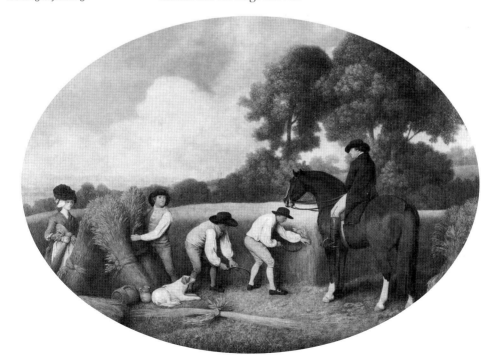

62. **Johann Zoffany**, *Colonel Mordaunt's Cock Match against the Nawab of Oudh at Lucknow*, 1784–86
Cock-fighting was a traditional Indian sport; here it is watched with equal passion by Indians and Britons. The Nawab of Oudh and Colonel Mordaunt discuss the match as they stand just behind the birds; Warren Hastings, who commissioned the picture, sits on the sofa to the right, with Zoffany himself behind, leaning over the back of a chair.

As if his classical credentials were not evident in every touch of his brush, Stubbs lingered long over a theme derived from a Roman sculpture of a horse attacking a lion. He frequently painted the subject, in different aspects: the horse first startled by the lion, the lion grappling with its prey. In portraying the tension of the violent scene in a grand craggy landscape, he anticipated the use some Romantic artists were to make of animals as proxies for human emotion.

Stubbs was also a consummate portraitist. Though he rarely paints a figure as the sole object of attention, he always conveys vividly the individuality of each person, whether a harvesting peasant or a lady riding a hunter. Particularly penetrating are his studies of grooms as they pursue their loving relationships with the animals in their care. It is a fully realized world, a central aspect of 18th-century life. 60,61 63

That centrality is reaffirmed by the popularity of sporting painting. Few of the artists who supplied views of hunts, shoots and races can aspire to Stubbs's pre-eminence, but several are masterly at a more modest level. Their work brings vividly alive the frosty mornings, the harum-scarum scampers over hill and field. Representative is Benjamin Marshall (1768–1835), who wonderfully suggests the muddy discomfort of an early start at a winter shoot or race-meeting, his slightly awkward characters confronting each other with the gritty camaraderie of dedicated sportsmen.

Stubbs's ladies and gentlemen may be taking the air in a phaeton, or conversing under a tree – though a horse or some other animal is never far away. The small-scale group portrait had become enormously popular by the 1750s and many artists pursued lucrative careers producing little else. As one might expect, it was much in favour among the more modest land-owners for whom life-size whole lengths might seem too ambitious. The Lancashire painter Arthur Devis (c. 1711–87), for example, catered to a broad spectrum of country gentry, and was successful enough to practise in London too. His neat and flattering formulas included a predesigned house and estate, or a handsome but wholly imaginary interior that did much credit to the taste of the commissioning gentleman.

After Hogarth's death the leader in this genre was a German, Johann Zoffany (1733–1810), who arrived in London in 1760, and began painting theatrical scenes under the patronage of the great actor-manager David Garrick. He had a flair for concise characterization, and could preserve on canvas the essence of a 62

63. **George Stubbs**, *Hambletonian, Rubbing Down*, 1800

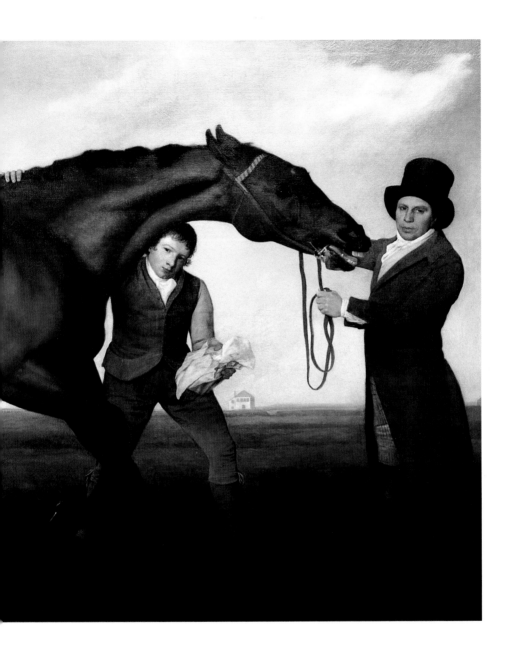

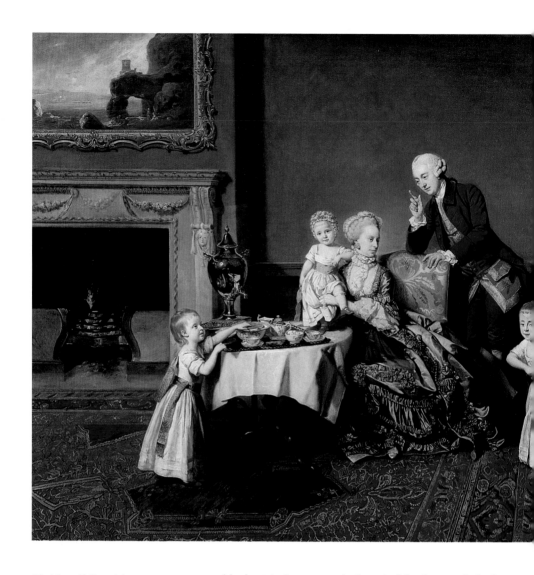

64. **Johann Zoffany**, *John, 14th Lord Willoughby de Broke, and his Family*, 1766
John Verney (1738–1816) was Lord of the Bedchamber to George III and will have been impressed by the royal portraits that Zoffany had painted in 1764. Like those, this group is set in an interior; it is an informal family breakfast, yet organized to give dignity to a marvellously observed assemblage of people and objects.

memorable theatrical moment, the 'stars' of the day caught in the very act of speaking their immortal lines. Equally, he could bring together the likenesses of a family group and relate them in lively, natural-seeming intercourse. He spent the years 1783–89 in India, painting individuals and group portraits. One of these was a commission from Warren Hastings: a scene showing *Colonel Mordaunt's Cock Match against the Nawab of Oudh at Lucknow* (1784–86). The canvas is crammed with dozens of vividly realized figures, British and Indian, and brings to life a broad swathe of Indian society in the glory days of the East India Company.

64

62

Zoffany took up both theatrical and conversation pieces from the point at which Hogarth had left them, and in his turn had many imitators. Among the theatrical painters, Samuel De Wilde (1748–1832) stands out with his ability to bring alive stage personalities, their clothes, gestures and fleeting expressions. The Irishman Francis Wheatley (1747–1821) approached Zoffany in the gentle warmth and charm of his family groups. Wheatley's drawings and watercolours of rustic figures and London street vendors are the British equivalents of the sentimental subjects of Jean-Baptiste Greuze in France. A rarer painter of unpretentious genre subjects is Henry Walton (1746–1813), who was taught by Zoffany around 1770 and during the ensuing decade painted a brief series of exquisite, softly coloured scenes of daily life, like the *Ballad-Seller* that he showed at the Academy in 1778.

If Stubbs found inspiration in science, so too did Joseph Wright of Derby (1734–97). Their work has much in common. In each case, enamel-like surfaces and crisp drawing are the natural outcome, it would seem, of a desire for objective accuracy. But while Stubbs allows poetry to emerge incidentally from his elegant observations, Wright more consciously seeks effects. He is the painter of the Industrial Revolution par excellence, producing some of the most original images of 18th-century Europe. His views in forges, whether those of blacksmiths or of iron-workers, revive the Baroque excitement of strongly

65

66

65. **Samuel De Wilde**,
John Bannister as Tristram Fickle and John Purser as Sneer in 'The Weathercock' by John Till Allingham, 1808
The scene is presented as it would have been seen on the stage, with scenery and props. Tristram Fickle, trying out his talents as a barrister, argues his case in front of his servant, Sneer, who acts as judge with a handkerchief as wig. Allingham's farce was first performed in 1805.

contrasted light and shade, with an entirely new sense of its pertinence to a real, modern world. The grandest of these 'scientific' subjects, *An Experiment on a Bird in the Air Pump* (1768), has some claim to be the most important picture of the age.

67

It is a large canvas in which several figures in a darkened room are grouped round the distressing experiment. The philosopher-scientist looks out at us like a wizard in an ancient legend; yet for all its mystery this is the affirmation of a new understanding of the natural world. Interested spectators watch eagerly, and a young girl shields her eyes from the sight of the white cockatoo dying as the oxygen is withheld. This is the world of the Lunar Society, to which Wright belonged: a group of scientifically minded Midlands professionals and gentlemen. Yet it is also a picture in a great European tradition. The dramatic

66. **Joseph Wright of Derby**, *An Iron Forge*, 1772
The iron-worker stands at the centre of this composition, a confident hero of the Industrial Revolution, while the white-hot metal irradiates the scene like a new Redeemer at a modern nativity.

67. **Joseph Wright of Derby**, *An Experiment on a Bird in the Air Pump*, 1768

lighting recalls Caravaggio and Rembrandt, and the skull in the illuminated jar in the centre is a 'vanitas' symbol of death.

This is a wonderfully dense compilation of ideas. Wright could be surprising in other ways. His clear-eyed, unflattering portraits of the prosperous new industrialists and scientists of his Midlands circle have a penchant for close-up, jaunty poses and unexpected accessories. The lively double portrait of *Peter Perez Burdett and his first wife, Hannah* (1765), is typically eccentric. Burdett sits nonchalantly on an awkwardly constructed rustic fence; he holds a telescope (he was, among other things, a mapmaker), and looks out at us with amused enquiry. His rather older wife, with her flounced finery and slightly anxious glance at him, is not glamorized.

The solidity of Wright's depictions of his patrons from the new moneyed class created by industrial enterprise contrasts palpably with the freer, more allusive styles of Reynolds and his great rival Gainsborough who made their fortunes painting the aristocracy. By the time Gainsborough moved from East Anglia to Bath in 1759 his style had matured to deal with larger projects than the little groups and Dutch-inspired landscapes of his

68

68. **Joseph Wright of Derby,**
*Peter Perez Burdett and his first
wife, Hannah,* 1765

opposite
69. **Thomas Gainsborough,**
William Wollaston, c. 1759
Gainsborough here makes use
of the precedent set by Van Dyck
in his portraits of his more
intimate friends, in which the
half-length format makes for a
sense of intimacy, enhanced by
the informal pose, and the
conversational attitude.
Gainsborough was fond of music,
and was drawn to people with
whom he could play.

Suffolk years. His portrait of *William Wollaston* (*c.* 1759), the M.P. 6
for Ipswich, is painted with a fluent elegance that can be com-
pared to Van Dyck without disadvantage. Wollaston is shown
holding his flute, with some music on his lap. He and the artist
must have made music together, for this is no official likeness: it
is the affectionate record of a congenial friend.

Like Reynolds, from whom as a creative personality he could
hardly be more different, Gainsborough was a born experi-
menter. He evolved a virtuoso way with the brush, effortlessly
evoking soft flesh, satins, and background landscape. After he
moved to a smart address in London in 1774, his method of
painting became ever freer. He would tie his brush to a cane and
so paint at long range, as it were. Reynolds admired 'his manner
of forming all the parts of his picture together; the whole going
on at the same time, in the same manner as nature creates her
works'. Gainsborough's great patrons relished the easy elegance
that he conferred on them. The 'liquefaction' of his draperies
carried echoes of Van Dyck. In his *Blue Boy* (*c.* 1770) he dressed
his young sitter in fashionable 'Vandyck' dress to salute that
inspiration. *The Hon. Frances Duncombe* (*c.* 1777) recapitulates all 71
the aristocratic assurance of one of Van Dyck's ladies. The young

70. **Thomas Gainsborough**, *Diana and Actaeon*, c.1785
Gainsborough's instinct was to extemporize. After his early experiments imitating the Dutch, his landscapes are inventions impelled simply by the fluency of his brush. This is an example; but uniquely, the subject is a mythological one, no doubt prompted by the current fashion for such scenes. Gainsborough makes it entirely his own, alluding to Titian's *Diana and Actaeon* while inventing freely in his distinctive idiom.

opposite
71. **Thomas Gainsborough**, *The Hon. Frances Duncombe*, c.1777

beauty stands in a romantic landscape, her fine complexion and glittering costume aglow in the fitful light. There is youthful nonchalance in even such a formal piece as this.

Gainsborough also enjoyed inventing 'fancy' pictures, which had matured as a genre since Mercier's day. The figures might be mythological, but these were not serious subjects. They might equally be rustic characters or street urchins. Gainsborough imitated the beggars and peasants of Murillo in scenes showing country children doing ordinary things – carrying pitchers of water or tending pigs. Reynolds, in his fancy pieces, naturally took a more intellectual line, painting whimsically erotic allegories like *A Snake in the Grass*, subtitled *Love unbinding the Zone of Beauty* (1784).

Gainsborough's penchant for experiment was most intriguing in the matter of landscape. He was given to muttering that he would gladly give up portraits altogether and paint landscape only. Of course portraits paid far too well. Most of his landscapes

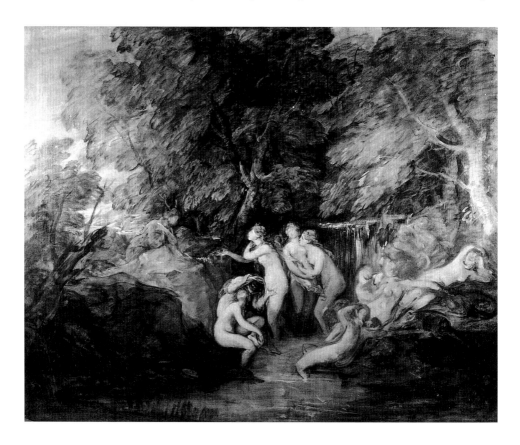

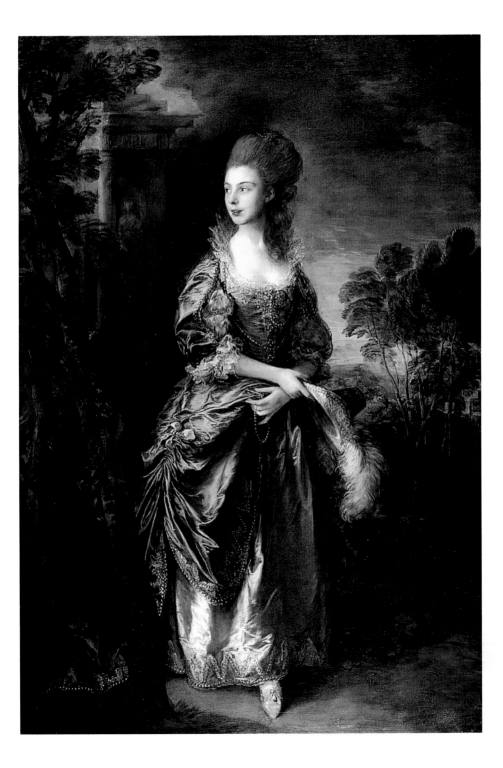

were imaginary. Even his view in *The Mall* (1783), with fashionable – and identifiable – couples strolling under the trees, has more in common with the courtly fantasies of Watteau than with late 18th-century London. He was disinclined to the 'idle affectation of introducing mythological learning in any of his pictures', though at the end of his life he made a large oil sketch of *Diana and Actaeon*, a ravishing rococo homage to Titian, in which nude figures are grouped in a purely imaginary woodland landscape.

Reynolds, oddly, thought that Gainsborough 'did not look at nature with a poet's eye'. But he added 'it must be acknowledged that he saw her with the eye of a painter'. Gainsborough sought to reconfigure the natural world according to the logic of the picture space, and here too he was a child of his experimental time. 'He even framed a kind of model of landskips on his table', Reynolds tells us; 'composed of broken stones, dried herbs, and pieces of looking glass which he magnified and improved into rocks, trees, and water.' Nature is a mere reference point; the important truth is the way natural elements can be made to harmonize pictorially. Gainsborough produced many dozens of landscape compositions, in oils, and also in chalks, or by a process

72. **Thomas Gainsborough,**
Peasants Returning from Market through a Wood, 1767

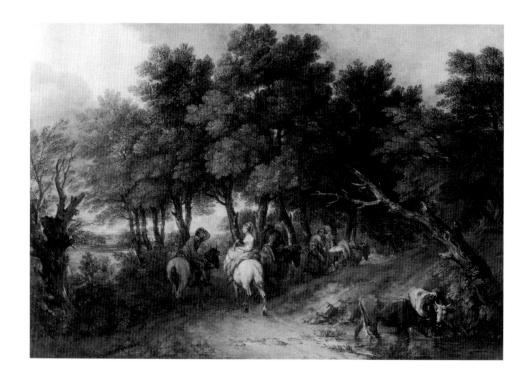

of monoprinting from a glass plate – more experiment – in which figures, trees, water and hills are endlessly permutated in a lifelong exploration of abstract design.

This, too, was a preoccupation of the age. It can best be understood from the work of a representative theorist. Alexander Cozens (1717–86) was all his life a teacher of drawing, both in schools – at Christ's Hospital and Eton – and to private pupils. His pedagogic tasks chimed admirably with a natural bent for analysis and categorization. In the words of his patron William Beckford, he was 'almost as full of systems as the universe', and spent his life attempting to list the phenomena of nature. One of his systems became famous: *A New Method of Assisting the Invention in Drawing Original Compositions of Landscape* was published at the end of Cozens's life, *c.* 1784. In its insistence on basic principles it has the air of being the product of a lifetime's attempts to convey aesthetic ideas to his pupils. Yet in its determination to make landscape painting a matter of abstraction, it is a textbook for its age. The use of random 'blots' to liberate the mind from specific objects so that it could explore the general rather than the particular was

73

73. **Alexander Cozens**, *A New Method of Assisting the Invention in Drawing Original Compositions of Landscape*, *c*. 1784: plate 13 Cozens published his remarkable series of sugar-ground aquatints at the end of his life, but had been developing the 'blot' technique throughout his career. In enabling the leisured classes to create landscape compositions that aspired to the sublime, he hoped to bring them into contact with noble ideas and so to make a moral as well as an aesthetic point.

13

exactly parallel to Reynolds's teachings about high art. Several painters experimented with Cozens's blot system, notably Wright of Derby.

This addiction to reorganizing the natural landscape reflected events in the real world. The countryside was being transformed by the Enclosure movement which brought huge areas into the estates of single landowners, while grand garden schemes were being laid out by Lancelot 'Capability' Brown (1715–83). Another theorist, the Rev. William Gilpin (1724–1804), taught the swelling numbers of tourists to appreciate natural scenery by applying the notion of the 'Picturesque' – judging it against the standards established in Claudian and Dutch painting. With such speculations in mind we must look at the work of Richard Wilson (?1713–82), a Welshman who contributed to Coram's collection, and had been happy to mix portrait and landscape in his output until he went to Italy in 1750.

There he decided to specialize in landscape exclusively. In Rome, inevitably, he modelled himself on Claude, but reinvented Claude in English 18th-century terms. Before Reynolds

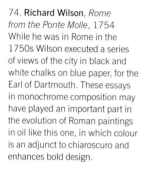

74. **Richard Wilson**, *Rome from the Ponte Molle*, 1754
While he was in Rome in the 1750s Wilson executed a series of views of the city in black and white chalks on blue paper, for the Earl of Dartmouth. These essays in monochrome composition may have played an important part in the evolution of Roman paintings in oil like this one, in which colour is an adjunct to chiaroscuro and enhances bold design.

75. **Richard Wilson**, *Snowdon from Llyn Nantlle, c.* 1766
Wilson's views of his native Wales are often couched in a golden Italian atmosphere that deliberately alludes to Claude. Here his capacity for formal rigour reveals itself in an unexpectedly abstract deployment of mountain forms in bold answering patterns and muted colours: a very idiosyncratic response to the notion of 'ideal landscape'.

pronounced on generalization, and when Cozens was only beginning to formulate his theories, Wilson generalized Claude. He painted views of Rome and its environs in which planes are set in simple relationships with one another, illuminated by a clear, cool light, and foliage is reduced to bold masses. The result is a monumental version of ideal landscape, in which nothing superfluous to the essential statement intrudes. The dark pines that flank Wilson's *Rome from the Ponte Molle* (1754) rise up against a luminous sky as silhouettes, the distant buildings simplified into an airy geometry. Even in northern, romantic Wales, Wilson could simplify to an almost Chinese degree: his view of *Snowdon from Llyn Nantlle* (*c.* 1766) is a picture that Cozens himself might almost have painted.

Wilson died impoverished: his version of landscape was too intellectual, perhaps, for most buyers. But he could also produce views that appealed to the common desire for information about places. House-portraits like those Siberechts and his colleagues

74

75

had painted were still much in demand. Views like that of *Syon House* (*c.* 1762) show Wilson obeying this mighty new market force, although topography was an inferior art form, 'the tame delineation of a given spot ... what is commonly called views', as Henry Fuseli contemptuously put it. In fact, topography throve. The army of watercolourists, led from the mid-century by Paul Sandby (1730–1809), who had trained as a military draughtsman, became adept at describing the individual character of places – towns, villages, ruined castles, abbeys or modern country seats. Many of these artists, whether they worked in oil or watercolour, came under the spell of one influential foreign visitor: the celebrated Venetian *vedutista* or view-maker, Canaletto (1697–1768).

Finding business in Venice dwindling because of war with Austria, Canaletto came to London in 1746, and stayed, with a return visit to Italy in 1750–51, until 1755. He had a shrewd sense of where to place his work, which with its crisp presentation of topographical detail appealed to the pragmatic side of the English character. He used bright clear colour and populated his foregrounds with deft suggestions of elegant figures. Translated from the canals of Venice (views of which were much sought after by gentlemen on the Grand Tour) to the Thames in London, his style answered perfectly, with the irresistible

76. **Paul Sandby**, *Windsor Terrace, c.* 1776
The artist repeated this view looking west along the North Terrace many times, varying the figures which appear in the changing costumes of the late 18th century. This example is washed with watercolour over a lightly bitten etched outline, in preparation for an aquatint, a print medium Sandby developed and which became popular as a means of reproducing watercolours.

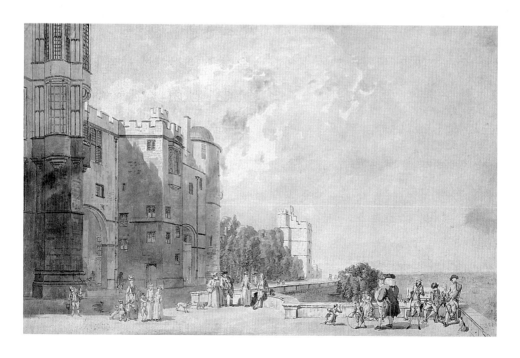

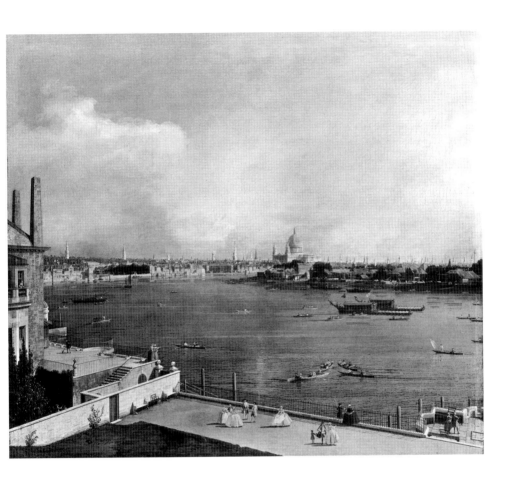

77. **Canaletto**, *The Thames and City of London from Richmond House*, c.1747
The Duke of Richmond was one of Canaletto's earliest patrons in London. This view and its pair, looking north from the Duke's house, are the artist's greatest English works. The informal composition seems to be a response to English topographical practice, and the picture records in accurate detail the scene as it then was: the Savoy Palace, old Somerset House, the Temple and the City church spires are all minutely described.

quality of seeming inevitable. He was able to learn something of the English approach from Samuel Scott (1702–72), who specialized in marines in the Van de Velde tradition, and produced Thames scenes. Scott is sometimes seen as a sort of English Canaletto, but whether among the wharves of Greenwich or the riverside villas of Twickenham he was recognizably himself, with a soberer palette and gentler touch.

Two of Wilson's pupils, Thomas Jones (1742–1804) and William Hodges (1744–97), figure in the development of a form that was to be important in the Romantic period: the open-air oil sketch. Jones, a Welsh landed gentleman, put himself to learn under Wilson and made the journey to Italy, hoping to distinguish himself as an academic landscape painter in Wilson's manner. He is not remembered today for his stiff essays in that mode, but for his small on-the-spot oil sketches. Their clarity

78. **Thomas Jones**, *A Window in Naples*, 1782
The intimate oil sketches that Jones made in Italy are the counterparts of his journals for that period, brought together in his *Memoirs*, which constitute a vivid and entertaining insight into the life of British artists in Rome in the 1770s and 1780s.

and directness owe something to Canaletto, but most remarkable is their plain-speaking approach to subject matter. Jones would perch himself on a window-sill in the Neapolitan sunshine and simply paint what was in front of him – a peeling wall with a line of washing, a rooftop with the cupola of a church rising above it. The frankness of these observations is engaging, and breaks new ground: few painters had attempted such intimate, immediate yet complete records of unimportant objects before.

78

Hodges's work too was ground-breaking: he accompanied Captain Cook as artist on his second expedition to the South Seas in 1772–76, hired like any other topographer to record what he saw. Unlike most topographers, he was recording the utterly new. Cook's voyages were part of the great scientific explosion, and Hodges's task was to bring a whole *terra incognita* into visual focus. The small panels on which he noted, through the windows of the ship's cabin, his impressions of tropical dawns and sunsets, the boats, homes and habits of the Antipodean peoples, are among our most remarkable documents of exploration. Along with Hodges's later work as a topographer in India they are in the vanguard of a long tradition of recording the territories and peoples of Britain's fast-expanding empire.

79

If Wilson's cool simplifications were a response to the need to rationalize nature through art, Gainsborough's flickering light and broken forms were equally theory-driven, his landscape compositions a complete statement of Picturesque laws. The scope of Picturesque influence can be seen in work as varied as the rippling pen outlines of the comic draughtsman Thomas Rowlandson (1756–1827) and the descriptively impasted paint of George Morland (1763–1804), whose scenes outside country inns and thatched cottages established rustic genre as a popular form that was to develop in important ways in the next century.

72

The master who invested the unpretentious world of picturesque rusticity with true magic was John Crome (1768–1821). He rarely stirred far from his native Norwich and was content to make pictures of its old houses, and lanes in the surrounding countryside. In a few canvases, resulting from a trip to France in 1814, the breadth of his brushwork and the clarity of the light mark him a fully fledged member of the Romantic movement. But more typically his pictures show gnarled oaks flickering in a bright East Anglian sun, or brick houses glimpsed among trees along the River Wensum. Crome was a lifelong admirer of the Dutchman Hobbema, and the invocation of such masters gave the Picturesque a serious pedigree.

82

But landscape, no more than portrait, could vie with the sublimity of history painting in the estimation of the period. The history painters, in their high-mindedness, embody some of the most significant ideas about painting of their age. One

79. **William Hodges**, *Otaheite and the Society Islands showing war galleys and war canoes at Pari*, 1774
Hodges' use of oil paint on paper or panel to depict the scenes that he witnessed during the second of Cook's voyages of exploration in the Pacific and Australasia was innovatory not only in technical terms but also as a means of making records that were intended for scientific purposes.

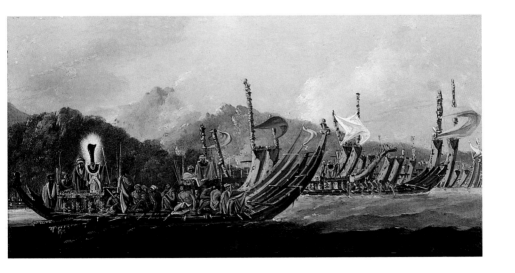

of the first, though short-lived, was John Hamilton Mortimer (1740–79), who specialized in subjects taken from early British history. A gifted draughtsman, he made etchings of banditti imitating Salvator Rosa, and other self-consciously wild, Romantic subjects better known today than his pictures.

The same might be said of the Irishman James Barry (1741–1806), who possessed, after Reynolds, perhaps the most incisive intellect of any British artist of the time. His writings on art, fired by a revolutionary passion that made him the bugbear of the Academy, where he was Professor of Painting until he was expelled in 1799, are still worth reading. When he decorated the Great Room of the Royal Society of Arts with a series of huge canvases expounding *The Progress of Human Culture*, he engaged in a typically 18th-century exercise, a grandiose celebration of the intellectual and scientific advances that coloured every aspect of modern life, classicizing, worthy, slightly ludicrous.

The ludicrous is, in a sense, part and parcel of this demonstrative art. The point is nowhere better made than in the work of a Swiss, Henry Fuseli (1741–1825). Fuseli was, as it were, artist in residence to the Gothick movement. His sense of the grotesque and the erotic was highly developed and, as an artist

80. **James Barry**, *The Progress of Human Culture: A Grecian Harvest Home, or Thanksgiving to the Rural Deities Ceres, Bacchus, etc.*, 1777–84
The Society for the Promotion of Arts, Manufactures and Commerce in London was the engine of important advances in design and art training in the mid-18th century. Barry's ambitious cycle of paintings for its Great Room expounds the artist's 'one great maxim of moral truth, viz. that the obtaining of happiness, individual as well as public, depends upon cultivating the human faculties'. In this scene we are shown an Arcadian 'state of happiness, simplicity, and fecundity' which 'is but a stage of our progress, at which we cannot stop'.

bringing the *Sturm und Drang* of 1770s German culture, via Rome, to Reynolds's London, where he finally settled in 1780, he has an important role in the spread of Romanticism. 'Imitative art, is either epic or sublime, dramatic or impassioned, historic or circumscribed by truth', he wrote. 'The first astonishes, the second moves, the third informs.' His life was dedicated to astonishing and moving his audience; he was contemptuous of mere 'information'. His early work in Rome was profoundly affected by classical art and literature, and by Michelangelo. The exaggerated gestures and expressions of his tormented heroes and heroines are impressive in his bold, generalized pen and wash drawings though less satisfactory translated into paint. All have an undeniable emotional charge, and Fuseli, ever the vocal champion of what he called 'poetical painting', remained a father-figure at the Academy until his death. True seriousness meant dealing with noble themes from great literature, and he drew on the classics from Homer, Dante and the Norse Sagas to Milton and Schiller. Most fruitfully, he followed the current rage for Shakespeare, producing numerous paintings illustrating the plays, some of which display a bizarre comedy rather than high tragedy.

81. Henry Fuseli, *Macbeth and Lady Macbeth*, 1774
Shakespeare was a great source of inspiration for late 18th-century history painters. The engraver-publisher John Boydell commissioned the leading artists of the day, including Fuseli and Reynolds, to paint subjects from the plays which were exhibited in a 'Shakspeare Gallery' and engraved for a lavish publication. The project enjoyed immense prestige, but like many such schemes to elevate public taste in art was a commercial failure. This is one of a large number of energetic drawings and paintings that Fuseli produced under the stimulus of the Shakespeare revival.

82. **John Crome**,
Norwich River: Afternoon, *c.* 1819

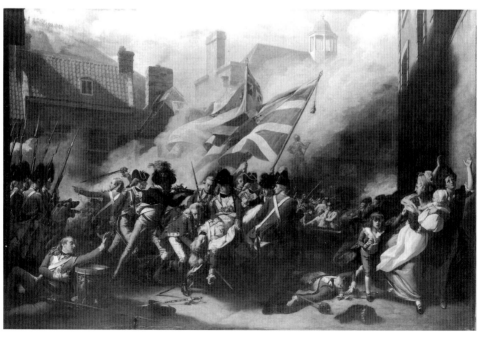

The most convincing demonstration of the status of history was the career of Benjamin West (1738–1820), who succeeded Reynolds on his death in 1792 as the Academy's second President. He had come from Philadelphia via Rome in the 1760s and had so prospered with subjects taken from classical literature and history that he was appointed history painter to King George III in 1772. Although often recondite and humourless, he sometimes achieves a miracle. Such is *The Death of General Wolfe* (1770), which daringly presents a modern historical subject with a direct allusion to the traditional *Pietà* (lamentation over the body of Christ). West could also turn his hand to an attractive landscape or small-scale genre subject.

Perhaps the finest of the history painters working in London, from a purely aesthetic point of view, was another American, John Singleton Copley (1738–1815), who came to England in 1775 at West's invitation. His colonial upbringing and early success as a portrait painter in Boston had confirmed him in a crisp, polished, unpretentious style. When he came to paint a scene from a minor engagement between the English and the French in Jersey in 1781, he built on West's achievement in his *Death of Wolfe* to create possibly the finest of all British modern history pictures: *The Death of Major Peirson* (1783). Drama of a highly theatrical kind, focusing on the group supporting the collapsed figure of Peirson echoing a Rubensian *Deposition*, is blended successfully with details of contemporary costume and accurate topography.

Fuseli and Barry were admired by another maverick rebel, William Blake (1757–1827), who is the best-known of the late 18th-century history painters today. We don't think of him as a history painter, perhaps; but is precisely what he was. Some early submissions to the Royal Academy suggest that he subscribed to current ideas as to serious subject matter: *The Death of Earl Godwin* (1780); *War unchained by an Angel: Fire, Pestilence and Famine* (1788). But he avoided the usual grandeur of scale, preferring watercolour, or an invented 'Fresco' of his own, a sort of tempera made using carpenter's glue, which tended to darken severely over time. He also evolved a unique printing technique that had been revealed to him by his dead brother in a vision. Here are further manifestations of the fascination with technical experiment so typical of the age. Oddly, Blake's watercolour technique is less adventurous than that of many of his contemporaries; but he uses it powerfully for his own purposes.

83

84

83. **Benjamin West**, *The Death of General Wolfe*, 1770
In this ground-breaking essay in modern history painting, West includes portraits of various figures involved in the action, though not necessarily present at Wolfe's death. He adds the moving figure of the American Indian with accurately observed details of costume and tattooing, as a reminder of the broader significance of the white presence in North America.

84. **John Singleton Copley**, *The Death of Major Peirson, 6 January 1781*, 1783
Copley's picture was commissioned by John Boydell, to commemorate the capture of St Helier, Jersey, from the French by the twenty-three-year-old Major Francis Peirson. Copley took pains to depict the setting accurately, but dramatized the action, placing the dying Peirson in the centre of a composition inspired by Baroque artists such as Rubens.

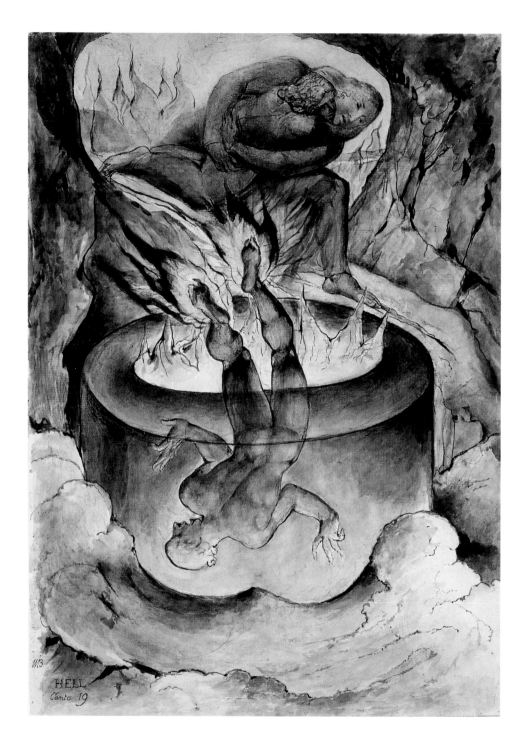

HELL
Canto 19

85. **William Blake,**
The Simoniac Pope, 1824–27
In 1824 Blake's young friend
and follower John Linnell
commissioned from him a set of
illustrations to Dante's *Divine
Comedy*. Blake, old and ill,
dedicated himself to one of his
most ambitious projects. Using
only pencil, watercolour and pen,
he created some of the most
remarkable images ever to have
been inspired by Dante's vision.
This subject illustrates a moment
in the *Inferno*, when Dante,
embraced by his guide Virgil to
prevent him falling, watches the
punishment of Pope Nicholas III
in a bath of fire for selling
ecclesiastical preferments.

86. **William Blake,** *The Angel
rolling away the Stone from
the Sepulchre*, c. 1805
From a large series of Biblical
subjects that Blake made in the
first decade of the century for
Thomas Butts, one of his most
assiduous patrons. The text it
illustrates is Matthew 28:2:
'And, behold, there was a great
earthquake: for the angel of the
Lord descended from heaven, and
came and rolled back the stone
from the door . . .' In its clarity of
outline, simplicity of colour –
it is almost monochrome – and
symmetry of composition it shows
Blake at his most Neo-classical,
and close to the cool, sculptural
inspiration of Flaxman.

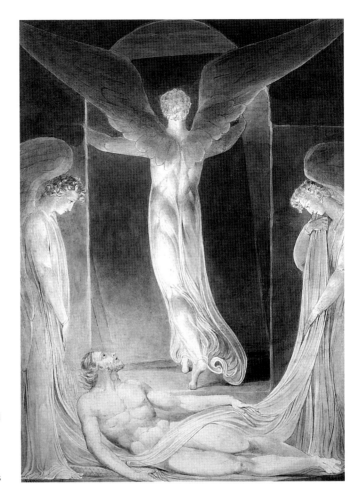

Blake's historical subjects are from the Bible or Milton, as
Fuseli's might be – Fuseli famously observed that 'Blake is
damned good to steal from'. But he also illustrated his own sto-
ries, legends from a complicated mythology expounded in a
series of long poems issued in his 'Prophetic Books' published (in
tiny editions, for private circulation) from the 1790s to the 1820s.
On their pages, long and dense texts are couched in richly imag-
ined illuminated borders in which he cast of idealized characters,
spirits and fairies come irresistibly to life.

Blake's visual language is highly personal, and to some eyes
shares the absurdity of his heroes Barry and Fuseli. It is essen-
tially the same as theirs: exaggerated gestures, distorted poses;

86

but his work has an intensity, partly the result of its relatively small scale, that gives it an altogether different resonance. It is based on an idea of pure outline that Blake elevated into a philosophy. He praised the 'distinct, sharp and wiry bounding line' as the essence of powerful expression. In this he was close to his contemporaries, most notably the sculptor John Flaxman (1755–1826), who in the 1790s became one of the most influential artists in Europe with his outline illustrations to Homer, Aeschylus and Dante.

Like most painters of history, Blake could not attract many patrons. All his career he was obliged to undertake hack reproductive engraving for a livelihood. Flaxman found him work for Wedgwood's pottery catalogues, and some of Blake's most influential inventions were a set of little woodcuts illustrating a school edition of Virgil's *Eclogues*. One of the young artists who came under the spell of these designs, John Linnell, commissioned from Blake in his old age a set of illustrations to Dante on which he worked during his last years. Incomplete as it is, this suite of large watercolours is a sustained demonstration of his passionate belief in the 'One Power alone' that 'makes a Poet – Imagination, the Divine Vision'.

Whether in line or stone Flaxman's art is cool, the epitome of classical restraint, while Blake's is afire with the afflatus of true inspiration, which he claimed to derive from his nightly visions of the great and good of past ages. Despite its often sophisticated invention, his work also has an almost childlike quality which echoes that of his lyric poetry: the author of 'Tyger, tyger burning bright / In the forests of the night' cannot be accused of empty pretentiousness. Blake's prophetic passion, with its accompaniment of 'visions', was often accounted lunacy, and when in 1809 he mounted an exhibition of his paintings, mostly in his experimental 'Fresco' medium, it was dismissed as the ravings of a madman. In some ways he was at a distant remove from the age of scientific rationalism; one of his most famous images shows Sir Isaac Newton crouched at the bottom of the sea of materialism, futilely measuring what can never be measured. Blake can better be understood as a pioneer of Romanticism.

87. **William Blake**, *Newton*, 1795
This is one of a set of twelve large prints that Blake made for Thomas Butts in the 1790s. They are ambitious pieces, elaborate in technique: the colour prints themselves were extensively worked up by Blake with pen and watercolour. Their monumental figures reflect the strong influence of Michelangelo on his imagery. The pose of Newton, for instance, is derived from that of one of the ancestors of Christ, Abias, in Michelangelo's Sistine Chapel ceiling. According to Blake, Newton represents the narrow vision of the purely rational thinker, unillumined by the imagination: 'He who sees the Infinite in all things sees God. He who sees the Ratio only sees himself only.'

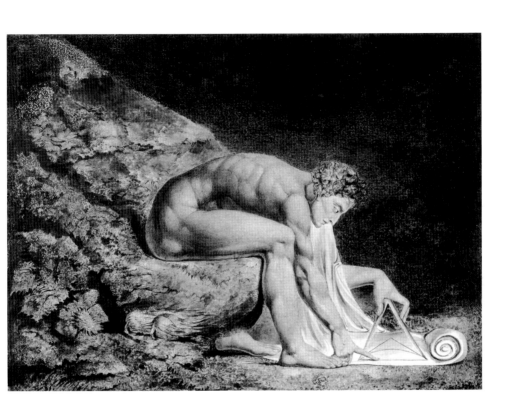

Chapter 5 Romantic Virtuosos: 1800–1840

The idealization and generalization that so dominated 18th-century aesthetics were manifestations of Neo-classicism: a reverence for the civilizations of ancient Greece and Rome, pinnacles of human achievement in literature, architecture, sculpture and philosophy. The Renaissance had revived the virtues of the antique world, and in such geniuses as Raphael and Michelangelo the spirit of Greece and Rome lived again.

One consequence of British economic expansion in the 18th century was the increased capacity for travel among a larger sector of the population. Newly rich magnates and their families could set off for the Continent on journeys that would once have been beyond the resources of all but a few aristocrats. Any young man of substance could go to Italy for himself on the Grand Tour and absorb Classical and Renaissance culture at first hand. More and more of it was becoming available: excavations at Herculaneum and Pompeii, begun in the 1740s, had unearthed vivid evidence of life in the Roman Empire; even Greece and Asia Minor were beginning to be described under the auspices of the Society of Dilettanti. If such discoveries were further manifestations of the scientific spirit of the age, they characteristically fed into aesthetic life as well. When, in 1789, the French revolted against their oppressively reactionary masters, they adopted Greek dress and Greek ideals as models for a brave new world.

The French Revolution was a violent political expression of the developments in European thought over the century since the English 'Glorious Revolution' of 1688. Inspired by the writings of Locke and others, French philosophers – Voltaire, Diderot, Rousseau – had insisted on the moral inadequacy of absolute regimes like that of France. The Americans' Declaration of Independence from Britain in 1776 formulated a blueprint for civil liberty, and at first the English were in two minds about the Revolution. But, when the Terror came in 1792 and the King and Queen were guillotined, most of them decided emphatically against.

Nevertheless they were part of this Europe-wide 'Enlightenment', and agreed that the Antique civilizations

embodied ideals of human conduct both social and personal. The Earl of Elgin gave a boost to the fashion when in 1802 he brought back sculptures from the Parthenon in Athens and exhibited them in London. They caused controversy, but became accepted as an aesthetic achievement only dimly reflected in the Roman statuary everyone had previously considered sublime. Gentlemen wanted their homes to reflect the refinement of that superior civilization, and having for nearly a century been content with the second-hand Roman architecture of Neo-Palladianism, now insisted on a more archaeologically correct use of Greek orders or Roman decorative motifs. The notion of classical purity took hold, and for some years in the first decades of the new century there were few aspects of art that didn't reflect the fashion in some degree.

But the American and French Revolutions uncorked other emotions. They asserted that people are individuals, with their own needs and feelings. While they each, in different ways, proclaimed the validity of the ideal state, they gave individuals a sense of participating in a heroic destiny, contributing something valuable simply by virtue of being human. Poets began to speak directly of their own moods, rather than enunciating public sentiments. Blake had celebrated the quiet joys of a modest rural existence, Wordsworth gloried in his own ecstatic sensations when confronted with the wonders of nature. When in 1794 Britain and France became enemies in a long-drawn-out war, a further dimension, of fierce patriotic pride, was added to the brew.

One painter who chimed with this emotionally charged cultural climate was a Cockney of unprepossessing appearance named Joseph Mallord William Turner (1775–1851). Bashful, awkwardly aware of his social shortcomings, he was nonetheless convinced of his genius as a painter, and cast himself, tacitly, as a national hero with a mission to place British painting on a par with the Italians and the Dutch. More, he would place landscape painting on a par with history. He was a student at the Academy Schools by the age of fourteen, sixteen when he listened to Reynolds's final Discourse in 1791. Reynolds remained a hero and model for him all his life, and to understand his art we need to recognize his origins in the Reynoldsian school of grand generalization.

It was integral to his ambition that he should be a Royal Academician, part of the body that represented his profession at its most august. He embraced the idea of the Old Masters as

88. **J. M. W. Turner**, *Dutch Boats in a Gale: Fishermen endeavouring to put their Fish on Board (The Bridgewater Sea-piece)*, 1801
The Duke of Bridgwater commissioned this large marine from the young Turner to hang as a pair to a picture by Van de Velde the younger. Turner adopts a composition that balances Van de Velde's symmetrically, and produces a virtuoso description of conditions at sea, with two fishing-boats in a near collision. Works like this cemented his reputation as the leading landscape and marine painter of the younger generation, and he was made a Royal Academician the year after this picture was exhibited.

89. **J. M. W. Turner**, *The Decline of the Carthaginian Empire*, 1817
Turner was fascinated by the story of Carthage, both in its mythical form, as related by Virgil in the fourth book of the *Aeneid*, were the love affair of Dido and Aeneas is recounted, and in its historical phase, when Carthage and Rome were rival powers for control of the Mediterranean. This picture deals with the last humiliation of the Carthaginians, when 'Rome being determined on the overthrow of her hated rival, demanded from her such terms as might either force her into war or ruin her by compliance' as Turner's citation ran. He added some lines of verse from his pessimistic poem 'The Fallacies of Hope'. The sunset symbolizes the extinction of a nation's ambitions, and the whole design is a triumphant adaptation of the harbour scenes of Claude.

exemplars of all that is greatest in painting. His own art would continue that tradition. He claimed it was the sight of a print after a seascape by Van de Velde that 'made me a painter', and his reputation as a master of the seascape was founded on his admiration for the Dutch marine artists. His love of ideal landscape equally originated in historical precedent. One day, looking at a Claude that belonged to the banker John Julius Angerstein, he was so overcome that he burst into tears. 'Mr Angerstein enquired the cause and pressed for an answer, when Turner said passionately, "Because I shall never be able to paint anything like that picture."'

That sense of rivalry with the best spurred Turner all his life. In so far as it was a matter of professional competition, it was a political emotion in the spirit of the age. But it was also a private, creative urge. Turner's art, with all its Academic tendencies, its emulation of the Old Masters, is quintessentially the art of a Romantic. In any case, it cannot be summarized in terms of one set of ideas. If Turner imitated his predecessors, and, despite his own misgivings, eventually did manage to out-Claude Claude, he was also a Wordsworthian, a meditater on the power and beauty of nature.

He began his career as a watercolour topographer, training as an architectural draughtsman even while he attended the Royal Academy's drawing classes. In the 1790s, he experimented with watercolour, forging it into an unprecedentedly powerful medium, able not only to vie with oil in evoking sublime grandeur, but to catch every nuance of landscape and atmospheric effect. His understanding of watercolour was enriched by experiments with oil at this time, and in due course oil painting became for him a translation of watercolour practice: the two disciplines cross-fertilized one another. He applied Reynolds's dicta about high seriousness to landscape painting, seeking examples in the work of his older contemporaries, especially Wilson, the watercolourist John Robert Cozens (1752–98), Alexander's son, and the Alsatian specialist in sublime landscape, Philippe Jacques de Loutherbourg (1740–1812), who had settled in London in 1771. Without that 18th-century point of reference, Turner would have been quite a different artist.

He might, for instance, have been more like John Constable (1776–1837). Constable was a prosperous miller's son from Suffolk, as much a middle-class East Anglian countryman as Turner was a working-class Cockney. He was a snob, where Turner was a man of the people. Yet Constable attached less importance to the traditions of the Academy than Turner did. He was scathing about 'High-minded members who stickle for the "elevated & noble" walks of art – i.e. preferring the shaggy posteriors of a Satyr to the moral feeling of landscape.' Why perpetuate the fictions of classical landscape when there is real English scenery out there to be painted, and a profound connection between nature and personal identity to be teased out? Wordsworth had spoken, in terms not unlikeConstable's, of recognizing

> *In nature and the language of the sense*
> *The anchor of my purest thoughts, the nurse,*
> *The guide, the guardian of my heart, and soul*
> *Of all my moral being.*

It was Constable's mission to bring landscape painting out of the Academic closet and face to face with the 'moral' truth of nature. His method was to paint natural scenes and objects as directly as possible, with as little intervening 'art' as he could achieve. 'My pictures will never be popular,' he said, 'for they have no *handling*. But I do not see *handling* in nature.' This is the opposite of Turner's approach, in which art is everything, and all nature becomes the subject matter for art. Constable, on the contrary, wants art to become the vehicle for natural expression. This too is a legitimately Romantic position.

A staple of Constable's working procedure was the small oil sketch, done out of doors, in rapt concentration: witness the story of his sitting so still while sketching that a mouse crept into his pocket. Turner rarely made oil sketches out of doors. When he did – in a boat on the Thames in 1805, and again on the hills outside Plymouth in 1813 – he produced little masterpieces very much in Constable's spirit. But he was impatient of such performances, and preferred to jot down a mass of quick pencil notes in a small sketchbook, for reference later when, in the studio, he came to work up a subject into an oil or an elaborate finished watercolour. He would never have undertaken to complete a large canvas out of doors. This too Constable tried. Much of his Academy submission of 1817, *Scene on a Navigable River (Flatford Mill)*, was painted on the spot, detail by detail – a

pioneering technique that anticipated the methods of the Pre-Raphaelites and the Impressionists.

After *Flatford Mill*, he embarked on a series that are among the great experiments in the history of painting, pictures he called his 'six-footers', from their lateral dimension: *The White Horse* (1819), *Stratford Mill* (1820), *The Hay Wain* (1821) and *View on the Stour near Dedham* (1822). *The Hay Wain* attracted the praise of Théodore Géricault when he saw it in London in 1821, and won a Gold Medal at the Paris Salon in 1824. For each of these pictures Constable prepared a full-scale study, a version of the composition executed very broadly as though it were an outdoor sketch, intended to capture transient effects of light and shade, the shimmer of willow branches as a breeze passes over them, the momentary shadow of a cloud, the gleam of moving water.

These wonderful sketches are clearly distinguishable from the finished, exhibited pictures. In a later series that distinction becomes less marked. *The Lock* was shown in 1824, and *The Leaping Horse* in 1825. *A Boat passing a Lock* was painted in 1826 and shown three years later. Two other subjects, *Hadleigh Castle* (1829) and *Salisbury Cathedral from the Meadows* (1831), relate to their preliminary sketches in even more surprising ways. Constable virtually suppresses any differentiation between sketch and finished work. This is something we might expect to happen in small pieces – finished pictures of a scale related to the open-air studies. But he brings the idea to its logical conclusion in pictures that explicitly take their place in the Academy exhibition alongside the considered statements of his contemporaries. *The Leaping Horse* is perhaps the canvas that, although finished and exhibited, most perfectly exemplifies this beatific state of immediacy and completeness.

The subject matter is in fact about as dramatic as anything he invented. Ordinary rural life is celebrated as though it were heroic – the boy on the horse recalls portraits of Napoleon crossing the Alps – but with no hint of exaggerated rhetoric. The incident is an everyday event by the canal side. The grand composition, with its bold upright to the left and open horizon to the right, consists only of trees, clouds and water. These elements are brushed in as though Constable were seeing them for the first time. The sparkle of light on the leaves of the central pollard willow embodies the new identification of paint with human feeling and with nature that he so painstakingly sought to realize.

Constable's innovations were so far-reaching and profound that they have come to be taken for granted, and his work now

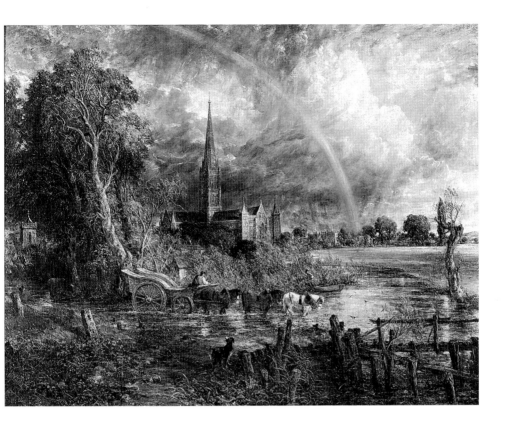

92. **John Constable**, *Salisbury Cathedral from the Meadows*, c. 1829–31
This is a full-size sketch for one of the last of Constable's large-scale exhibition pictures, which he worked on in the months after the death of his wife. The rain-cloud over the cathedral has been seen as a symbol of his despair after this tragedy, although he claimed that it reflected his concern over the state of the Anglican Church itself. It is appropriate to note the sparkle of the returning sun on the wet grass, and the promise of hope in the rainbow. Constable's awareness of the endless rebirth of organic nature was a central motif of his art.

seems archetypally traditional. *The Hay Wain* is synonymous with a comfortable view of rural England. Yet before him, no one had painted nature with such intensity, freedom and insight.

Given this achievement, it is the more remarkable that an equally great landscape painter was working in London at the same time. Turner and Constable knew each other only slightly, and we do not know what Turner thought of Constable's work, though Constable famously said that Turner displayed a 'wonderful range of mind' and admired his 'tinted steam'. The phrase well sums up the elusive light and atmosphere that Turner captures so expertly in his later paintings. *Rain, Steam, and Speed – the Great Western Railway* did not appear until 1844, after Constable's death. It has come to be regarded as typical of Turner's output, and is a great celebration of the modern world. If Turner sought sublime effects, he was looking for them in very new areas – no one had attempted to depict 'speed' before, unless in scenes of horse racing. He sought to represent the inherent

94

93. **John Constable,**
The Leaping Horse, 1825
While he was painting this
picture Constable wrote to a
friend: 'It is a canal and full of
the bustle incident to such a
scene where four or five boats
are passing with dogs, horses,
boys & men & women & children,
and best of all old timber –
props, waterplants, willow
stumps, sedges, old nets,
&c &c &c.' In another letter he
said 'It is a lovely subject . . .
lively – & soothing – calm and
exhilarating, fresh – & blowing'.

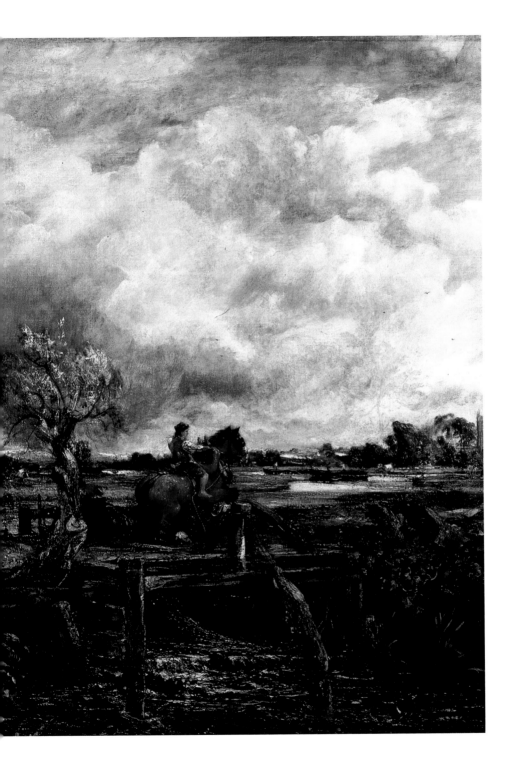

dynamism not only of machines but of nature itself – its capacity to change, to slip past us as we watch.

Turner painted with an immediacy that owed much to the sort of direct observation that Constable prized. His *Snow Storm. Steam Boat off a Harbour's Mouth, making Signals in shallow Water and going by the Lead* (1842) is nothing if not specific. If it presents the appearance of a 'mass of soap-suds and whitewash', as one critic complained, that is because it shows us the reality of nature – 'I painted it to show what it was like', Turner said. Constable, more conservative politically and socially, was more concerned with the life of the ploughman and his kind than with modern machinery. Turner embraces all existence, past and present, town and country, rich and poor, in a comprehensive excitement that his great admirer John Ruskin (1819–1900) had no hesitation in calling 'Shakespearean'.

He was seen as something of a conjurer: his sheer proficiency as a painter astonished even his Academy colleagues. In the later part of his career he took to sending in to the annual exhibitions framed canvases that were almost blank. Then, in front of them all, he would 'perform': as a contemporary observed, he 'went about from one to another . . . piling on, mostly with the [palette] knife, all the brightest pigments he could lay his hands on, chromes, emerald green, vermilion, etc., until they literally blazed with light and colour. They looked more like some of the transformation scenes at the pantomime than anything else.' His ostentatious virtuosity was compared with that of Paganini on the violin. So the 'academic' Turner demonstrated his Romantic credentials in the very heart of the Academy.

Turner had rooted his career in picturesque view-making and his landscape art grows out of the topographical tradition. The peace encouraged new markets for painting among the industrialists of an increasingly productive society. Turner found himself patronized not by the aristocrats who had supported him in his youth but by tycoons from Birmingham, Belfast, even New York. His 18th-century notions of the Sublime were becoming out of date, but Ruskin devoted a long and eloquent panegyric, *Modern Painters* (1843), to his defence, insisting that he was an artist for the new times, a faithful recorder of the multitudinous variety of nature. In doing so, Ruskin stressed the qualities the new bourgeoisie wanted: precise observation and specific detail.

The sketch made out of doors, whether in oil or watercolour, was now an essential part of the landscape painter's practice. In

the hands of John Robert Cozens, Turner, Thomas Girtin 95-97,
(1775–1802), and John Sell Cotman (1782–1842), watercolour 99
achieved its golden age. Cozens discovered a new language of
space and atmosphere in which mountain scenery and Italian
arcadias could be poignantly evoked. Girtin was trained as a
topographical watercolourist in London, an early associate of
Turner's. With Turner, he took up the challenge to reinvent
watercolour as a medium capable of expressing the grander
aspects of landscape – the sublimity of mountains, waterfalls and
storms. To achieve this he not only simplified the forms in his pic-
tures but restricted his palette as well, so that his work typically
relies on a sombre gamut of purples, browns and dull greens. The
example of Wilson hovers in the background of Girtin's achieve-
ment, and it is not out of place to describe his landscape, despite
its Romantic character, as Neo-classical, since its emotional con-
tent is conveyed in structures of such sobriety and order. Inspired
by these experiments, watercolourists saw that their hitherto
humble medium might aspire to greater heights. In 1803 a
group of them founded a Society of Painters in Water-Colours to
provide a place of exhibition in which the Academicians would
not outshine them in their efforts to produce 'high art'.

Few oil paintings by Girtin are known, but he did execute
one ambitious project in oil, a 360-degree panoramic view of
London from the roof of the British Plate Glass Manufactory,
near the southern end of Blackfriars Bridge. The surviving
watercolour studies for this now lost work are among his most 96
atmospheric. After Girtin's early death, Cotman seemed to take
up where he left off, bringing an even more refined sense of
design to sonorously coloured landscapes and architectural 97
studies that are precisely yet nervously and evocatively drawn.
His oils are as sensitive and harmonious as his watercolours. In
the 1820s and 1830s he experimented with the bright colour then
fashionable, creating subjects of startling chromatic brilliance.

The popularity of topography grew, stimulated by the new
freedom to travel. Views were engraved and published in lavish
volumes for home consumption, and many artists benefited from
the demand. An especially able topographer is William Daniell
(1769–1837), who with his uncle Thomas (1749–1840) had
spent seven years in India and between 1795 and 1808 issued a
classic collection of plates, *Oriental Scenery*, consisting of six vol-
umes of large hand-coloured aquatints which they themselves
engraved. William Daniell also undertook a topographical
tour worthy of Turner himself: a *Voyage Round Great Britain*,

on pp. 128–29
94. **J. M. W. Turner**, *Rain,
Steam, and Speed – the Great
Western Railway*, 1844
Although this is one of Turner's
most astonishing feats of
atmospheric suggestion, it is also
a picture that refers back to the
most classical of his inspirations –
the paintings of Nicolas Poussin,
who had shown how diagonal
lines of perspective provide a
structural geometry in landscape
compositions. As in *The Fighting
Temeraire tugged to her last Berth*
(1839), Turner contrasts old
technologies with new: the steam
engine roars past fields in which
a ploughman still pushes his
plough, and a small sailing boat
idles on the water below. Nature's
own 'racer,' the hare, hurtles
along the railway track in front
of the train.

127

which, when published, incorporated 308 views which he again engraved in exquisitely refined aquatint. An equally refined sensibility is apparent in his oil paintings, which bring both elegance and drama to topographical subjects gleaned from his travels across the world.

David Cox (1783–1859) was also primarily a watercolourist, but he too exemplifies the fertile liaison between watercolour and oil painting in this period. His paintings in oil date mostly from the last two decades of his life. He might be seen as a follower of Constable, so thoroughgoing is his dedication to wind and weather, and his ability to capture the breezy fluctuations of climate on paper or canvas. *Flying the Kite— a Windy Day* exists in both oil (1851) and watercolour (1853), each equally fresh and spontaneous. His later studies in North Wales, which may be rapid charcoal outline sketches, watercolours or oil paintings, achieve an astonishing atmospheric freedom. In his oil of

98. David Cox, *Rhyll Sands*, c.1854
Cox was highly innovative, and his later work has become almost synonymous with airy freshness of effect: as one admirer said, 'How fond you are of painting *wind*, Mr Cox! There is always a breeze in *your* pictures! I declare I shall take cold, and must put on my shawl!' He took up oil painting (as here) relatively late in his career, but, like Turner, developed a technique inspired by his watercolour experiments.

97. John Sell Cotman, *The Drop Gate, Duncombe Park*, 1805
Cotman's visits to Yorkshire as a drawing master from 1803 to 1805 resulted in a long sequence of watercolours, 'colouring from Nature,' as he said, 'close studies of that fic[k]le Dame, consequently valuable on that account'. 'Leave out, but add nothing,' he advised his son and pupil Miles Edmund.

Rhyll Sands (*c.* 1854) subject matter seems abolished in favour of a general impression of light and air. 98

These works of Cox's maturity and old age retained the esteem of collectors, although their breadth was quite at odds with the increasing popularity of minute finish. The whole period is characterized by the opposition of the technical audacity of the artists who sought, like Constable, to capture the fleeting effects of evanescent nature, and of those who wished to present reality in all its concrete specificity. Turner's pre-eminence is perhaps attributable to his simultaneous accomplishment of both these goals. It is at its most striking in the watercolours he made for engraving in the series *Picturesque* 99 *Views in England and Wales*, published between 1826 and 1838. These all-embracing panoramas brought together a transcendental topography and the modern reality of ordinary folk subsisting as best they can in an all-too-real world of toil and tempest.

The desire for descriptive precision manifested itself in a new fashion for detailed narrative, with accurately costumed figures and lively characterization. This was very much a bourgeois variant of the heroic dramas of sublime history painting, and it drew its inspiration from the 17th-century Dutch.

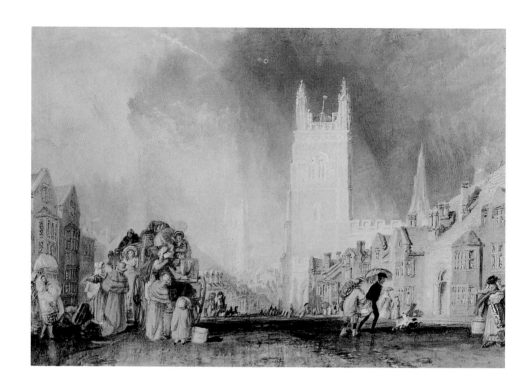

99. **J. M. W. Turner**, *Stamford, Lincolnshire, c.* 1828
Turner worked on the *Picturesque Views in England and Wales* from 1825 until the late 1830s, producing over a hundred subjects, though the project was never finished. It is concerned with the conditions in which ordinary people live their lives. Here, at Stamford, a staging post on the Great North Road, passengers are getting out of the mail coach and hurrying to the inn across the road to avoid a downpour.

The first great exponent of this genre was a Scot, David Wilkie (1785–1841), who astonished London as a young man in 1806, when he showed his *Village Politicians* at the Academy. An elabo- 100 rately finished and comical scene of rustic life, it was a clever revival of the kind of subject associated with artists like Jan Steen and Isaak van Ostade. Even Turner was struck by it, and painted a 'riposte' in 1807: *A Country Blacksmith Disputing upon the Price of Iron.* Wilkie went on to paint many more such subjects, his work becoming subtler, less overtly comic. It was founded on a skill in drawing that had been rare among British artists in the 18th century. Now, thanks to the standards passed on by the Academy, fine draughtsmanship becomes much more a matter of course, and there is a discernible increase in the level of sheer professionalism among painters. Technical virtuosity is a central quality of the arts of the Romantic period: a physical manifestation of creative genius.

Wilkie's genre subjects set the mood of the period. *Chelsea* 101 *Pensioners receiving the News of Waterloo* (1822), commissioned by the Duke of Wellington, is a defining masterpiece of Romanticism. It crowds together a mass of characters typical of

the moment, of London, and of England, commemorating one of the great moments in modern British history as it affected ordinary men and women. Gone is the bombast of Neo-classical painting, with gods and heroes battling for the crown of honour. The man in the street is the protagonist, the bustle of the every-day contemporary world a proper setting. This is a return to the scenes Hogarth painted, and it sets the stage for the novels of Dickens. In the 1820s Wilkie visited Spain, and the art of Velásquez and Murillo radically changed his style. His handling broadened to become more overtly virtuoso, the scale of his figures increased, and he often painted Spanish subjects, modern or historical. Just before his death he visited Turkey, Egypt and the Holy Land. All these places were to be important goals for artists in the coming decades.

Portraiture was equally the vehicle for new technical, or pyrotechnical, skills. Henry Raeburn (1756–1823) and Thomas Lawrence (1769–1830) reinvented the Reynoldsian portrait with lavish displays of scintillating brushwork. Raeburn was

100. **Sir David Wilkie**, *Village Politicians. Vide Scotland's Skaith*, 1806

on pp. 136–37
101. **Sir David Wilkie**, *Chelsea Pensioners receiving the London Gazette Extraordinary of Thursday, June 22d. 1815, announcing the Battle of Waterloo!!!*, 1822

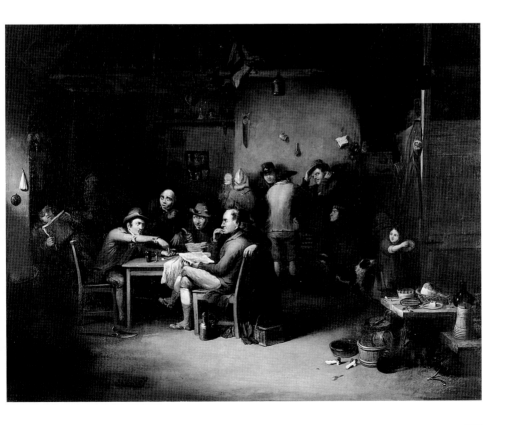

trained in Edinburgh, and an adept at portraying the sober Edinburgh temperament in both his male and his female sitters. Nonetheless, he painted with an almost libertine freedom of handling, as in his masterly likeness of *Lord Newton* (*c.* 1806), where the solid monumentality of a legal dignitary is achieved with the most economical use of boldly applied paint.

Raeburn was especially fired by the eccentric characters of his Highland sitters, often Catholics, who were less strait-laced than the Protestant Lowlanders, and happy to don a kilt or a plaid for a sitting. *Alasdair Macdonell of Glengarry* (1812) uses Highland costume and theatrical lighting to create a full-blooded Romantic image of a civilized North Briton who seems to pose as the type of the Noble Savage. Portraits like this provided models for Wilkie when he came to paint George IV on his visit to Scotland in 1822, dressed in the Highland fancy dress that Sir Walter Scott, master of the ceremonies, had devised for him.

Lawrence is perhaps the portrait painter who most completely embodies the idea of Romantic virtuosity. He began

102. **Sir Henry Raeburn**,
Lord Newton, c. 1806
Lord Newton (1740–1811) was one of the worthies of Edinburgh in the cultural heyday of 'the Athens of the north'. He was created a Lord of Session in 1806, and Raeburn celebrated his elevation with a bold simplification of palette and handling that marries the dynamism of the imposing public figure with a fine Scottish sobriety.

103

his career in story-book style, sketching visitors to his father's inn near Bristol, already proficient as a pastellist in his early teens. He matured into a handsome, personable man, at ease, as portrait-painters must be, in the best society. By the age of eighteen he was showing work at the Academy, and in 1789 painted Lord and Lady Cremorne as whole-lengths in oils. These earned him a commission to paint Queen Charlotte, whom he portrayed with brilliant panache as a homely lady seated comfortably but with immense natural dignity before a view from Windsor Castle towards Eton College. The effect is a compromise between the Reynoldsian grand style and the frank humanity of Hogarth's *Captain Coram* – a daring coup for a nineteen-year-old. It is a measure of the picture's originality that the Queen took exception to it. Notwithstanding, it was shown at the Academy in 1790, Lawrence was elected A.R.A. the following year, and made Painter-in-Ordinary to the King in 1792.

47

His meteoric rise was only fitting: his draughtsmanship is superb, his portrait heads in chalks exquisite. As for his brush-

103. **Sir Thomas Lawrence,**
Queen Charlotte, 1789

104. **Sir Thomas Lawrence,**
Count Platov, 1814
Platov distinguished himself as the Cossack commander who led the pursuit of Napoleon's army during its retreat from Moscow in 1812. As the Wars drew to an end a commemoration was planned for which Lawrence was asked to paint the portraits of the leaders of the Allies and other key figures. His presentation of the military personalities takes Reynolds's heroic romanticism (ill. 56) to a climax of dignified and glamorous drama.

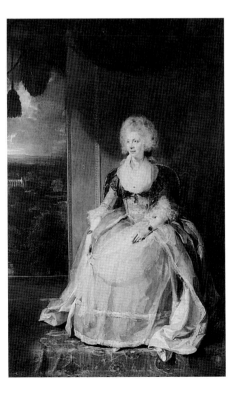

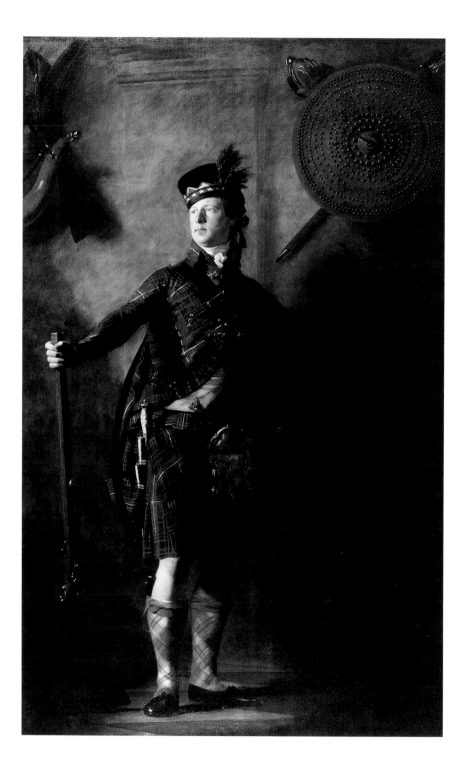

work, it astonishes. He sweeps broad ribbons of sharp impasto, white or black, on to the canvas to clothe sitters who are fully realized in glowing flesh, their eyes flashing brilliant glances. His large 'half-histories', of the actor John Philip Kemble as Hamlet, Coriolanus and other theatrical heroes, are avowedly Romantic, and his stormy whole-lengths of the leaders of the 104 allied armies, which hang today in the Waterloo Chamber at Windsor Castle, are hardly less so. This prestigious commission included a portrait of the Pope, Pius VII (1819), immensely dignified and one of his most penetrating likenesses. By the late 1810s Lawrence was perhaps the most influential portrait painter in Europe, imitated widely. Some of his most inventive pictures result from the challenge to present a group – families including adults and children are especially rewarding, with 106 intricate compositions created from ingeniously varied poses and subtly interrelated figures. He became President of the Academy in 1820, the year George, Prince Regent, came to the

105. **Sir Henry Raeburn**, *Alasdair Mcdonnell of Glengarry*, 1812
Alasdair Mcdonnell of Glengarry (1771–1828) was one of the most colourful of the Highland chieftains. Raeburn shows him proudly wearing the tartan of his own Glengarry militia, of which he was colonel. He lived picturesquely in feudal style, and was a fierce partisan in the quarrels of the clan (a branch of the Macdonalds).

106. **Sir Thomas Lawrence**, *The Children of Sir John Julius Angerstein*, 1796
Angerstein was an assiduous patron of British artists. He commissioned several portraits from Lawrence. This one, featuring no adults but only small children, illustrates the artist's ability to construct a grand subject from unlikely material – a lesson he had learned from Reynolds. His effects are his own, however: ingenious lighting and a diffuse design in which the figures are flung apart rather than being woven together.

107. **Richard Parkes Bonington**, *Henry III of France*, 1828
Like his friend Delacroix, Bonington was interested in historical costume and armour, and enjoyed inventing subjects in which these could be deployed in a rich mixture of romance and wit. His figure subjects are sometimes pure inventions, but often, like this one, show informal moments in the lives of the French kings.

throne, and died in the same year as the King, whose public image he was largely responsible for creating in a series of brilliant state portraits.

A virtuoso who flashed meteor-like across the heavens of George IV's reign is Richard Parkes Bonington (1802–28). Even more than Lawrence he is mainly memorable as an inspired performer, someone who could simply put the paint on with luscious ease and expressive immediacy. His little pictures of sun-drenched coastal scenes or buildings in northern France – his short career was spent mostly in Paris, with a trip to Venice in 1826 – are nominally 'topographical', appealing to an interest in particular places and picturesque antiquities. But really they are objects with their own intrinsic justification as dazzling exercises of the brush. Unlike his French colleague Eugène Delacroix, he didn't feel the urge to sing the praises of the heroic modern Greeks in their struggle for independence, but he enjoyed painting small historical subjects for their richness of colour and charm of costume. Delacroix valued his friendship: 'there is much to be gained in the company of this fellow, and

I assure you I have made the most of it', he wrote. 'Le bonington-isme' became an influential international style.

Bonington's compositions are often little more than a low 109 horizon articulated by a feathery tree below a pile of creamy cloud, or a choppy sea buoying up carefully spaced fishing-boats: a structural clarity derived from the Neo-classical landscapists of the foregoing decades. He could achieve his airy effects equally brilliantly in watercolour, which lent itself to simplification, to the reduction of a subject to bold, unified masses that could be expressed in a single wash.

William Etty (1787–1849) made his distinctive contri-bution in the virtuoso depiction of the nude. His approach is overtly sensuous, as opposed to the Neo-classically chaste manner usual among British artists. He modelled his technique specifically on Rubens, his colouring on Titian. And his ability to evoke those masters earned him special respect. His *Parting of Hero and Leander* (1827) may have influenced Turner's 108 choice of the same subject a few years later.

The need to emulate the old masters, bequeathed by the pre-cepts of Reynolds, hung like a weight round the necks of this generation. We have seen how Turner dealt with the challenge.

108. **William Etty**, *The Parting of Hero and Leander*, 1827

109. **Richard Parkes Bonington,** *Versailles,* c.1826

Benjamin Robert Haydon (1786–1846) would hire a room and exhibit a single masterpiece – *Christ's Entry into Jerusalem* (1822), for instance, contained a whole gallery of portraits of his friends (including Keats and Wordsworth), and embodied months of frenzied labour, which he described with passion in his very readable *Journals.* But the public preferred the thrills of the diorama and panorama, and Haydon, disillusioned, cut his throat.

Several panoramas were set up in London, purveying often sensational subject matter on a grand scale. We have seen Girtin trying his hand at one. The 360-degree panorama was invented (and the word coined) in the 1780s by Robert Barker (1739–1806), who believed that it was 'an Improvement on Painting, which relieves that sublime Art from a restraint it has ever laboured under'. Many panoramas were fantastical – a view of Pandemonium, for instance, from Milton's *Paradise Lost.* Even topography was often sensational: in 1827 the Scots topographer David Roberts (1796–1864) with the marine artist Clarkson Stanfield (1793–1867), both of them experienced

theatrical scene-painters, produced a panorama of *The Battle of Navarino* that they intended for exhibition on the Continent. The desire to present paintings in dramatically effective ways led artists to hire rooms in which to display large single pictures depicting historical events. The room was darkened and the canvas ingeniously lit so that visitors had the impression that they were witnessing some *tableau vivant*.

James Ward (1769–1859) never painted a panorama, but like Haydon aspired to work in the grandest dimensions. He specialized in animal and landscape subjects, following his hero Rubens in scale and technique, though his work has a hardness that counteracts the energetic fluidity he sought to emulate in the Flemish master. His ambitions are summed up in a colossal canvas – measuring 10 feet 11 inches × 13 feet 10 inches (over 3 × 4 metres) – of *Gordale Scar* (1815), which takes Sublime theory quite literally and presents a naturally grand subject on a huge scale so that we seem to be incorporated into the space encompassed by the beetling cliffs. The aesthetic of the panorama is applied to easel painting – a development that was to be taken up in America in the ensuing decades.

As a purveyor of grandiose subjects, John Martin (1789–1854) was far more successful, perhaps because he didn't insist

113

110

110. **John Martin**, *Joshua commanding the Sun to Stand Still*, 1816
Martin painted picturesque landscape subjects in oil and watercolour, but from 1812 on enjoyed a reputation as the most sensational of the 'apocalypse' painters. He frequently invoked Biblical accounts of natural commotions, such as the story of Joshua using his priestly powers to intervene in the normal processes of the cosmos.

on the intellectual pretensions of his work, but played
unashamedly to the gallery. He also caught a contemporary
mood, a sense of impending doom that had grown up during the
Napoleonic wars and remained long into the ensuing peace, with
its industrial unrest in town and country, and radical political
change, epitomized by the great Reform Bill of 1832. Martin was
a Millenarian, convinced of the imminent end of the world.
Many of his pictures reflect that foreboding. His first appearance
at the Academy, with a work entitled *Sadak in search of the Waters
of Oblivion*, coincided with Turner's hardly less apocalyptic
Hannibal crossing the Alps, in 1812. Martin went on to portray the
Destruction of Jerusalem, the *Destruction of Pompeii and
Herculaneum*, and eventually the destruction of everything, in a
trio of huge canvases: *The Great Day of His Wrath*, with its sequel
The Day of Judgment, and a serene aftermath in *The Plains of
Heaven* (1851–53).

The religious intensity that fuels Martin's eccentric genius
crops up often at this time. Francis Danby (1793–1861) essayed
apocalyptic subjects too, though with a surer grasp of technique
and a stress less on melodrama than on dramatic effects of light.
More unusual than his Deluges and Apocalypses is *The Upas*,

or *Poison-Tree, in the Island of Java* (1820), one of the most extraordinary visions of bleak desolation in Romantic art. When not painting such glimpses of horror he made a speciality of tender sunset effects, and much of his work is altogether more modestly poetical. Born in Ireland near Cork, he spent the years from 1817 to 1824 in Bristol, and painted exquisite little scenes of picnics or children playing in the woods round the Avon Gorge. Subjects and handling alike seem close to the neat paintings of the German Biedermeier, a feeling reinforced by a more substantial picture, *Disappointed Love* (1821), which, with its single weeping figure surrounded by gloomy woods, reiterates a classic image of German Romantic fiction and music.

111

112

If Martin's preoccupations seem a touch naïve, there is naivety of a subtler order in the work of Samuel Palmer (1805–81). In Palmer's early drawings we can clearly see his admiration of Blake, and especially of Blake's wood-engravings for Robert Thornton's school edition of Virgil's *Eclogues*: 'visions of little nooks, and dells, and corners of Paradise; models of the exquisitest pitch of intense poetry' Palmer called them. He aimed at intense poetry in his own delineations of the English

114

112. **Francis Danby**, *Disappointed Love*, 1821
The immediacy of emotion in this picture was appreciated even by contemporaries who found it technically unsatisfactory. 'It was a queer-coloured landscape, and a strange doldrum figure of a girl . . . leaning over a dingy duck-weed pool. Over the stagnant smeary green, lay scattered the fragments of a letter than she had torn to pieces, and she seemed considering whether she should plump herself in after it . . . [but] There was more touching invention in that daub than in nine-tenths of the best pictures exhibited . . .'

113. **James Ward**, *Gordale Scar (A View of Gordale in the Manor of East Malham in Craven, Yorkshire, the Property of Lord Ribblesdale)*, 1815
The scenery of Yorkshire had been admired for its sublimity since the mid-18th century. Ward, inspired no doubt by the current rage for panoramas, chose to paint the great limestone cliff at Gordale on a scale unprecedented in pure landscape, that would place the subject on the same 'sublime' level as history painting.

countryside, first in the vale of Dulwich in the mid-1820s, and shortly afterwards in the Kent village of Shoreham, where he settled for some years. The 'gothic' naivety of his earliest work is a deliberately childlike invocation of innocence in the very method of describing nature. After 1828, in Shoreham, among his friends 'the Ancients', he forsook the black wash with which he had imitated Blake's illustrations, and worked in oil, watercolour, or thick, impasted gouache. He bent all these media to his purpose of conveying the richness, both spiritual and economic, of the agricultural landscape around him.

Among his fellow Ancients were George Richmond (1809–96), another devotee of Blake's, who went on to become a fashionable portrait painter, and John Linnell (1792–1882), whose small watercolour studies of landscape have something of Palmer's intensity, something of the fresh directness of Constable. While oil painting always occupied a subsidiary place in Palmer's output, it became important for Linnell, who executed many landscapes in oil, carrying on the tradition of Blakean inspiration, though on a more ambitious scale and with some corresponding loss in intensity. Palmer, meanwhile, went

114. **Samuel Palmer**, *Late Twilight*, 1825–27 Palmer associated his intense experience of nature with religious revelation or ecstasy: he wrote to George Richmond in 1827: 'I have beheld as in the spirit, such nooks, caught such glimpses of the perfumed and enchanted twilight – of natural midsummer . . .'

to Italy in the late 1830s and transferred his special allegiance from Blake to a different sort of visionary, Turner. His later work continues the search for spiritual intensity in elaborate pastoral subjects taken from Milton. They blend various media – ink, watercolour, gouache – in dense, complex images suffused with rich colour and golden light. Palmer often reproduced these as etchings.

William Mulready (1786–1863), the son of poor Irish Catholics, began as a landscape painter and worked in the circle of Linnell, preoccupied with the observation of nature at close range. He was an excellent figure draughtsman, and gravitated to genre painting, after the fashion set by Wilkie. His closely focused subjects are presented matter-of-factly, but are distinguished by a characteristic softness of touch that infuses them with a poignant tenderness.

The ambitions of this generation of figure painters are embodied in the career of Charles Lock Eastlake (1793–1865), who began by painting Neo-classical subjects like *The Spartan Isadas* (1827) or scenes from medieval history, and went on to become President of the Royal Academy and Director of the National Gallery. This signalled an important development. Artists had been campaigning for a properly housed national collection for years, and when in 1824 the government bought the fine group of Old Masters belonging to Angerstein, to which the redoubtable connoisseur and critic Sir George Beaumont added his own pictures, that collection at last acquired a core.

It was some years before a suitable building could be erected, and the present one, built on the site of the old Royal Stables, was opened in 1838. Beaumont had owned a few British masters, and even one very modern painting, Wilkie's *The Blind Fiddler* (1806), but these hardly did justice to the national school. However, in 1847 the National Gallery's holdings were augmented when Robert Vernon presented his wide-ranging collection of modern British art to the nation. Gainsborough, Constable, Turner, Bonington, Wilkie, Etty and many others were represented. True, the new Gallery had no room to display these valued acquisitions; but at last the aspirations of British artists to be recognized as a school worthy of a place beside the great Continental masters had been in some sense realized.

Chapter 6 Middle-Class Moralities: 1840–1860

The expansion of Britain's industrial economy in the early 19th century was accompanied by political reforms and the beginnings of change in the social structure. The population was increasingly concentrated in the towns, with a steady loss of contact with a traditional rural way of life. Two practical advances brought Britain into the modern age, the first country on earth to enter the baffling yet thrilling epoch that Turner hailed in his *Rain, Steam, and Speed.* The building of the railways abolished distance and suddenly made time, synchronized in far-flung places, crucially important. Later in the century, the gradual introduction of mains drainage was to lead to the conquest of epidemic cholera.

The difference between town and country was now polarized into a series of sharp contrasts, bringing new attitudes to both, and as a corollary, new attitudes to the purposes served by art. The middle-class collector of pictures has made his appearance already. His interests were not those of the aristocrat: if he wanted portraits, they must display not his ability to spend money but his qualifications for high responsibility in the global empire that Britain now governed.

The sense of Britain's world importance was embodied in two great enterprises of the middle decades of the century. One was the great International Exhibition in the Crystal Palace in London, opened by Queen Victoria in 1851 – the first World's Fair. The products of Britain and her extensive dominions were displayed for visitors from all over the globe to see. The other was the new building for the Houses of Parliament, which rose from the ashes of the old (destroyed by fire in 1834) during the 1840s, to designs by Charles Barry and A. W. N. Pugin. Pugin preached the absolute superiority of Gothic architecture to all other building styles, covering Barry's four-square, responsible blocks beside the Thames with teeming Gothic ornament. Inside, the walls were to be decorated with paintings celebrating the history and greatness of Britain: artists were invited to submit designs. Haydon of course did, and of course failed. More successful were younger artists like the Irishman Daniel Maclise

115. **William Dyce**, *Religion: the Vision of Sir Galahad and his Company*, fresco in the Queen's Robing Room in the Palace of Westminster, London, 1851–52

(1806–70) from Cork, and his exact Scottish contemporary William Dyce (1806–64) from Aberdeen.

115

Both exemplified the style now in vogue, heavily indebted to current German fashions. This is not surprising, given that the Queen's Consort, Prince Albert of Saxe-Coburg, wielded huge influence in matters of public taste, and had been appointed chairman of a commission to superintend the work at Westminster. And in 1841, the year after Victoria's marriage to Albert, the German painter Peter von Cornelius visited London. He had overseen the decoration of the Residenz in Munich and would shortly undertake a similar task in Berlin. His views carried enormous weight. Dyce had worked with German painters while he was in Rome, absorbing the ideas of the Nazarenes, who drew and painted with deliberate simplicity and clarity, imitating Perugino and Raphael. This is the manner of Dyce's pictures of the 1830s and '40s. But when he was lured to London from his portrait practice in Edinburgh his work for the decoration of the House of Lords put his Italian Renaissance principles to a stringent test.

He strongly supported the notion, encouraged by Cornelius, that fresco was the ideal medium for the murals, and went abroad to study the technique, whereby pigments are painted on to wet plaster, so that they become permanent. Few artists had attempted it in the damp conditions of England. The Bath painter Thomas Barker (1767–1847) had essayed an ambitious *Massacre of the Sciotes* on the wall of his home in 1824; but that was a flash in the pan. Given the absence of any fresco tradition, Dyce emerges covered in glory. His German models gave him the required directness of approach, and his experience in painting simply and modestly ensured that his murals are not overblown or unduly rhetorical: they have a sincerity and grace unmatched by any other Westminster painters. *Sir Galahad, or the Spirit of Religion* (1851–52), in the Queen's Robing Room, shows how intelligently he could play with prototypes drawn from Raphael, blending medieval chivalry with ideas culled, ambitiously, from the *Disputà*, the *Transfiguration* and the Mortlake tapestry cartoons.

Maclise's style also is very Germanic, but tends to the glossy. He was a virtuoso draughtsman, and could organize large figure compositions with ease. When he followed Dyce's Nazarene principles, in such subjects as *The Spirit of Justice*, he produced powerful work, lacking Dyce's refinement. His later projects at Westminster, dealing with more modern subjects – *The Death of Nelson* and *Wellington's Meeting with Blücher* – are impressive for their mastery of complex compositions involving many figures, but have suffered from technical problems. Indeed, the whole Westminster project was jinxed: either the artists could not master the methods of fresco painting, or the climate damaged their work. Dyce saw the difficulties, and despite his remarkable successes returned to easel painting, which he pursued until his death.

A similar preoccupation with lucid drawing distinguishes the work of the animal painter Edwin Landseer (1802–73). 116 Landseer didn't contribute to the Westminster scheme but was taken up with enthusiasm by the Queen and Prince Albert. They delighted in his brilliantly observed studies of their favourite dogs and horses and enjoyed the way he could endow an animal with human qualities, placing it in some situation where expression and attitude took on comic or pathetic significance. *The Old Shepherd's Chief Mourner* (1837), showing a sheep-dog beside a coffin in a humble cottage, attracted the praise of Ruskin for its feeling sympathy with animal ways, but many of Landseer's

subjects are either droll or gruesome. There was a wild, unhinged streak in him that revelled in the horrors of Tennyson's 'nature red in tooth and claw', and in the grimmer details of blood sports. In 1848 Victoria and Albert acquired their retreat at Balmoral, and the Highlands, already popular on account of Scott's novels and poems, became a fashionable resort. Landseer had painted Scottish scenes, brilliant little oil studies of mountain landscape and sporting subjects, since 1827, when he exhibited *Highlanders returning from Deer Stalking*. The grand Scottish scenery combined with sport appealed to a large new market, and now the railways brought Scotland close to London, so that it became a holiday retreat from the cares of office, of industry or commerce. Stag hunting supplied Landseer with subjects until the end of his life.

Landseer sometimes painted Victoria and Albert themselves, but their preferred portraitist was Franz Xaver Winterhalter (1803–73). Trained in Munich, he had painted most of the royalties of the Continent, and was the right person to record these two who were, after all, the first couple in

116. **Sir Edwin Landseer**, *Windsor Castle in Modern Times*, 1841–45

Landseer presents the Queen and her consort, Albert, informally as a couple relaxing at Windsor among their numerous pets, with one of their nine children. His skill in portraying the individual characters of the animals was especially admired, and he creates an image of royal domesticity that makes a fascinating contrast with Van Dyck's (ill. 22).

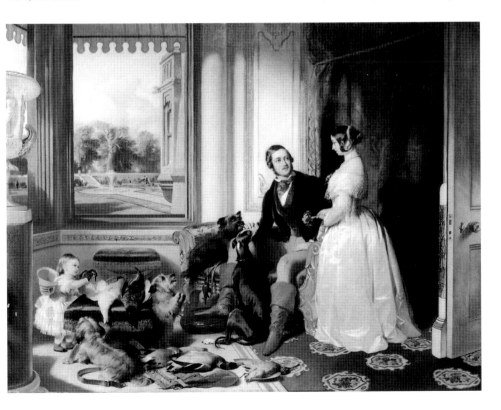

117. **Ford Madox Brown**, *Work*, 1852–63

Work was Madox Brown's most important exercise in the high Pre-Raphaelite manner. For one reviewer, it implied 'not only the man of technical ability, but the man of mind . . . "Work" is simply the most truthfully pathetic, and yet the least sentimental, rendering of the dominant aspect of English life that any of our painters have given us.' Biblical texts on the frame all relate to work and its central place in life.

Europe. He could invest them with proper grandeur, and could imbue everything he painted with an easy elegance. But with his German training he did all this with due regard for surface: there is a middle-class gloss to his canvases that accorded with Albert's preferences, and exactly suited Victoria, presiding over a nation dominated by a thrusting new middle class.

As the Great Exhibition was designed to show, this was pre-eminently an age of new wealth. The newly rich continued to favour pictures that were realistic rather than conceptual. Not surprisingly, the most revolutionary development of the mid-century was more to do with the descriptive qualities of painting than with its power to stimulate thought. Indeed, the conceptual

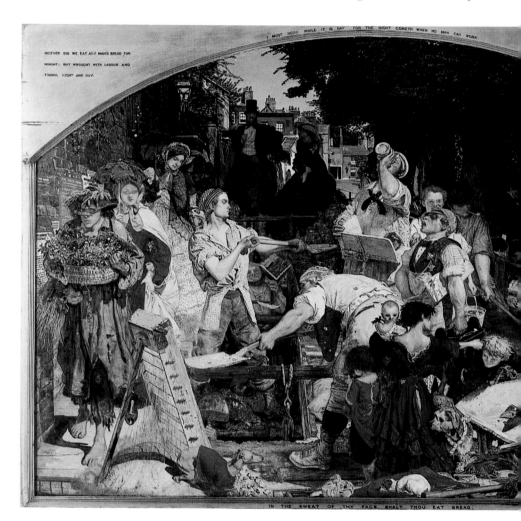

tradition had long ago decayed, despite the efforts of the Westminster Commissioners. In conscious rejection of that tradition, a group of young artists met in 1848 to form an English version of the Nazarenes, calling themselves the Pre-Raphaelite Brotherhood. If anything, the PRB were more radical than the Germans, for they rejected the Renaissance art of Raphael himself, and sought a more inspired simplicity in the painting of the late Middle Ages.

There were seven PRBs in all, including a sculptor. Three are important. William Holman Hunt (1827–1910), pious and bookish, was much impressed by a reading of Ruskin's *Modern Painters*, which came out in five magisterial volumes between 1843 and 1859, and expanded from its initial defence of Turner into a sweeping condemnation of post-Renaissance painting, and especially of landscape painting from Claude onward. Where the 18th century had found Claude insufficiently generalized, Ruskin criticized him for his lack of fidelity to nature. The conscientious artist must 'go to nature . . . rejecting nothing, selecting nothing, and scorning nothing', he wrote. But these studies, he insisted, were 'referred to a great end, – sought for the sake of the inestimable beauty which exists in the slightest and least of God's works'. The second PRB, John Everett Millais (1829–96), tall, handsome and precociously gifted, was impressed by some outline engravings of the frescoes in the Campo Santo at Pisa. The third, Dante Gabriel Rossetti (1828–82), was the passionate dreamer of the group, obsessed by the life and writings of his namesake Dante Alighieri in 13th-century Florence.

Rossetti was an admirer of the Nazarenes, whom he thought of as working in an 'Early English' style, and another student of the Nazarenes, Ford Madox Brown (1821–93), became closely associated with the Brotherhood from the first, though he was never formally a member. He brought to the group a formidable creative intelligence and wide-ranging experience: he had trained in Belgium under a latter-day Rubens, Baron Wappers, and had studied with the Germans in Rome. After settling in London in 1844, he designed cartoons for the Palace of Westminster competition.

There was, from the start, a confusing dualism in the Pre-Raphaelite movement. While it announced the technical virtues of medieval art and the romantic appeal of medieval history, its aim to abolish the obfuscations of Academic history painting implied a commitment to explicitly modern subject matter.

117

Much of the most characteristic Pre-Raphaelite work is indeed about modern life. Madox Brown's *Work* (1852–63) gives a comprehensive survey of contemporary London society, a Victorian equivalent of one of Hogarth's modern moralities presenting town life with all the sharp critical energy of a passage from Dickens. It is a far from complacent view: Thomas Carlyle, who had inveighed against the commercialism and exploitation of modern capitalism in his *Past and Present* (1843), stands watching the crowded scene. Yet Carlyle's prophetic rage against the modern world is balanced by the artist's delight in observed humanity, his idiosyncratic vision of things – the sleeping day-labourers half-glimpsed below the railing, the tussle between the ragamuffin children in the foreground. The brilliant, saturated colour is 'the effect of hot July sunlight', chosen, as Madox Brown said, 'because it seems peculiarly fitted to display work in all its severity'.

That comprehensive humanity is the true morality of the picture. But there is also some straightforward, very Victorian moralizing. The picture's purchaser complained that there was not enough morality in it, and at his instigation Madox Brown inserted the young woman giving away religious tracts on 'The Hodman's Haven, or Drink for Thirsty Souls'. A sardonic embodiment of the image is a labourer lustily draining a pot of beer. Carlyle and his friend the Christian Socialist F. D. Maurice, looking on at the right, are 'brain-workers', essential to the completeness of Brown's survey. The picture announces the new state of labour in England, what had been achieved by the Industrial Revolution, the very antipodes of the rural toil that Constable had celebrated at Flatford Mill.

Recognizably in the same genre is Holman Hunt's *The Awakening Conscience* (1853–54), in which a young woman is made suddenly aware of the futility of her life as the kept mistress of an indolent, dissolute young man. Here too we seem to be watching enacted a scene from a novel. Again, there is overt moralizing; but it is not superimposed arbitrarily, rather felt as a vigorous and necessary element of the human drama represented. Each detail of the banal suburban scene is recorded as clearly as if in a nightmare: the claustrophobic colours and patterns of the cluttered interior, the French clock with an ormolu allegory of Chastity binding Cupid, the predatory cat under the table, the tangled silks. The bright garden reflected in the mirror has been seen as a glimpse of the woman's lost innocence. It is also, surely, a promise of redemption, a light towards

118. **William Holman Hunt**, *The Awakening Conscience*, 1853–54 Hunt used a Biblical quotation on the frame of this work: 'As he that taketh away a garment in cold weather so is he that singeth songs to a heavy heart' (Proverbs 25:20).

which she turns as she sees the folly of her position. Hunt had proposed 'A Still Small Voice' as title for his picture, and by accumulating detail upon detail he builds up a psychological picture that vividly evokes the elusive faculty of conscience.

But if some of the most vigorous productions of Pre-Raphaelitism sprang from its concern for the moral issues of modern life, the late medieval inspiration of the movement led to the realization of many historical subjects. Here, too, intense realism brings what might otherwise be merely whimsical or illustrative to piercingly relevant life. Millais produced at least one Biblical subject, *Christ in the House of His Parents* (1849–50), whose audacious realism was deemed blasphemous by a scandalized public. Holman Hunt's *The Scapegoat* (1855) presents a powerful symbol of the outcast and vilified Christ which also comments on the ostracism faced by the truthful artist. He

121

119

travelled to Palestine to paint the landscape background with as much fidelity as possible. The startling aspect of these works was not their moralizing; it was the searing directness with which they were painted. Rossetti's *Ecce Ancilla Domini!* (1849–50) is perhaps too mannered to be counted realist, but its austere concentration on a stark image of the terrified Virgin in a bare room confronted by an almost flesh-and-blood angel still looks startlingly modern today.

The Ruskinian objective of painting every detail of the world exactly as the eye sees it gripped Hunt and Millais like an ideology. They would spend hours in the woods and fields, rendering the drops of dew on every last blade of grass. When he was painting his *Ophelia* (1851–52), Millais sat by a Surrey stream over a period of nearly five months, in conditions of discomfort that, he claimed, 'would be a greater punishment to a murderer than hanging'. He made his model climb into a bath so that he could correctly render her appearance half submerged. The model caught a severe cold. She was Elizabeth Siddal (1834–62), who later married Rossetti and had some distinction as an artist in her own right.

Millais's method in painting the elaborate landscape background of *Ophelia* was one that came to be recognized as a Pre-Raphaelite trademark. His ground was dead white, the details painted directly onto it while it was still wet. The resulting clearness and transparency are very distinctive and were

119. **William Holman Hunt**, *The Scapegoat*, 1855
The scapegoat of the ancient Jews was cast out into the wilderness to 'bear upon him all their iniquities unto a land not inhabited' (Leviticus 16:22). Hunt recognized the parallel with the Christian Saviour 'despised and rejected of men', and decided to portray the goat in the wilderness landscape of the Dead Sea, carefully painted from life.

120. Dante Gabriel Rossetti,
Ecce Ancilla Domini!, 1849–50
Rossetti's revolutionary intentions are proclaimed in the tight composition of his treatment of a familiar religious subject. The Virgin, usually depicted reading, is instead huddled on a bed with no bedclothes 'which may be justified inconsideration of the hot climate' – an explanation no one would have thought necessary before; and the almost total whiteness of the scene symbolizes the Virgin's purity.

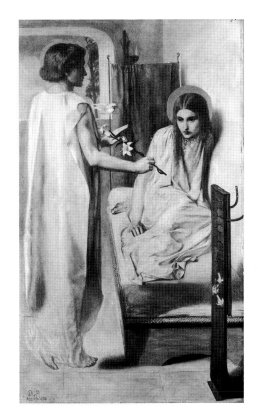

121. John Everett Millais,
Christ in the House of his Parents (The Carpenter's Shop), 1849–50
Millais here exploits the Pre-Raphaelites' commitment to authenticity by presenting a religious subject not, as Holman Hunt would do, by painting it in the Holy Land, but by making every detail true to its imagery. The carpenters' tools, drawn from life, act as symbols: the nail on which the boy Christ has hurt his hand prefigures the nails of his crucifixion, the dove on the ladder the descent of the Holy Ghost, the boy with the bowl of water St John the Baptist, and so on. The realism shocked contemporary audiences, and the stark immediacy of the image remains powerful today.

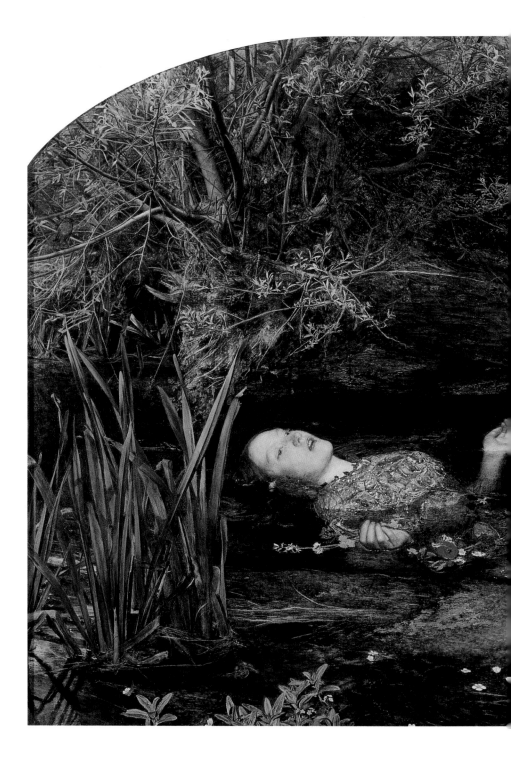

imitated by many young artists during the 1850s. The Pre-Raphaelites' use of brilliant, industrially produced pigments with preponderant sharp greens and aniline purples gives their pictures an almost shocking vividness. Their youthful intensity of gaze, their often irreverent imagination, make for an output of striking freshness. Millais in particular had a gift for catching the telling gesture, the glimpse of informal, unobserved behaviour that brings his characters to life: the young man kicking the greyhound as he cracks nuts in *Isabella* (1848–49); or *Mariana* (1851), stretching languidly in the boredom of her moated grange (the pictures illustrate Keats and Tennyson). Madox Brown, the most intellectually gifted of the group and in many ways the greatest artist among them, has a disturbing knack of seeing people obscured by the impedimenta of ordinary living: beyond barriers, half-hidden, unawares, or grimacing in ways that people being painted never normally do.

Intense as this flowering was, Pre-Raphaelitism was destined to last only a brief time. Ruskin declared it dead in 1854, and accused Millais of betraying its principles in 1858. Some of the group's members remained true to them, but Millais notoriously changed his manner and became a highly successful society portrait painter. By the end of the '50s, however, many other artists had experimented with the style. One of the first was Arthur Hughes (1832–1915), whose *April Love* (1855) and *Home from Sea* (1856–62) epitomize many of the leading qualities of Pre-Raphaelitism, especially the insistence on telling, often symbolic detail, and highly pitched colour. Another early follower was John Brett (1831–1902), who was also hugely impressed by Ruskin. To meet Ruskin's stringent requirements to the letter, Brett painted his landscape *Val d'Aosta* in 1858, only to be rebuffed by the great man for producing 'mirror's work, not nature's'. The confrontation was symptomatic of Ruskin's impatience with the very movements he set in train.

Pre-Raphaelite artists did not necessarily work only on a small scale. Occasionally they tackled ambitious cycles of pictures. William Bell Scott (1811–90) was an adherent who in the late 1850s painted a series of scenes of Northumberland history for a house in that county; and in later life Madox Brown created an impressive sequence of murals for Manchester's new Town Hall illustrating events in Mancunian history with vigour and originality (1878–93).

One of Ruskin's passions was geology, the study of the underlying structure of the earth we live on, the very core of

131

123

on pp. 162–63
122. **John Everett Millais**,
Ophelia, 1851–52
The popularity of Shakespeare as a source for paintings had not diminished since the heyday of Garrick and Boydell in the late 18th century (cf. ill. 80). Millais had exhibited a scene from *The Tempest* in 1850. As in *Christ in the House of his Parents* (ill. 120), he delights in assembling symbolic details, many of which are flowers listed by Ophelia herself in her mad scene (*Hamlet*, Act IV, scene 5).

any landscape. His own drawings, often beautifully washed with watercolour, place stress, as we would expect from the author of *Modern Painters*, on these finer points of scientific analysis, as they do also on architecture and plant-forms. Brett was very conscious of the geology of the Val d'Aosta, and had previously painted a view of *The Glacier of Rosenlaui* (1856) that is effectively a pure geological study. Dyce too, who was keenly interested in geology and astronomy, had seen the connection between his own aims and those of Pre-Raphaelitism, and painted his *Pegwell Bay, Kent – a Recollection of October 5th, 1858* (1859–60) as a landscape in which time is one of the dimensions. Donati's comet, first observed in 1858, streaks across the sky, reminding us of the vastness of the universe, while shell-gatherers in the foreground seem to allude to the infinite variety of natural forms, and stratified cliffs beyond suggest the aeons of geological time. The publication of Sir Charles Lyell's *Principles of*

124

123. **John Brett**, *Val d'Aosta*, 1858
Although Ruskin was dismissive of Brett's eager fidelity to his precepts, he had some praise for his efforts: 'standing before this picture is just as good as standing on that spot in the Val d'Aosta, so far as gaining of knowledge is concerned; and perhaps in some degree pleasanter, for it would be very hot on that rock to-day, and there would be a disagreeable smell of juniper plants growing on the slopes above.'

Geology (1833) had already demolished the traditional view that the earth is no more than four thousand years old. By the time *Pegwell Bay* was shown at the Royal Academy in 1860 Darwin's *Origin of Species* had appeared, demonstrating that all living creatures had evolved through many modifications during the uncounted ages of the earth's history.

Another aspect of modern science that apparently influenced Dyce in *Pegwell Bay* is photography. It had been developed almost simultaneously in France and England in the 1820s and 1830s, and by this date its remorseless new view of the world can occasionally be seen at work in the traditional visual arts. The cool objectivity of Dyce's picture, its unemphatic palette and undramatic composition, all seem to reflect photography. This way of presenting the world is noticeably different from that of the Pre-Raphaelites with their hectic colour and dense, moralizing narratives. Some artists had taken up photography, arranging objects as though they were painting them, or taking pictures of buildings in the spirit of the picturesque topographers. Others – Millais among them – used photographs of models instead of making drawings. The applications of the new medium were endless, and in the long run it would change

124. **William Dyce**, *Pegwell Bay, Kent – a Recollection of October 5th, 1858*, 1859–60
The shell-gatherers in the foreground, in front of the stratified chalk cliffs, are members of Dyce's family. At the zenith, Donati's comet marks a faint streak in the sky. The traditional Picturesque admiration for a general view of nature is replaced in the Victorian period by an earnest search for the scientific truth of the world around us.

the nature of painting decisively. At this stage, it harmonized perfectly with the fascination for precise detail that dominated the aesthetic of the period. Yet its most imaginative practitioners – noteworthy among them women like Julia Margaret Cameron and Clementina, Lady Hawarden – were already exploring the expressive and psychological potential of photography. To this extent they were bringing it into line with the higher goals of Pre-Raphaelitism.

Although the Pre-Raphaelite preoccupation with modern life was central to its credo, that was not, in the end, what endured of the movement. Given the dynamic of commercial, industrial and imperial Britain at the time, this is surprising. In the 1850s, at least, the market was avid for detailed renderings of the everyday world. The fashion for historical genre subjects that had flourished in the 1830s and 1840s lingered into the 1850s in forms that sometimes come close to Pre-Raphaelitism. The best instance is Augustus Leopold Egg (1816–63), who had been contributing *A Scene from Romeo and Juliet* and suchlike pictures to the Academy since the 1830s. In 1854 he painted a pair portraying *The Life and Death of Buckingham* with arresting immediacy and brilliancy of touch. In 1858 he showed that he could rival the Pre-Raphaelites in a searing modern subject. It comprises three separate canvases, now known as *Past and Present*, with a reminiscence of Carlyle's great polemic against modern life that is not inapposite. They tell the story of a prosperous middle-class man learning of his wife's adultery, and show her subsequent destitution. A contemporary critic found this 'terrible "London Trilogy" as tragic as any that ever held an Athenian theatre mute, though its actors wear coat and crinoline instead of peplum and chiton'.

The doyen of the modern genre painters was William Powell Frith (1819–1909). He made a speciality of large crowded subjects which, with less intellectual complexity than Madox Brown, explore the social spectrum and present it in anecdotal form. He had begun as a bit of a rebel, and in the later 1830s had belonged to a group of young artists calling themselves 'the Clique', rejecting the Academy and its ways. But by the late 1840s he had joined the Establishment, and the first of his big crowd scenes, *Life at the Seaside* (1854), showing Ramsgate Sands in holiday season, was bought from the Academy by the Queen. He followed it with *The Derby Day* (1858) and *Life at a Railway Station* (1862), a scene at Paddington that includes the apprehension of a felon by the police. Every face in the large crowd is

125

studied with care, each group an episode in a sprawling narrative of contemporary life and manners. It is their novelistic vitality that sustains these pictures, which, despite their lack of visual coherence, are wholly convincing on their own terms, and contain beautiful isolated passages of sheer painting.

Frith shows that a fascination with minute detail was not a purely Pre-Raphaelite concern. In so far as the PRB derived it from Ruskin's teachings, that was largely because Ruskin was, above all, the spokesman of the new culture. What he most admired in Turner – his truth to nature – was that which could be most readily assimilated by mid-19th-century society.

By the same token he admired the wonderfully lifelike grapes and bird-nests in the watercolours of William Henry Hunt (1790–1864) and the exquisitely detailed scenes of Middle-Eastern life in the work of John Frederick Lewis (1805–76). Lewis travelled to Spain and Egypt in the 1830s, settling in Cairo in 1841. His renderings of richly patterned oriental fabrics dappled by hot sunlight filtering through lacy Moorish screens have all the sensuousness that travellers to those exotic places sought and loved. Until the 1850s he rendered these complicated effects in watercolours which, though often large, are executed

125. **William Powell Frith**, *Life at a Railway Station*, 1862 In his scenes of modern life Frith transforms the traditional genre picture into a survey of contemporary manners. Here he presents a wide range of characters reacting to the imminent departure of the train: porters loading luggage onto the roof, a family seeing two boys off to school, a tycoon arguing over a tip with his cabbie, a wedding party seeing off the happy couple; and, at the extreme right, a police officer apprehending a forger just as he is about to board the train.

12

with the fine touches of a miniaturist. Ruskin was ecstatic about Lewis's accuracy of observation. He termed him 'the fourth Pre-Raphaelite' and enjoined his readers to 'take a magnifying glass' to the eyes of the camels in the *Frank Encampment in the Desert of Mount Sinai* (1856), where 'there is as much painting beneath their drooping fringes as would, with most painters, be thought enough for the whole head'. But although Ruskin could find it in him to admire Lewis's 'breadth' as well as all this detail, Lewis himself began to tire of the effort involved. By the end of the 1850s he had realized that watercolour and oil were effectively seeking the same results. He consequently decided to switch to oil: why continue 'to get by water-colour art 500 £ a year . . . when I know I could with less labour get my thousand'?

The artists who satisfied Ruskin with their 'completeness of finish, to the uttermost corners of the canvas' were, then, to some extent in a trap created by the conditions of the time. Their need to make money was at odds with their wish to comply with his demand for total conscientiousness. Artists completely free of economic constraints were perhaps better placed to portray a world teeming with minute incident. No one could have escaped more effectively from the hurly-burly of Victorian life than Richard Dadd (1817–86). He began as a member of the Clique, and something of a virtuoso in the current style of the 1830s. Then in 1843 he murdered his father, and was incarcerated in insane asylums for the rest of his life. He spent his time painting and drawing, producing many watercolours and a group of paintings as obsessively crammed with detail as any work by Frith or Millais. But instead of observing the world around him, they minutely record the life of his interior imagination, his fantasies peopled with fairies, goblins and elves, ogres and symbolical figures of all kinds.

Many other Victorians made fairyland the subject matter of their pictures, delighting in the inconsequential bustle of luminous little people in the dells of giant woods. Danby contributed significantly to the genre, as did the Scot Noel Paton (1821–1901), a friend of Millais's, whose overcrowded paintings illustrating Shakespeare's *A Midsummer Night's Dream* appealed greatly to another fantasist, Lewis Carroll.

The fairy painters, and especially Dadd, loaded their pictures with dense meanings, sometimes comic, sometimes not a little obscure. The modern genre painters, on the other hand, were content to let their subject matter speak for itself. The Pre-Raphaelites again sought a much denser conceptual texture.

127

A rich cumulative symbolism, like that of *The Awakening*
Conscience for instance, is overlaid with a specifically 19th-century feeling for allusion that is present in the illustrations to Dickens's novels made by George Cruikshank (1792–1878) and Hablot Knight Brown – 'Phiz' (1810–88). Once again, the proximity of painting to literature in the period is very apparent. Much of the intellectual strength of Pre-Raphaelite painting lies in the building up of layers of symbolic significance. It was precisely the symbolic content of Pre-Raphaelite art that was to have most impact on the next generation.

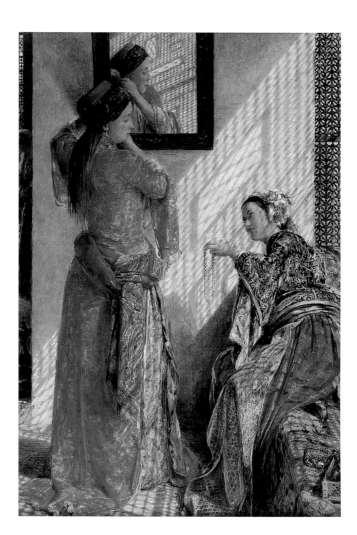

126. **John Frederick Lewis**,
Indoor Gossip (Hareem), Cairo,
1873
After his sojourn in the Middle East in the 1840s, Lewis was equipped with many elegant and detailed drawings of the characters, costumes and appurtenances of Levantine life. He drew on these for the rest of his career to produce a succession of handsome, intricately wrought works in which hot dappled light and cool interiors set the scene for quiet, intensely observed moments of exotic intimacy.

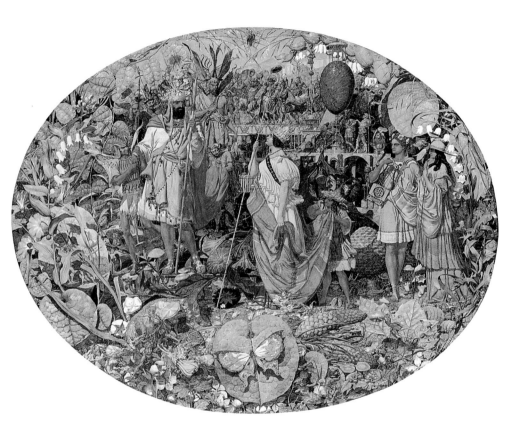

127. **Richard Dadd**, *The Contradiction. Oberon and Titania*,
1854–58
Taking the quarrel between Oberon and Titania in
Shakespeare's *A Midsummer Night's Dream* as his starting-
point, Dadd allows his imagination free reign to create a
complete fairy world populated with innumerable fantastic
characters, and fairies sporting among a multitude of
different plants. The subject was a popular one at the time,
and Dadd may well have chosen it deliberately
to challenge his contemporaries.

Chapter 7 The Apogee of Empire: 1860–1910

Rossetti was always the odd man out among the Pre-Raphaelites. He attempted only one full-blown modern subject, *Found* (1858), and never finished that. He based his work not on guaranteed personal observation like his fellow PRBs but on his own imaginings. A saner Richard Dadd, he peopled his inner world with characters from medieval Florence, or from the Arthurian legends as recounted by Sir Thomas Malory in his *Morte Darthur*, originally published by Caxton in 1485. The doings of these heroes from a misty, half-real past were more important to him than the present day which, like Carlyle, Pugin and Ruskin, he thought tainted by corrupt and exploitative capitalism. His associate in a number of enterprises, William Morris (1834–96), was a committed socialist whose projects, whether for book design or for a Guild of Art-Workers, were driven by a combined need to return in spirit to a more honest past and a desire to make the arts expressive of the whole community rather than a small privileged class. His principal activities were in the applied arts, but in the 1850s he was a painter, in a decidedly Rossettian version of Pre-Raphaelitism.

As for Rossetti himself, his art became more and more introspective. His concentrated watercolours and pen-and-ink drawings of scenes from the life of Dante, especially concerning Dante's idealizing love for Beatrice, were largely autobiographical, expressing his own yearnings and aspirations. But in spite of the spirituality of his inspiration he was a highly sensual personality, stirred by strong feelings for women. By the end of the 1850s he had begun to paint portraits of his inamoratas, idealized and increasingly shorn of the constraints of normal portraiture. They appear, in close-up, staring out languishingly and framed in cascades of red-gold hair. A woman tending and combing her loose hair, like *Lady Lilith* in Rossetti's picture of 1863, is engaged in an act that is a metaphor for caressing the body, in rapt reverie, as though preoccupied by erotic thoughts. The title of Rossetti's *Bocca Baciata* (1859) goes straight to the point: 'the kissed mouth' is not an ordinary portrait title. The model – Fanny Cornforth, whom Rossetti was in love with and regularly painted – gazes not so much at us as at herself in a mirror. The

picture surface becomes the pane through which a world, like our own but subtly altered, more dreamlike, can be discerned.

During the 1860s and 1870s Rossetti painted and drew innumerable portraits of this type. Usually he gives them titles evoking a situation from romance. *Lady Lilith* refers to 'Adam's first wife', as he put it in a sonnet on the same theme: she is the original temptress responsible for the Fall of Man – these women are dangerous. *Beata Beatrix* (1864–70) returns to the 128 Dante and Beatrice motif, and shows Rossetti's wife, Lizzie Siddal (the model for Millais's *Ophelia*), as Dante's beloved in 122 ecstatic prayer. A haloed bird brings her a white poppy. But that poppy symbolizes death. This is a picture about death, the death of both Beatrice and Lizzie herself, who had taken an overdose of laudanum in 1862. The figure, both actual sitter and imagined subject, is both alive and dead: the exact moment of transition is portrayed. These thoughts of death are shot through with a powerful eroticism: the often-mentioned parallel between death and orgasm inevitably comes to mind.

In pictures like this Rossetti anticipates developments that were to gather momentum in European art over the next decades, and would find literary expression in poetry – his own, and that of his friend Algernon Charles Swinburne, and several French writers, notably Charles Baudelaire. Love and death are perennial themes, the woman-monster, seducer and destroyer a recurrent image. The culminating formulation of this international movement, variously known as 'Symbolism' or 'Decadence', is Sigmund Freud's work on dreams and the workings of the unconscious.

These developments arose at least in part as a result of the disorientation and desolation felt by many people in the wake of Darwin's terrible revelations. If the world we know had evolved slowly by chance over many millennia, and men were descended from apes, was there room for God? Christianity began to seem vulnerable, illusory. Hardly surprisingly, the Christian art of the late 19th century breathes of pallid ghosts. The supreme image-maker in the period is Edward Burne-Jones, who is inseparably associated with greyish, etiolated figures, their pale thin faces 129 staring unfocused into nothingness.

He began more robustly as a dedicated follower of Rossetti, producing neurotically intense drawings and watercolours of subjects taken from medieval ballads and Christian legend. He designed stained glass for Morris's firm, Morris, Marshall, Faulkner & Co., with bold simplified forms and strong colour.

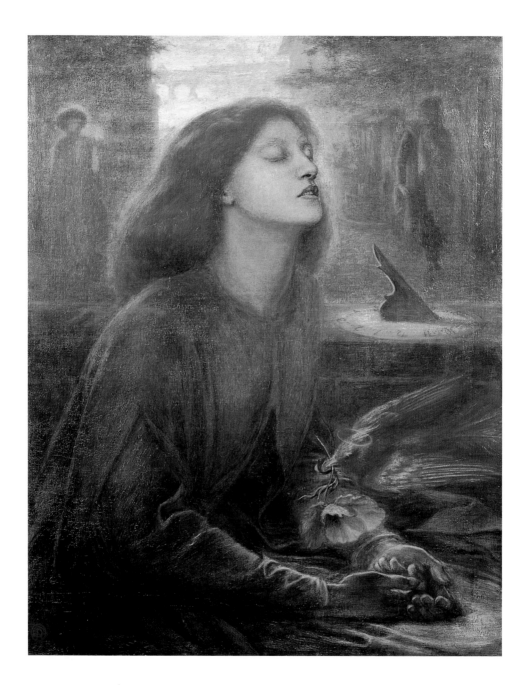

His work of the 1860s is strange, beautiful and highly personal. After about 1870 he responded to public acclaim with larger pictures, executed sometimes in a form of tempera, sometimes in a dry scumbled oil technique. Both methods have the effect of interposing a membrane between the viewer and the image, the mirror-glass between us and the world of dreams.

In the late 1860s Burne-Jones began work on a series of four pictures showing the story of *Pygmalion and the Image*. The artist, Pygmalion, falls in love with his own creation. The loved object is both alive and not-alive, a statue given breath by the goddess of love. The refinement and cool restraint of compositions and colouring belie the suppressed eroticism of the series. Burne-Jones took up the theme again in *King Cophetua and the Beggar Maid* (1884), based on a poem by Tennyson, in which the king's love transforms the beggar girl into a queen. The suggestion of egalitarianism appealed to Morris and

129

128. Dante Gabriel Rossetti, *Beata Beatrix*, 1864–70 Rossetti was obsessed with certain female types, and made of them the substance of much of his art. They are often presented as blowsy sirens, enveloped in the trappings of a sybaritic existence. His wife presents a more poignantly unattainable beauty here, presented as she is at the very moment of death. The muted palette and hazy light contribute to a sense of distance and immateriality.

129. Sir Edward Burne-Jones, *Pygmalion and the Image, No. 4: The Soul Attains*, 1868–78 The story of Pygmalion, the sculptor who falls in love with his statue, which becomes a living woman, Galatea, occurs in Ovid's *Metamorphoses*. The four panels of Burne-Jones's series are entitled *The Heart Desires*, *The Hand Refrains*, *The Godhead Fires*, and *The Soul Attains*. The blending of sexuality, spirituality and aesthetics is characteristic of the artist, and of the Symbolist movement in Europe.

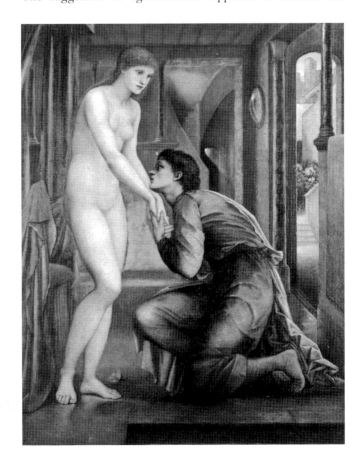

Burne-Jones's other socialist friends, but it is less a political than a romantic statement of the power of love to transcend all barriers. *Cophetua* was acclaimed at the Paris Exposition Universelle in 1889. Burne-Jones was imitated in Belgium by Fernand Khnopff, in Vienna by Gustav Klimt, in Spain by the youthful Picasso. The Continental links were emphasized when in 1877 Sir Coutts Lindsay founded the Grosvenor Gallery in Bond Street, where British and Continental painters and sculptors showed work side by side.

The perceived importance of the British artists was not unconnected, of course, with the fact that Britain was now uncontested leader on the world stage. Oddly, the art of her most respected representatives was on the whole pessimistic, reflecting more post-Darwinian angst than imperialist jingoism. The classic case is that of George Frederic Watts (1817–1904). Over a long career Watts's reputation grew and grew, but he began with ambition enough. He won a premium in the Westminster competition with his cartoon, never carried out, of *Caractacus led*

130. **George Frederic Watts**,
Paolo and Francesca,
c. 1872–74
Dante's story of the adulterous lovers murdered by a jealous husband and condemned to spend eternity in the howling winds of Hell was a powerful inspiration for many late 19th-century artists: the interplay between the ideas of love and death was a preoccupation of the age.

in Triumph through the Streets of Rome (1843). He conceived his role as expounding noble ideas about the human condition. He had embarked on this mission with some distressingly realistic subjects around 1850, like *Found Drowned*, a bleak social comment more hard-hitting than anything the Pre-Raphaelites conceived. In the early 1870s he painted one of his most powerful canvases on the Dantean subject of *Paolo and Francesca*, which had been treated by Rossetti and was popular with Symbolists across Europe. The lovers, murdered for their adultery, are shown in each other's arms, blown about forever in the winds of Hell. Like Rossetti, Watts is fascinated by the ambiguity of a half-alive, half-dead state, and presents these figures as sentient corpses, knowing nothing except a generalized anguish.

130

Watts felt the need to become more abstract, dealing in allegorical generalizations that transcended local instances. We may detect the surviving influence of Reynolds here, but a high-minded Idealism was very much in the late 19th-century air. It was the obverse of the coin of Decadence. Watts experimented with spiritualism and Theosophy in his search for peace of mind, but the sermons he preaches are disturbing. In *Love and Death* (1874–87) the message, we are surprised to realize, is not one of optimism, but of a stoical nihilism. Read in this light, his work acquires considerable power and its subtlety of expression becomes apparent. Like Burne-Jones, he enjoyed enormous international esteem.

Watts was also much admired for his portraits. In the course of his career he painted nearly all the great men and women of his day, endowing them, no less than his allegorical figures, with immense weight and dignity. Looking at the pale faces of his statesmen, staring out of dark backgrounds, clad in black, we feel that these are indeed men on whose shoulders rests responsibility for the whole world. The same goes for the official portraits of Millais, who by the 1870s had metamorphosed from a Pre-Raphaelite chrysalis into a highly successful society butterfly, painting the great and the good in a pictorial language close to Watts's. His likenesses of Gladstone or Tennyson lay stress on the solid worth of those great men, but despite his undeniable painterly skill, take little delight in virtuoso brushwork or subtleties of colour. When provoked by a real character, like *Mrs Bischoffsheim* (1873), though, he could be both penetrating and diverting. He diversified with subject pictures like the famous *Boyhood of Raleigh* (1870) or fancy pieces, deliberately evocative of Reynolds, like *Cherry Ripe* (1879).

131

131. **John Everett Millais,**
Mrs Bischoffsheim, 1873
Millais's career as a society
portrait painter was well launched
by the early 1870s, and
continued for nearly thirty years.
Only occasionally, however, did
his subjects provide him with the
excuse to show off his bravura
technique; this lady – 'Mrs Bisch,'
as she was known, the wife of
Louis Bischoffsheim, of the
banking house of Bischoffsheim
and Goldschmidt – certainly did.

Watts twice refused a baronetcy but accepted the award of
the Order of Merit in 1902; Millais accepted the baronetcy he
was offered, and became President of the Academy a year before
his death. He succeeded Frederic Leighton, created Baron
Leighton of Stretton (1830–96). Academicians could aspire to
the highest honours, though their institution was beginning to
attract serious criticism. 'Rome in all its glory could scarcely
have produced more than thirteen hundred works of art in a
single year,' a magazine had gushed in the 1850s; by 1870 the
quantity had increased to 2,000, but the critics were pointing to
much stodgy and predictable work, and other spaces in London,
like the Dudley Gallery in Piccadilly, which specialized in water-
colour exhibitions, were attracting the brighter young artists.

Burne-Jones showed at the Dudley in his revolutionary youth, and his relationship with the Academy was always ambivalent.

However, there were real talents to be discovered at the annual summer shows at Burlington House. Several women were now regular exhibitors. Elizabeth Southerden, Lady Butler (1846–1933), produced a succession of accomplished and popular military subjects: *The Roll-Call: Calling the Roll after an Engagement, Crimea*, an elegiac yet monumental account of the human cost of war, was picture of the year in 1874 and bought by the Queen. Scots and Irish continued to show in London although both Edinburgh and Dublin gained their own exhibiting academies in the course of the century. Outstanding among the Scottish contributors are William Quiller Orchardson (1832–1910), who followed several of his compatriots in developing Wilkie's pioneering work on the genre subject, and William McTaggart (1835–1910), whose swiftly brushed shore scenes take the breadth of Turner and Cox to astonishing lengths.

If the Academy was worthy of 'Rome in all its glory', Leighton was the artist who embodied its Antique aspirations. A prodigy, he trained abroad, in Frankfurt, Rome and Paris. His earliest work betrays links with the Nazarenes. His large canvas, *Cimabue's Madonna carried in Procession through the Streets of Florence* (1855), was sufficiently German in taste to appeal to Prince Albert, and the Queen acquired it. He eventually moved towards classical subject matter, and became the doyen of the 'Olympians', a loosely associated group of artists specializing in scenes set in ancient times. Leighton's paintings are characteristically suave, brightly coloured, and beautifully drawn. His large-scale compositions with many figures are mellifluously organized, deriving their special quality from a pleasing antagonism between coolly refined finish, suggesting the pure, clean atmosphere of a pristine world, and sensuously invented bodies endowed with lustrous flesh.

The elevated grandeur of these pictures is in direct contrast to the more prosaic inventions of Lawrence Alma-Tadema (1836–1912), of Dutch parentage and trained in Belgium. While Leighton aspires to emulate Raphael, Alma-Tadema remains in the category of historical genre. His figures are models, late 19th-century people in fancy dress, his carefully researched representations of the details of life in ancient Athens or Rome curiously pedantic. Yet he paints coloured marbles with a silky, seductive touch and can place a vivid magenta azalea against deep blue sky to such effect that one almost forgets that the

132

132. **Frederic, Lord Leighton**, *Captive Andromache*, *c.* 1886–88
The story of Andromache, widow of the Trojan hero Hector, is told by Homer
and Virgil. Leighton took Hector's vision of his wife's exile among the Greeks,
in the *Iliad*, as his starting-point; but he is not concerned with the dramatic
or moral content of the legend: his picture is an exercise in aestheticism,
a visually satisfying evocation of an unspecific Ancient past.

picture is titled *Unconscious Rivals* (1893) and concerns two pretty women eyeing a passing youth.

The narrative overkill in these paintings makes the emergence of Aestheticism seem both welcome and inevitable. Aestheticism tends to be defined by its literature and decorative arts – the poetry of Swinburne, the fashion for everything Japanese – but it had an important place in painting as well. An art that did not wish to tell a story, but offered simply the work itself as it was – paint on canvas – was a breath of fresh air. Albert Moore (1841–93) also painted models in classical dress, but he leaves them to speak for themselves, in arrangements of objects and fabrics that create warm chords of colour and easy pictorial rhythms evolved from careful mathematical calculations. *Azaleas* ¹³ (1868) is a symphony in yellow, with the creamy white of the blossoms set off against lemon drapery and apricot accessories. The art theorist and historian Walter Pater opined that 'All art constantly aspires towards the condition of music', and pictures like this can only be enjoyed as abstractions: their representational content is reduced to a minimum.

The 1860s were a time of radical change, and young artists took inspiration from the audacities of Rossetti and the intensity of Burne-Jones to insist that painting should be 'removed . . . from common life and ordinary experience, significant of something beyond the usual course of nature'. The atmosphere of this moment is elusive, for the strident self-confidence of contemporary life tended to drown out the doubtful, the hesitant and the genuinely passionate. Simeon Solomon (1840–1905) chose subjects that take us into a lonely world of solitary erotic fantasy, reflecting his sense of alienation as a Jew and a homosexual in a society too ready to discriminate against both.

We can perhaps best grasp the mood of these rebels by looking at the landscape painters among them. George Heming Mason (1818–72) had come into contact with the Italian painter Giovanni Costa and his 'Etruscans', who were seeking to express the spiritual forces lurking in the Italian countryside, the ghosts of past ages that thronged the groves and mountains. Leighton was much affected by this group and throughout his life painted sensitive landscape studies. When he returned to England, Mason tried to give form to his sense that the country people he met were the modern embodiments of similar ancient life-forces, painting them at work in muted landscapes.

Millais can be counted as a member of this group, for he turned to landscape again in his later years, painting several in

restricted harmonies of grey and brown. There is something autumnal about the movement, which has a musical parallel in the work of Elgar. The elegiac quality is summed up in a painting by Fred Walker (1840–75), *The Harbour of Refuge* (1872), in which a familiar village setting, with almshouses grouped round a chapel, becomes the stage on which a gentle drama of youth, age and death is acted out by country people. Walker was the leader of the illustrators who flourished during the great magazine boom of the 1860s, and even on this large scale his painting retains something of the compression and intensity of that work. These artists are sometimes known as 'Idyllists', but they often engaged with an earthier view of country life.

By the 1880s grain imports from America and Australia were bringing down the price of crops, and many country people were having to find new work in the fast growing industrial cities. There was widespread poverty and distress. Some artists felt that this was where their subject matter should be found, and, inspired by the Naturalist movement in France, where they had trained, brought a gritty new penetration to their examination of rustic life. Taking their lead principally from the French *plein-air* ('outdoor') movement led by Jules Bastien-Lepage, a group of painters formed the New English Art Club in 1886, dedicated to the unflinching depiction of workaday life and landscape. Their leader, who imitated Bastien-Lepage's style

133

133. **Fred Walker**, *The Harbour of Refuge*, 1872

and subject matter closely, was Henry Herbert La Thangue (1859–1929). Other key members of the NEAC were George Clausen (1852–1944) and Stanhope Forbes (1857–1947). They united their admiration for the new French painting with principled antagonism to the Royal Academy, and their work proclaims the theoretical and technical divide. Its concern with peasant life is hardly different from that of Mason, but it insists much more on the rough, unlovely aspects of rural labour, eschewing the Idyllists' lyricism. Yet there is a warmth and tenderness in the NEAC style of painting that imbues the coarse subjects with grace as well as dignity. Forbes applied the satiny touch of the NEAC's characteristic square-ended brush to ambitious, many-figured subjects: a country auction or a village wedding. He was also a leader among the artists who worked at Newlyn in Cornwall in these years, as did his wife Elizabeth Armstrong (1859–1912). His *Fish Sale on a Cornish Beach* (1884), executed in this sober, restrained style, set the mood for the realist painting of the end of the century.

134. **Albert Moore**, *Azaleas*, 1868
The reduction of content in this picture is carried even to its colour, which is a minimal harmony of pale yellows and white. In the opinion of the poet Swinburne, Moore's painting demonstrated a sense of 'absolute beauty'. It represented 'the faultless and secure expression of an exclusive worship of things formally beautiful.'

135. **Stanhope Forbes**, *A Fish Sale on a Cornish Beach*, 1884

These artists, whether Idyllists, Naturalists or genre painters, were well aware of contemporary aesthetic ideas. Their canvases are noteworthy for their controlled colour – the subdued palette of the workaday rural world, of winter dusks and dawns. They exploited these qualities self-consciously, building up symphonies of cool, dull hues in the spirit of a more robust Aestheticism. As we have seen, it was not only painters trained in Paris who arrived at such conclusions. But the French influence certainly helped. It must take an important place in any assessment of James Abbott McNeill Whistler (1834–1903), an American who lived in Paris in the second half of the 1850s. Much of what London, where he settled in 1860, found difficult to digest about him was assumed to come from that capital of questionable standards.

Whistler had an innate sympathy for the bold departures of Édouard Manet, and learned to simplify and dramatize his subjects from him, and from the Japanese woodcuts that Manet and his friends admired. Orchestration of colour and line became more important than subject. It was Whistler who made musical analogies explicit in painting. He would entitle a portrait of his mistress *Symphony in White*; a group of figures in carefully related hues, somewhat like Albert Moore's, might be called *Harmony in Flesh Colour and Red*. In the 1870s he painted a sequence of evening views, mostly along the Thames at Battersea and Chelsea, which he called 'Nocturnes'. They are still, minimal evocations of twilight, the broad sweeps of the brush interrupted only by dots and sparkles of yellow light, or the silhouette of a distant building. 'By using the word "nocturne,"' he explained, 'I wished to indicate an artistic interest alone, divesting the picture of any outside anecdotal interest which might have been otherwise attached to it.'

But he was nevertheless interested in subject matter. His early pictures of the Thames waterfront at Wapping are full of local incident, and he was a prolific etcher, making prints that record the life of the riverside with a Rembrandt-like penetration. Rembrandt might spring to mind, too, when we look at his two most famous portraits: *Arrangement in Grey and Black, No. 1: Portrait of the Artist's Mother* (1871), and *Arrangement in Grey and Black, No. 2: Portrait of Thomas Carlyle* (1872–73). The titles, as usual, draw us away from the likenesses to the pictures as integral compositions. Yet Whistler doesn't succumb to ostentation. His portraits are lucidly but quietly conceived, with bold but unobtrusive structures. With their sitters presented in

profile and their soft, drab colour there is an austerity about them that fully expresses the Scottish rigour and seriousness of both subjects. Whistler continued to paint portraits all his life, and although he went on calling them 'Harmonies' or 'Arrangements' he never lost the sense of the individual presence so vital to the portrait.

Whistler made a point of acting out his opposition to the establishment. He dressed as a dandy, and wrote and spoke provocatively on art, his own painting most of all. His crepuscular landscapes chime well with those of the Etruscans; yet in his methods he was alone. When Ruskin accused him of being a 'coxcomb' who had asked 'two hundred guineas for flinging a pot of

136. James Abbott McNeill Whistler, *Symphony in White, No. 1: The White Girl*, 1862

paint in the public's face' when he exhibited his *Nocturne in Black*

and Gold: the Falling Rocket (1875), the old guard met the new. Whistler took offence and sued. He was famously awarded a farthing damages, but financially ruined by the costs.

Another American who came to settle in London via Paris was John Singer Sargent (1856–1925). He had been brought up in Italy, and there was little of the American in his artistic make-up: if Whistler betrays a Protestant dourness in his rigorously controlled art, Sargent's exudes the opulence of the Catholic cultures of southern Europe. In Whistler's portraits there is little trace of Van Dyck. Sargent is unimaginable without him. He quickly established himself as a virtuoso of the brush, allying a dangerously facile technique with a redeeming quickness of eye and a loving delight in every aspect of the visual world. 'He was like a hungry man with a superb digestion, who need not

137. **James Abbott McNeill Whistler**, *Nocturne in Black and Gold: the Falling Rocket*, 1875

188

138. **James Abbott McNeill Whistler**, *Arrangement in Grey and Black, No. 2: Portrait of Thomas Carlyle*, 1872–73

be too particular what he eats', William Rothenstein wrote. 'It was this uncritical hunger for mere painting which distinguished him.' He could catch a likeness with masterly concision, while investing his sitter with wonderful glamour. The suggestion of flattery, combined with the facility, has led people to think of him as merely flashy. But it is the essence of society portraiture

to flatter: Lawrence, Gainsborough, Van Dyck himself, all made more of their sitters than they saw in front of them.

While Sargent's free brushwork recalls Van Dyck and the great tradition of portrait painting, it is also closely related to the broad handling of the Impressionists. Sargent knew Claude Monet and after his arrival in London in the mid-1880s painted a number of pictures in a style that is as much Impressionist as anything else. Some are landscapes, some informal studies of interiors with figures. The large scale agreed with him: many of his portraits are conceived in grand proportions, fitted to their destinations in equally grand houses.

Sargent took intelligent note of Lawrence's cunning ways with the composition of groups, developing the space in which they are placed deep beyond the picture-plane. The sitters in *Mrs Carl Meyer and her Children* (1896) are posed with linked gestures so as to draw the eye deep into the picture-space. The viewpoint is high, and all three look up at us inquisitively. Sargent conveys calm repose and a certain expectancy at the same time: masterly.

139. **John Singer Sargent**,
Mrs Carl Meyer and her Children,
1896

140. **John Singer Sargent,**
Sir *Frank Swettenham*, 1904

Like most portrait painters he felt no such pressure to be creative when he painted men. He tackled Sir Frank Swettenham as a huge whole-length and in three-quarter format, evoking 140 Britishness as personified in the aristocratic official of a distant dominion, yet cheerful in a way that Watts and Millais rarely managed. Not being British, Sargent may have been happier to take the burdens of Empire lightly. When he was painting his own friends, he could put aside all pictorial aids, and convey a human personality, like *Henry James* (1913), with loving insight and force.

In 1918 Sargent painted a colossal canvas, *Gassed*, which depicts a frieze of First World War soldiers stumbling blindfold across a bleak plain strewn with casualties. The world he had recorded with such sympathy, the world of the country house and the aristocratic patron, of Raj and Royalty, had been blown to pieces. The age of Empire was virtually over.

Chapter 8 The Great Debate: 1910–1960

'Modern Art' originated long before the First World War. The popular perception that there was a difference between traditional art and a new kind, more difficult to understand, went back to the early 19th century, and to France. There, in the 1820s, writers and artists became conscious of the responsibility of the artist to be both prophet and political agent, leading society into a frightening but challenging future. They began to call themselves an 'avant-garde', as though they were at the forefront of an army going into battle.

After the seismic changes wrought on painting in the later part of the 19th century by the Impressionists and Post-Impressionists, the 20th century inherited a need to continue identifying an avant-garde, generation by generation. As in some contemporaneous Communist theory, a state of perpetual revolution was the great objective. A sense of urgency was therefore associated with the 'new', ensuring a heightened dynamic of change in the work of artists who saw themselves as

141. **Philip Wilson Steer**,
A Summer's Evening, 1888

'modern'. The rate of stylistic and conceptual change among these artists was, accordingly, swifter than among those who opted to pursue traditional disciplines.

Looking back over a hundred years we can see that while the hares of the avant-garde produced much that was vital and important, the tortoises of tradition were not necessarily unfruitful. Assessing the century as a whole, we may find that some of the laggards were, in their way, as original as those who proclaimed originality as their sole creed. In any case, in Britain the story of Modernism begins with some fairly ambiguous forays into the field of innovation.

Any history of Impressionism in these islands must begin with the achievement of Constable, Cox and Bonington, and a study of the ways in which their work interrelated with that of their contemporaries in France. This gives a background to the later stage when Impressionism crossed the Channel. During the Franco-Prussian War of 1870–71 many artists fled to London, Monet among them. He then first saw the work of Turner – a revelation, and a confirmation, as he felt, of the direction he had been taking, though not a direct influence on his evolution to that point.

More significant practically was the arrival of the painter and printmaker Alphonse Legros (1837–1911), who in 1876 became Professor at the newly formed Slade School of Art in London. His teaching profoundly affected generations of students, establishing in particular the primacy of fine draughtsmanship. With a progressive academic training in France, he was much influenced by the gritty peasant subjects of Gustave Courbet and Jean-François Millet. We have seen, in the Realist painters of the New English Art Club, how the innovations of modern French painting percolated into Britain. At first the dominant influences were relatively traditional, but by the end of the 1880s the full effect of Impressionism was apparent in the work of Philip Wilson Steer (1860–1942).

Steer trained in Paris in the mid-1880s, in rigorously academic schools, but he absorbed what he saw in exhibitions of more advanced work, and had imbibed Whistler's lessons when he plunged into the shimmering waters of Impressionism. His large, light-toned canvas showing three nude bathers on a beach, *A Summer's Evening* (1888), was shown in international company 141 in Brussels in 1889. Its informal, 'meaningless' subject perhaps derives from the abstract groupings of figures favoured by Whistler and Moore, but its bright outdoor light and broken

142. **Walter Richard Sickert**, *The Gallery of the Old Bedford*, *c.* 1895
A fascination with the reactions of theatre audiences goes back to Hogarth.
This is perhaps the most important of many depictions of the Bedford Music
Hall that Sickert made in various media during the 1890s.

dabs of primary colours are wholly in the spirit of the later Impressionists. The grand scale leaves no doubt of Steer's ambitions. A succession of smaller canvases confirms the French influence. *Girls running, Walberswick Pier* (1888–94) is both intimate and spontaneous, a 'snapshot' of life on holiday where light and colour become vehicles for a naturalism liberated from the overcast palette and drab social truths of the NEAC and Newlyn. 135

Steer went on to incorporate a veritable history of English 'impressionism' into his later work. He abandoned his strict French technique in the 1890s and adopted the manner of Gainsborough's freer fancy subjects, impressed particularly by the fantasy *Diana and Actaeon*; then painted landscapes in a style 70 consciously reminiscent of Constable, and fluid watercolours evoking Turner. His career can be seen as an attempt to align British painting with the continental avant-garde, while drawing attention to the significant part that earlier British painters had played in forming that current.

If Steer moved between two or more different impressionisms, never uniting them in a single style, Walter Richard Sickert (1860–1942) had the creative individuality to forge an entirely personal version of contemporary French painting and

143. **Walter Richard Sickert**, *The Camden Town Murder, or, What shall we do for the Rent?*, c. 1908 Sickert came to associate his series of bedroom interiors with one or two figures with the well-publicized murder of a local prostitute. The exact relationship between the man and woman here is not explicit: they are bound together by Sickert's rich impasto and the sombre range of colours and tones from which they emerge, immobile, listless, despairing, or simply resting on a hot afternoon The title, of course, suggests that the woman is actually dead.

graft it, with abiding consequences, on to the English stock. His father was a Danish artist working in Munich when Sickert was born, but he trained in London, briefly at the Slade, and then under Whistler, who once again had a crucial mediating influence between England and France. But it was acquaintance with Edgar Degas, whom he met in Paris in 1883, that clinched Sickert's style. Whistler taught him to etch, and showed the way in creating pictures out of closely related, muted tones; Degas inculcated refined draughtsmanship and a love of ordinary life, especially as it occurred in music-halls and theatres. In his early pictures Sickert loved to borrow Degas's favourite view through the gloom of an auditorium, over the heads of audience or orchestra, on to a stage with spotlit figures. The palette is subdued, often a range of browns punctuated by gold accents, the paint applied with a strong feeling for its sensuous value in the whole statement. In Dieppe, which became something of an English artists' colony, or Venice, where Whistler had etched, Sickert painted buildings – the church of St Pierre, the Basilica of St Mark's – making of them grand, brooding designs that speak of the human history those buildings represent.

In London this understated style became the vehicle for Sickert's wryly ambiguous observations of Cockney life, on stage and off. He thought of himself as promoting a distinctive 'London Impressionism', preoccupied with the squalor of ordinary existence. 'The more our art is serious, the more will it tend to avoid the drawing room and stick to the kitchen', he wrote. 'The plastic arts are gross arts, dealing joyously with gross material facts.' His etchings, drawings and paintings are sharply witty views of ordinary people caught off-guard, chatting in a pub, enthralled by a music-hall turn (*The Gallery of the Old Bedford*), bored by married life (*Ennui*, 1913). He began to paint little interior scenes with figures, nude and clothed, which take his interest in the unconsidered ordinariness of life a stage further. He gave them titles – *The Camden Town Murder*, for instance (after a notorious case in 1907) – that suggest more than is presented, ironically implying drama where there apparently is none, while acknowledging that it is in the context of daily routines that strange, even outrageous things happen. He achieves a balance between the traditional English love of anecdote and the cool objectivity of the French Nabis, who were exploring rather similar domestic subjects at the same time. What he also shares with Bonnard and Vuillard is a predilection for harmonies of close-toned colours given life by a rich, fluent use of paint that

142

143

144. **Walter Richard Sickert**, *King George V and his Racing Manager: A Conversation Piece at Aintree*, c. 1929–30
The image is based on a press photograph, taken unawares: 'In those circumstances,' Sickert said, 'you get much more information . . . If you put people into their proper milieu with others it is not like putting them up on a platform and asking them to "look pleasant."' This revealing intimacy is offset, however, by the impersonal way in which Sickert plots the tonal relationships of the photograph in paint.

can be liquid or brittle according to need. Over his long career the brittleness won out over the liquidity, developing, it seems, hand-in-hand with the wry humour: many subjects of the 1930s comment on other visual images, reworking 19th-century prints or modern newspaper photographs.

Many of his contemporaries acknowledged Sickert as a leader, and his style – luscious pigment, sombre palette, unrhetorical subject matter – remained recognizable in much British painting throughout the century. To begin with, he had distinguished followers and colleagues in William Nicholson (1872–1949) and William Rothenstein (1872–1945), both accomplished practitioners of a painting style evolved from Whistler, and strongly affected by the bold pattern-making of

French exponents of the advertising poster such as Toulouse-Lautrec. Both were accomplished portrait-painters, and Nicholson produced a long succession of lusciously painted, beautifully observed still-lifes. A little later, Sickert came to be surrounded by a group of artists who were all in their different ways responding to the innovations in French painting. At first they took their identity from the Fitzroy Street flat in which they met; but Sickert eventually called them the Camden Town Group because 'that district had been so watered with his tears that sooner or later something important must spring from its soil'.

The Camden Towners were eager for the lessons Sickert could teach them, and open to new ideas. In 1910 a painter and critic, Roger Fry (1866–1934), organized an exhibition at the Grafton Galleries in London bringing the work of the Post-Impressionists to England for the first time. The show created a sensation, and Fry mounted another in 1912. Confronted by the paintings of Cézanne, Van Gogh, Gauguin, Matisse and Picasso people were horrified; the traditional aim of the avant-garde, to shock the middle classes (*épater le bourgeois*), was most satisfyingly achieved. But many artists responded with excitement to the challenges presented by the exhibitions (some actually showed work in them), and by Fry's defiant attacks on native British art of the time.

The leading lights of the Camden Town Group were Harold Gilman (1876–1919), Frederick Spencer Gore (1878–1914) and Charles Ginner (1878–1952). Their work shows how a generation of painters in their thirties came to terms with the new French art. Fry later remembered that he had called for 'more vigorously planned construction, for a more close-knit unity and coherence in pictorial design, and perhaps a new freedom in the interpretation of natural colour'. We can recapture something of the sense of adventure these artists experienced by looking at their responses to these demands. Their work is highly coloured, with stark simplifications of drawing and bold juxtapositions of hue and tone. Often it is obviously a heroic failure, rejoicing, even, in the impossibility of absorbing the strange new idioms of the Post-Impressionists. There was the bright-coloured language of Gauguin and his circle, and their derivatives, the Fauves ('wild beasts'), led by Matisse and Derain. There was the geometrical language of Cubism adumbrated by Cézanne and evolved, in the light of a fascination with the art of the indigenous peoples of Africa and the Americas, by Picasso and Braque. But the Camden Towners applied that language to subjects of a quintessential

145

145. **Harold Gilman**, *Mrs Mounter*, 1916–17 Mrs Mounter was the landlady of Gilman's first London lodgings, where he lived from 1914 to 1917. She features in several of his drawings and paintings, the subject both of his painterly experiment and of his concerned enquiry into a real person – or personality, indeed. In the words of a modern scholar, it is 'a confrontation that dignifies without flattering and is not limited by any class condescension.'

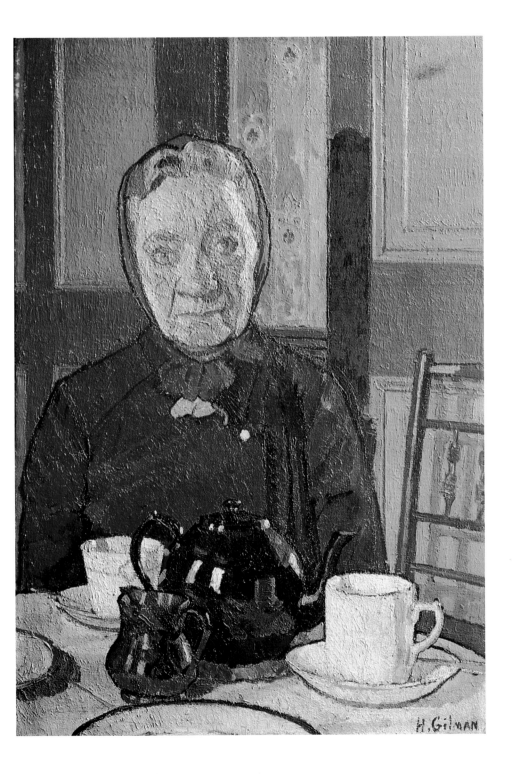

H.Gilman

Englishness. Gilman painted portraits of his landlady, Mrs 145
Mounter, with mauve and green shadows in the wrinkles of her
Cockney face; Gore took up the Sickertian theme of the theatre,
or painted domesticities in a more brilliantly coloured variant of
Sickert's manner; Ginner loved London gardens and squares.

This marriage of Englishness and Frenchness is endearing,
and the characteristic works of the Camden Town group are
among the most attractive of modernist British paintings. Yet
the juxtaposition draws attention to the discrepancy between
two very different traditions. A parallel movement in Scotland,
centred round the figures of Samuel John Peploe (1871–1935)
and John Duncan Fergusson (1874–1961), has much the same
problems of assimilation, though Peploe's still lifes and interiors
lusciously painted in sharp black, white and primary colours
have a convincing verve.

But there were others who took to the French manner like
ducks to water. Matthew Smith (1879–1959) was at the Slade, then
lived in Pont Aven in Brittany and in Paris where he was briefly
taught by Matisse. He spent much of his life in France and was
completely in his element with Matisse's style, deploying easy,
broad rhythms and vivid colour without awkwardness or embar-
rassment. It says much for his identification with French art that
he made the nude a recurring subject, painting warm-coloured, 147
languorous female bodies with unbridled sensuality – like Etty,
most unEnglish. His later work became somewhat repetitious,
but in the early decades of the century he was producing some of
the most vigorous Fauvist pictures to be seen anywhere.

There is much in common between Smith's work and that of
Duncan Grant (1885–1978), who was closely associated with
Roger Fry and contributed effectively to Fry's 1912 Grafton
Galleries exhibition, marking himself out as a born modernist.
Like Smith he had a natural sense of vivid colour, and naturally
adopted a Fauve palette, absorbing at the same time the excite-
ment of Diaghilev's Russian Ballet, with its exotic and brilliant
sets and costumes. Grant had an innate gift for decoration, and
was equally happy painting figures – he was as drawn to the male
nude as Smith was to the female – and abstract design, often
employing motifs borrowed from African art and from Cubism.

Another 'natural' was Gwen John (1876–1939), sister of the 146
brilliantly talented and exhibitionistic Augustus. Like him she
was a Slade pupil, one of the many women who now began
to receive professional art training. She also studied in Paris.
Her work is generally on a small scale: intimate drawings and

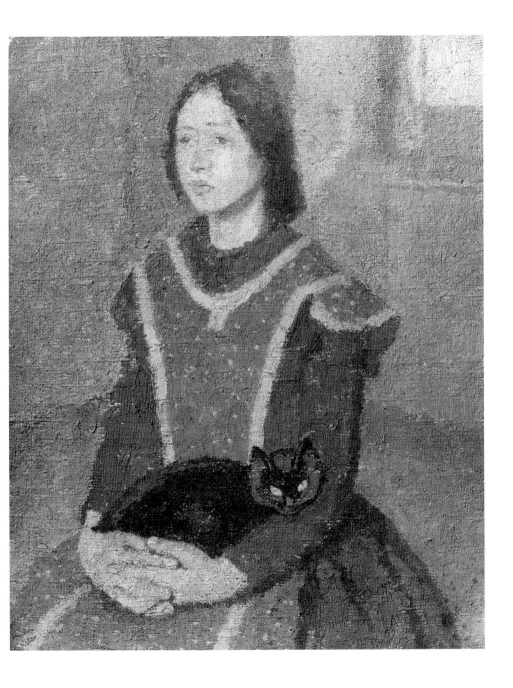

146. **Gwen John**, *Girl with Cat*, 1915–20

paintings of friends, cats, or girls glimpsed in church at a French 146
convent. Her palette is extremely restricted, cool greys predom-
inating, and her compositions are simple: a single figure against
a plain background is a standard type. In her most perceptive
portraits there is a glow of humanity, and a gentle pulsation of
colour, that carries all the more weight for having so unassum-
ing a setting. The contrast with her brother's showy work could 148
hardly be greater.

Augustus John (1878–1961) was always torn between the
facility of his technique, both as draughtsman and painter, and
his desire to rank as an *enfant terrible* of the avant-garde. He
wanted to shock, but he also wanted to exercise his ability to pro-
duce glamorous portraiture. Some of his finest work has a foot in
both camps. His portrait of his mistress Dorelia McNeill as a
Woman Smiling (1908–9) is wayward and unconventional, yet a

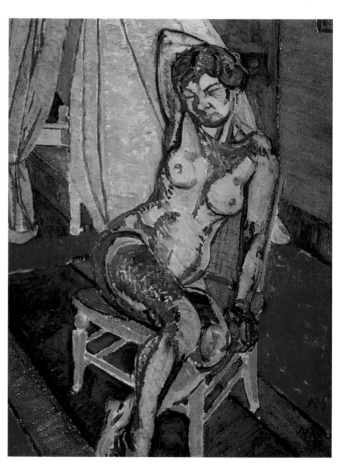

147. **Sir Matthew Smith**,
Nude, Fitzroy Street No 2, 1916
Smith's short time at Matisse's
art school in Paris in 1911 had a
critical effect on his development.
His eyes were opened to the
possibilities of colour, and his
handling broadened. In the Fitzroy
Street Nudes of 1916 (named for
the address of his studio) these
elements are subject to rigorous
control, the sensuousness of the
female form firmly disciplined by
rigorous formal considerations.

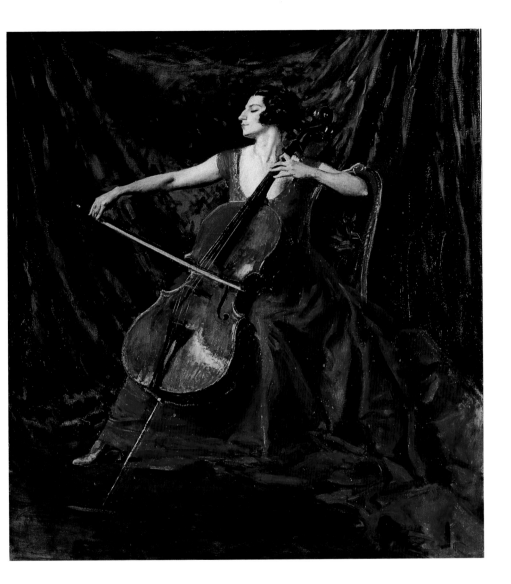

148. **Augustus John,**
Madame Suggia, 1920–23
Guilhermina Suggia (1888–1950) was a Portuguese cellist
who had studied under Casals.
Both artist and sitter conceived
the portrait as a demonstration
of virtuosity that would promote
their careers. Despite its almost
Baroque grandeur, this is really
a celebration of the independence
of the modern artist.

masterly likeness by traditional standards; and the virtuoso
Madame Suggia (1920–23) continues the manner of Sargent
with a flamboyance even Sargent would not have contemplated.
It is the flamboyance of artistic Bohemia, not the swagger of the
rich. Some of John's best work reflects the gypsy life his circle
liked to lead, and shows figures, usually his girl-friends in
Romany costume, in rugged Provençal coastal settings, as the
subjects of impromptu sketches, boldly simplified with strong
colour. A similar bohemianism is celebrated in the fairground

148

scenes of the young Alfred Munnings (1878–1959), who revelled in colourful throngs of gypsies and glossy horses. His fluent technique as a painter of horse-portraits earned him a glittering career that brought him, in 1944, to the Presidency of the Royal Academy.

A Slade-trained artist who kept his distance from the Modern was William Orpen (1876–1931), an Irishman who trained in Dublin before coming to London in the late 1890s. He was a friend of Augustus John's, and like him a brilliant portrait painter. He had a line in self-portraits, often quirky in conception, and imbued with wry humour. His manner is dryer than John's, and his sense of design, arising naturally out of his subject matter, fresh and striking. The absence of painterly show conveys a sort of bluff honesty that has in recent years been found more attractive than John's overt virtuosity. It consorts well with Orpen's delight in jokes, which crop up unexpectedly in all sorts of contexts in his work.

But jokes were to be in short supply for a number of years. The outbreak of the First World War in the summer of 1914 gave the visual arts a new, grim direction and purpose. The old order gave way to a stern realities, which needed urgently to be comprehended as imagery. But before that happened there had to be a reordering of ideas, a coming to terms with a new climate of thought. It was in 1914, though before war broke out, that the rumblings of unease and foreboding erupted in various expressions of discontent. The Rebel Art Centre was one; another took the form of a short-lived magazine, aptly named *Blast*. Both were the brain-children of Wyndham Lewis (1882–1957), a maverick half-American writer and painter who had been at the Slade and travelled widely in Europe. He had seen the Expressionists in Germany, the Futurists in Italy, and the abstraction of Mondrian in Holland. Already in 1909 he had painted a picture, *Theatre Manager*, that picked up ideas from Picasso's extraordinary proto-Cubist *Demoiselles d'Avignon* (1907); he was possibly the first artist outside the Paris School to do so. Like Grant, he showed at the Grafton Galleries in 1912, and collaborated with Fry in his Omega Workshops, which produced furniture, pottery and other items of applied and fine art, using the decorative language of Cubism.

But he wanted to lead his own revolution, and in 1914 formed the Rebel Art Group and, almost immediately after, the Vorticist Group. The Vorticist Manifesto appeared in the first issue of *Blast* and took many of its salient ideas from the Futurists,

149. **William Orpen,**
Mrs St George, 1914
Orpen's approach to portraiture owes much to Whistler's refined sense of design. This, combined with energetic and unfussy handling, enables him to present personalities vividly and at the same time with a lively sense of decoration. Mrs St George was the daughter of a New York banker, and married a cousin of Orpen's, Howard Hugh St George. She and the painter embarked on a long affair about the time this portrait was painted.

affirming that modern civilization, with its noise, speed and machinery, was the rightful preoccupation of the artist. At the same time, Lewis believed, these concepts could be expressed without recourse to direct representation. His own work consists largely of coloured drawings, making use of bold, machine-like shapes overlapping in repetitive patterns. The human is subsumed in the mechanical, the machine becomes half-human. This identification of man and machine is the shape of the world of the future. It was epitomized in a defining work of sculpture by Jacob Epstein, *The Rock Drill* (1913–14).

Lewis's ideas were fully realized in the paintings of David Bomberg (1890–1957), whose early career had progressed from training as a lithographer through study under Sickert and at

150. **Percy Wyndham Lewis**,
Portrait of an Englishwoman,
1913
Much of Wyndham Lewis's pioneering work as a Vorticist was executed in pen and ink with watercolour, a medium that gives his images the quality of plans, diagrams or blueprints, as it were, of a new vision. Here the technique combined with the unspecific title suggests a satirical intention.

the Slade to mingling with Picasso and Modigliani in Paris. Bomberg exhibited with the Vorticists in 1915, but had already in 1914 produced a key work of the movement, *The Mud Bath.* This large canvas illustrates how completely these artists had absorbed the ideas of the Futurists and the Cubists. The subject matter is far from conventional, its treatment uncompromisingly schematic, following an aesthetic that stops just short of abstraction. Some of Bomberg's work, like Lewis's, was totally abstract, but the languages of abstract and semi-representational merge. There is a continuum between the purely conceptual and the figurative which gives each authority. Both artists convey a conviction, an identification with the aims of Continental progressives, that takes British Modernism much further forward than the work of Camden Town. Later, Bomberg was to become more painterly, though he continued to oscillate between representation and abstraction. Some of his finest later works are landscapes, in Devon, Spain or Palestine, executed in an essentially Expressionist style of broad brushwork and thick, clogged paint.

 151

Mark Gertler (1891–1939), who was like Bomberg of Polish-Jewish extraction, studied at the Slade and later gravitated towards Bloomsbury. Post-Impressionism and, especially,

151. **David Bomberg,**
The Mud Bath, 1914
After a long period of neglect, this large canvas, along with other work of Bomberg's early career, is now recognized as one of the pioneer works of British Modernism. It is not wholly abstract, being inspired by the athletic attitudes of men at a Jewish massage and sauna in the East End of London; but in concentrating on the essential lines of energy in their movements it strips away all local reference and becomes a dynamic pattern.

Picasso's Primitivism had a crucial effect on his style, which tends to the stiff and monumental even when he is painting still lifes. His most memorable statement is the garishly coloured *Merry-go-Round* (1916) in which the twirling, doll-like figures, some in military or naval uniform, seem trapped and terrified by their pointless, endlessly circling entertainment. D. H. Lawrence on seeing it wrote in admiration to Gertler of his 'terrible and dreadful picture'.

If many of the images produced by these artists tend to the abstract, that is because they were pondering large, amorphous concepts, including the role of the artist in society. The war suddenly gave those concepts a brutal application, and it gave the artists a task that could not be abstract any longer. The appalling stresses of those years produced some of the most memorable painting of the century, and although it was of necessity concerned with the recording of facts, it gained in authority from the conceptual exercises that had gone before. The ability of British artists to use the new Continental idioms to distill the essence of their experience of war into something wholly aesthetic, transcending mere reportage, is unmatched by any other group in Europe.

The Ministry of Information commissioned artists of many stylistic and theoretical allegiances to make drawings and paintings of all aspects of the war both at home and on the Front, and afterwards planned a Hall of Remembrance, to be hung with large pictures by the principal contributors. The Hall never happened, but many ambitious works were executed for it. Sargent's *Gassed* is one. Wyndham Lewis was involved, as were C. R. W. Nevinson (1889–1946) and William Roberts (1895–1980). Nevinson had been at the Slade, and at the Académie Julian in Paris. He was a friend of Filippo Marinetti, the principal theorist of Italian Futurism, and with him published another manifesto, *Vital English Art*, in 1914. He was a natural member of the Vorticist Group, and his pictures and prints celebrating the dynamism of the modern world, often making use of strong geometrical patterns, show him as well suited to the tasks of the war artist. His *Star Shell* (c.1916) perfectly demonstrates the value of abstract experiment in realizing the violence of the war. Roberts too had been a Vorticist, as well as one of Lewis's Rebel Artists. He had developed his own version of the machine-men of Futurism and Vorticism, influenced by some Cubist work in which the human body is expressed as a complex of tubular forms.

152. **Mark Gertler**,
Merry-go-Round, 1916
The idea for this picture came from a bank-holiday roundabout on Hampstead Heath in London. The image derives its power from the ironic contrast between an ostensibly carefree, traditional form of entertainment and the harshly constrained adult figures in their military uniforms (presumably on leave from the First World War) who occupy the places that we are accustomed to seeing filled by children.

153. **C. R. W. Nevinson**,
A Star Shell, c. 1916
Nevinson was fascinated by the
geometry of accidental forms, and
used his observations of wartime
objects to a language that
transforms Futurist experiment
into powerful patterns that express
the 'terrible beauty' of war.

Perhaps the most impressive large works commemorating
the war are by Stanley Spencer (1891–1959), who attended the
Slade from 1908 to 1912, among the galaxy of young artists
inspired by the teaching of Henry Tonks (1862–1937). Tonks
thought he showed 'signs of having the most original mind of
anyone we have had at the Slade and he combines it with great
powers of draughtsmanship'. For a while Spencer was working
in a manner close to his fellow students Bomberg and Roberts,
but he was never a declared Vorticist, though he did show work
in Fry's 1912 exhibition. He produced some precocious canvases
in which his strong religious bent combines with a passion for
the detail of contemporary life to create images both touching
and disturbing, as in *The Centurion's Servant* (1914) where a
Biblical incident occurs in an ordinary modern bedroom.

In his paintings of the war the astringencies of Vorticism
sharpened Spencer's imagery into something more than abstract

154. Stanley Spencer,
Travoys arriving with Wounded at a Dressing Station at Smol, Macedonia, September 1916, 1919
This work was commissioned by the Ministry of Information immediately after the close of the First World War. The scene was observed while Spencer was in Macedonia with the 68th Field Ambulance Unit, a period that would supply the subject matter for his Sandham Memorial Chapel in the 1920s. It represented for him 'not a scene of horror, but a scene of redemption', and he modelled his composition on that of a traditional *Adoration of the Shepherds* (compare Wright of Derby's response to modern industry, ill. 66).

or polemical. He shows us scenes of gripping immediacy, brought into focus by an acute sense of the strangeness of things, and an ability to render that strangeness with a dreamlike logic. The two big canvases that he executed for the Hall of Remembrance are episodes from the war in Macedonia, which Spencer witnessed in 1915–18. *Travoys arriving with Wounded at a Dressing Station at Smol, Macedonia* (1919) illustrates his ability to find bold, striking patterns in the details of real life, presenting them with no diminution of the intensity of deeply felt experience. Trivial events had an almost sacramental meaning for him. 'When I scrubbed floors, I would have all sorts of marvellous thoughts, so much that at last, when I was fully equipped for scrubbing – bucket, apron and "prayer mat" in hand, – I used to feel much the same as if I was going to church.'

He drew on the same experiences of war for his designs to decorate the interior of the Sandham Memorial Chapel at Burghclere, on which he worked from 1926 to 1932. The panels

154

155. **Stanley Spencer**, *The Resurrection, Cookham*, 1924–27
There are many levels of meaning in this very large picture. Spencer explained that
'In this life we experience a kind of resurrection when we arrive at a state of awareness, a
state of being in love.' This scene in his village churchyard is a meditation on human life in
general (some of the resurrected are Africans) seen in terms of his local community, and
more particularly of his own emotional development. His first wife, Hilda Carline, appears
as several of the figures.

flanking the small oratory, with their insistence on the oddity of day-to-day events, are dominated by an east wall showing *The Resurrection of the Soldiers*, in which grave-crosses are piled up in a straggling forest, suggesting a mass crucifixion. He had already painted a huge *Resurrection* (first exhibited in 1927) set in the Berkshire village of Cookham, where had had been born and with which he is always associated. Here the inhabitants of an ordinary place are seen rising from their graves as still ordinary, yet indefinably transformed people. So the soldiers of Salonica push aside the serried rows of their white crosses to shake hands with one another, to rewind their puttees, and comfort their horses undergoing the same dreamlike experience. 155

The imaginative intensity of this achievement was sustained throughout Spencer's long creative life. The mingling of religious and secular, the perception of the divine in everyday events, are recurrent themes. In his landscapes and portraits he adopts a more literal style, painting what he sees with almost obsessive attention to detail – he was an admirer of the Pre-Raphaelites, as well as of early Italian art. Sometimes his concerns are decidedly squalid; among his many landscapes, he chooses to paint scrap-yards, decaying suburbs. The series of paintings he hade of his second wife occasionally include himself, thrust into a disturbingly earthy intimacy with nakedness. 156

These wilful flights spring from Spencer's eccentric temperament, but there are links between his clear-eyed frankness and the contemporary German *Neue Sachlichkeit* (New Objectivity), a movement that rejected Expressionism and Abstraction in favour of (notionally) honest reporting. In this connection other artists might be mentioned: Laura Knight (1877–1970), Gerald Brockhurst (1890–1978) and Meredith Frampton (1894–1984), though none of these adopted objective realism as an item of aesthetic belief. All three were capable of producing startlingly vivid portraits at a time when society portraiture was in decline.

There was emerging a deep split between artists who adhered to passionately held views on the nature of Art – who published and followed manifestoes – and those who avoided such categorization. Brockhurst and Spencer became Royal Academicians, and so seemed to declare for the effete Establishment against the avant-garde. These distinctions, now perhaps unimportant, mattered a great deal at the time. Fry's teaching that French art was good, i.e. serious, to do with painting as such, with paint surface, form and colour in themselves,

156. **Stanley Spencer**, *Self-portrait with Patricia Preece*, 1936
Spencer's feelings for his second wife are expressed very differently from those for his first. Gone is the 'sacramental' attitude to sex (see ill. 155); here a blunt physicality is the keynote, and the closeness of the figures to the viewer is startling, almost repellent. At the same time, man and woman are related to one another in an ambiguous way, intimate yet disconcertingly distant, a record of an awkward, frustrating and masochistic relationship.

while British art was bad – concerned with the descriptive and anecdotal – had instilled a profound mistrust of traditional genres. By the 1920s the ferment of new ideas that had bubbled up at the time of the war had settled into a clear understanding that the new in art was not merely aesthetically more advanced: it was morally sounder. In due course that sense of moral 'rightness' attached itself particularly to abstraction, which by definition could not be 'about' anything except itself: a state of aesthetic purity that somehow carried with it the implication of moral purity as well.

The British had difficulty in following the pioneers of abstraction in Europe. Grant and his close associate Vanessa Bell (1879–1961) were among the first to do so: Bell's *Composition* (c. 1914) is an early example making use of mixed media and collage. But it was not until the 1920s that any sustained practice in abstraction was established. In the years between the World Wars the abstractionists assumed the roles of social and political visionaries. There was also a religious strand. In Holland, Piet Mondrian, who was interested in Theosophy, had spoken of the power of abstraction to penetrate to the essence of things, stripping away the incidental and the mundane – shades of Watts, whom Mondrian was aware of, and his generalization in the

157

157. **Vanessa Bell**, *Composition*, *c.*1914
Bell's experiments with abstraction are few, but they are important because
they are unusually early and thoroughgoing. In this example figurative
elements are suppressed until there is only a hint of a landscape idea behind
the free patterns of boldly used collage with mixed oil and gouache.

158. **Ben Nicholson**, *First Abstract Painting, Chelsea*, 1924
This early essay in almost pure abstraction was prelude to further experiment with mixed abstract and representational subject matter before Nicholson realized a fully fledged and extreme minimalist abstract language in the 1930s. Here, beneath the determined elimination of recognizable objects, there are hints of the familiar pattern of mugs and bottles on a table-top.

interest of a higher truth. Clive Bell, Vanessa's husband, had urged artists to seek and paint 'significant form', and in his immensely influential book *Art* (1914) suggested that a true presentation of the 'pure form' of an object enables the viewer to become aware of 'its essential reality, of the God in everything.' Ben Nicholson (1894–1982), who became the doyen of British abstractionists, embraced another late 19th-century religious cult, Christian Science, which also emphasized an ulterior 'truth' behind material appearances. He saw abstraction as a commentary on the real world, the 'expression of an idea' about life. It could be argued that he shared the prevailing English doubt about abstract art. His own grew organically out of landscape and still-life painting (his father, William, was as we have seen an inspired still-life painter), and never entirely shed those references. A crucial stepping-stone in his progress, as for Mondrian, was the abstracted still life that was so typical of Cubist painting.

158

The salient characteristics of Cubism – the breaking down of three-dimensional forms into interrelated planes and schematization of colour, first in near-monochrome, and later in juxtaposed blocks of strong, often unmixed hues – helped Nicholson refine his own subjects into superimposed planes punctuated by isolated masses of colour. As time went on the planes became more geometric, the colours more schematic. References to the sweeping Cornish landscape round St Ives or to objects on a table-top were eliminated, even while they remained as what might be called the 'sub-text' of the works. His *First Abstract Painting, Chelsea* was shown at an exhibition of the Seven & Five Society in 1924. The Society had been inaugurated in 1919 as an ecumenical attempt to organize artists of many different persuasions after the war.

158

Pursuing the process of abstraction to a logical conclusion, Nicholson began in the 1930s to translate his wholly abstract pieces into shallow reliefs, occasionally large, and entirely white. These colourless surfaces with their play of light and shadow are decidedly architectural, reminiscent of the geometric white buildings being created by the Bauhaus, the great German

159. **Ben Nicholson**, *1951 (St Ives – Oval and Steeple)*, 1951 Much of Nicholson's later work is purely abstract, austere in form and colour. Here, however, he reverts to the landscape themes that inspired him in the 1920s, and in particular to St Ives, the Cornish fishing town in which he found much of the material for his blend of geometrical meditation and refined landscape drawing.

school of design at Dessau, which revolutionized the applied arts between the wars. Nicholson's contemporaries noted the connection, and felt that his art belonged in such settings. One of the finest of these large-scale works is not a relief but a painting mounted on a curved framework, to act as a screen. It is a typical, minimalist derivation from Cubist still life, a circle and intersecting rectangles in a network of thin black lines on a white ground, with planes of subdued yellow and brown. The screen decorated a café at the 1951 Festival of Britain, and its presence there signalled Nicholson's 'Establishment' status as one of the taste-formers of the post-war age. His work – the carefully balanced colours, the spidery geometry, even the parabolic curve of the screen – helped define the aesthetic of the period. 159

There are links between Nicholson and a contemporary who rarely practised pure abstraction, but who was deeply attached to landscape and produced a parallel, highly personal version of another Continental movement: Surrealism. Paul Nash (1889–1946) had attended the Slade and worked as an official artist in the second half of the Great War. He was the prime mover of a 160

160. **Paul Nash**, *We are making a New World*, 1919
'I have seen the most frightful nightmare of a country more conceived by Dante or Poe than by nature, unspeakable, utterly indescribable . . . no glimmer of God's hand is seen anywhere. Sunset and sunrise are blasphemous, they are mockeries to man . . .'

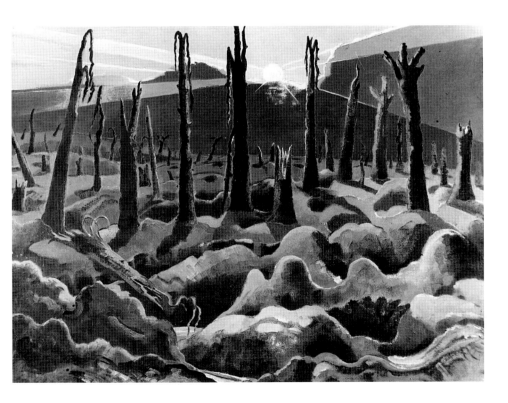

thrusting group of artists who undertook to hold the modernist front in the 1930s. Unit One was founded in 1933, and included Nicholson and two important sculptors, Henry Moore (1898–1986) and Barbara Hepworth (1903–75).

For Nash, nature remained the primary inspiration for painting, drawing and printmaking. At the same time, he saw natural objects with the eyes of the generation of artists who had exulted in modern technology and witnessed its destructiveness in the war. Like Spencer, he came under the influence of the Pre-Raphaelites, especially Rossetti's dreamlike visions. But his contribution is primarily as a landscape painter. His evocations of the blasted woods of Flanders after the armies had shelled them 160 and tramped through their mud are, alongside Spencer's Macedonian subjects, among the most moving images to have been prompted by any war. Nash expressed his sense of horror in a passionate letter to his wife: 'It is unspeakable, godless, hopeless. I am no longer an artist interested and curious, I am a messenger who will bring back word from the men who are fighting to those who want the war to go on for ever. Feeble, inarticulate will be my message, but it will have a bitter truth ...' All Nash's anger is concentrated in the savage irony of the title he gave to *We are making a New World* (1919).

161. **Paul Nash**, *Equivalents for the Megaliths*, 1935
By the 1930s the art of Samuel Palmer had been rediscovered and the intensity of Palmer's intimate identification with nature inspired Nash among many others. Palmer's fecund stooks of corn and swelling moon (see ill. 114) are transmuted, however, into a more ambiguous vision of a half-prehistoric, half-mechanized landscape in which ancient and modern forces are quietly at work.

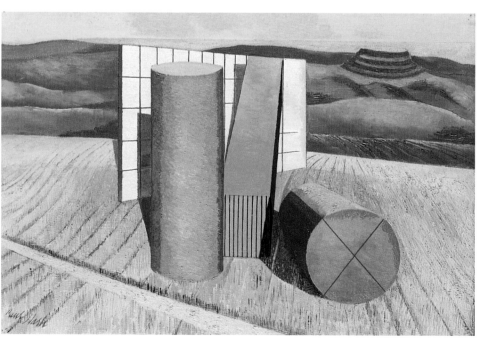

Ever afterwards, English scenery was fraught with ambiguous, sometimes sinister meaning for him. The serene pastoral landscapes of Sussex or his native Buckinghamshire exist in a time-frame of immense extent. They reveal evidence of their ancient origin in the form of bones or megaliths. The immemorial rituals of fire-worship and sun-worship, appearing as cosmic lights, fitfully illuminate the contemporary land. Sometimes Nash imports alien objects into his landscapes, as when he fills a field of stubble with abstract geometrical shapes. At others he depicts the things that belong in the landscape as though they were alien, seeing them with surprise and even shock.

This surprise at natural objects was important to the inter-war generation. It was the age of the *objet trouvé*, the stone or the piece of twisted stick found on the beach and kept as domestic sculpture. The circle round Nicholson, Moore and Hepworth drew continual inspiration from such chance discoveries, and made evident use of them in their work. Moore's immensely influential sculpture can be seen as a celebration of the realization that at a profound level the human body is a paradigm of the physical structures of all nature. So the 'skeleton' of a landscape is revealed in the clear outlines of animal bones or tree roots. But the uncovering of the essence of landscape can have a more disturbing aspect, and many of Nash's pictures imply a darker history of both land and nation.

This sense of the nightmare potential of the natural world, sharpened by the experience of the war, recurs in much work of the period. Edward Wadsworth (1889–1949) had been a Vorticist with Lewis and had, like Nevinson, seen the possibilities for abstract pattern-making in wartime camouflage and artillery emplacements. He now chose to paint monumental piles of found objects like trophies, memorials to the past history of places now silent and deserted. In the carefully burnished mixed-media pictures of John Tunnard (1900–1971) airy constructions, sometimes three-dimensional, are poised above empty landscapes, hovering like alien invaders from an ethereal world of pure geometry.

During the Second World War Nash was again an official artist, inspired once more by the realization in actual life of the ambivalence of nature. His painting of a 'graveyard' for crashed German planes is titled, once again ironically, *Totes Meer (Dead Sea)* (1940–41). Painting the Battle of Britain, Nash was fascinated by the calligraphic arabesques of the vapour trails as the fighters wove about in deadly combat overhead. Like Spencer, he

was searching for the poetic content of a world obscured by ugliness and violence.

L.S. Lowry (1887–1976) also grappled with the ugliness of modern life. He was a minor municipal official in Salford, outside Manchester, and did not need to describe war: the industrial towns of Northern England provided enough bleak subject matter. There too machines dominated the lives of men and women. His views of mills and factory chimneys, starkly presented in a uniform grey light, are self-consciously naive. The people who wander among these gaunt buildings and dot the drab open spaces between them verge on the comic: little matchstick figures absorbed in a joyless parade.

A love of naivety, intended or unintended, was an aspect of the search for that simplicity of utterance so much prized by the artists of the inter-war generation. Ben Nicholson, his artist wife Winifred (1893–1981), Christopher Wood (1901–30), and their associates at St Ives in the late 1920s had discovered the seascapes of an old fisherman, Alfred Wallis (1855–1952). They were well aware of how Picasso and Braque had adopted the 'Douanier' Rousseau two decades earlier. Wallis's little scenes of ship-in-a-bottle schooners engulfed in seas of white impasto seemed to them true because unsophisticated, the honest expression of a seaman's love of his element. Wood, who was also drawn to ships and the sea, painted the fishing villages of Brittany in a direct, almost childlike way, bringing a dreamlike tension to scenes that on the surface are serene and reassuring.

After the war, the interlocking themes of menace and poetry in life and landscape – themes that had been literally present in the everyday life of millions of people for a significant part of the century – dominated the work of British painters for a number of years. Nash's Surrealism, Nicholson's abstraction, Sickert's painterly reportage, all bore significantly on the work of the 1940s and '50s. Spencer continued to paint his wry village epiphanies – often with almost caricature humour – well into the latter decade. But before and during the war there emerged a new dimension, a nostalgia for the England that was being swept away by so much rapid change.

Perhaps the archetypal expression of that nostalgia is the work of Rex Whistler (1905–44), precocious, debonair and sociable, killed in action in Normandy. His decorations for country houses in the 1930s sum up the fading pleasures of the old social order, based on memories of Claude Lorrain and the

Rococo, evoking an eternal idyll of classical pavilions dotted about a perfectly landscaped world. In some of his small paintings, like his self-portrait as St John the Baptist *In the Wilderness* (1939), there is a mood of gentle melancholy that introduces a note quite alien to his charming decorative creations.

A brooding spirituality motivated many landscape painters. The inspiration was Samuel Palmer, whose work, especially his early pen drawings and later etchings, had been rediscovered in the 1920s. For the critic Geoffrey Grigson, Palmer's powerfully felt scenes of rural life constituted 'a visible image of an invisible, hardly attainable blessedness'. Palmer's style was imitated with frank exactness by a number of artists in the 1930s, notably by Graham Sutherland (1903–80), whose early etchings are effectively pastiches of Palmer's. The attraction was no accident. Palmer's influence coincided with an increased consciousness of 'Englishness', a turning away from Continental Modernism with its international, Socialist connotations. The Surrealist approach, typified by Salvador Dalí in his object-filled dream-deserts, could be adapted to Nash's Sussex downland, or to the Welsh mountain valleys that Sutherland knew and loved.

These developments came to be known as 'Neo-romanticism': a movement – if movement it can be called – that approached the English countryside with a nostalgia sharpened by war and the lessons of Surrealism. It also embodied elements of a kind of landscape Expressionism, embodying the intense inner moods engendered by nature in bold painterly effects and strong colour. Another painter of Welsh scenery, John Piper (1903–92), uses pen, ink and gouache in a bold, calligraphic style to evoke the brooding masses of the mountains. Piper was also a prolific topographer, making attractive records of historic buildings in the sprightly manner of a practised theatre-designer. The dreamlike drawings of David Jones (1895–1974) are among the most elusive and subtle of the nostalgic yet disturbing meditations of these troubled years: spidery pen or pencil outlines inspired by William Blake are washed with diaphanous veils of pale colour, as figures from religion and mythology mingle with soldiers and lovers in idyllic and ancient Celtic landscapes. The pull of the landscape idyll changed the work of Ivon Hitchens (1893–1979), too. He had been an out-and-out modernist in his youth, painting precocious abstractions in the 1920s, but in his most characteristic work his relationship with a familiar landscape – that of the Sussex valleys near his home at Lavington Common, Petworth – is more traditional. He thought of himself

114

161

as continuing in the footsteps of the Old Masters, using broad sweeps of a wide brush laden with the rich colours of water, earth and foliage. After 1936 his pictures took on a long horizontal format that became his characteristic 'signature'. 162

Sutherland was converted to Roman Catholicism in 1926: as with so many of the Neo-romantic generation his meditations have transcendental overtones. His experience of industrial scenery and machinery while working as an official war artist between 1940 and 1945 had an effect on him similar to that of First World War scenes on the previous generation: machines seemed monstrous extensions of the natural landscape, the forms of nature became monsters. In T. S. Eliot's play *The Family* 163 *Reunion* (1939) the Eumenides-haunted Harry Monchensey describes this surreal world:

> *a twilight*
> *Where the dead stone is seen to be batrachian,*
> *The aphyllous branch ophidian.*

The human figure, when it appeared in such gaunt and desolated settings, was vulnerable, mutilated. The close of the Second World War in 1945, with its concomitant horrors – the uncovering of the Nazi concentration camps, the explosion of atom bombs over Japan – if anything intensified the dark mood. The action of war was succeeded by the horrified contemplation of what was left. Despairing nihilism became the keynote of much European thinking; Jean-Paul Sartre's Existentialism, with its claim to help people, as Simone de Beauvoir put it, 'to face horror and absurdity while still retaining their human dignity, to preserve their individuality,' spread abroad a mood of aggressive alienation. The distorted figures of Picasso's famous

162. **Ivon Hitchens**, *Winter Stage, Moatlands Park*, 1936

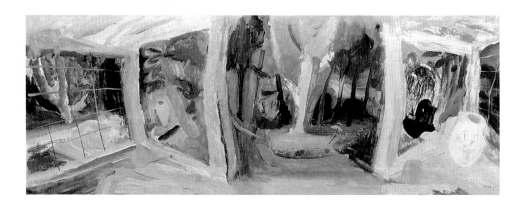

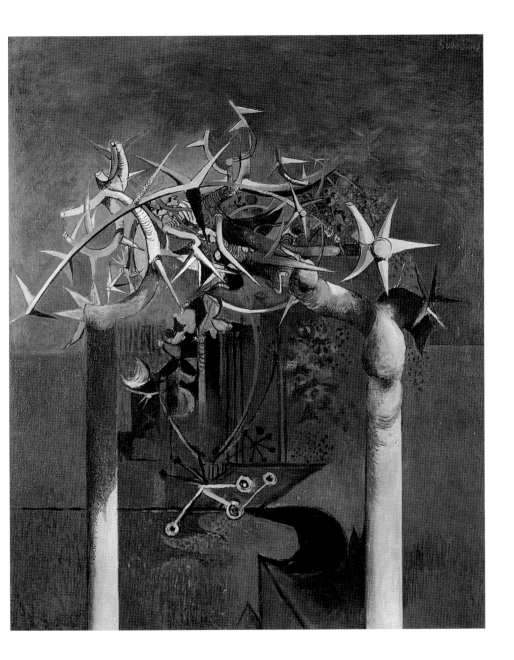

163. **Graham Sutherland**, *Thorn Trees, c.* 1945
The forms are ostensibly natural, but the sharpness and linearity
are those of man-made objects of aggression. The suggestion of a
Crown of Thorns alludes to a motif that was central to the Catholic
Sutherland's sense of human pain and suffering in a world where
redemption seemed remote.

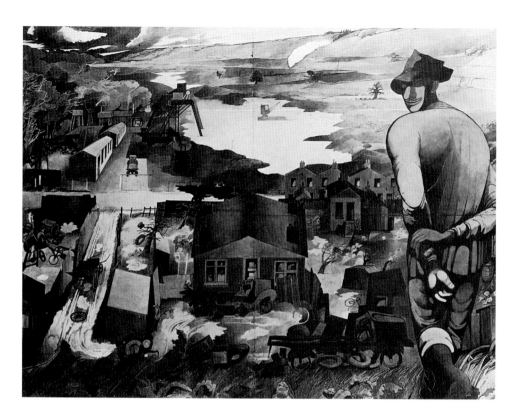

164

164. **Edward Burra**, *Rye Landscape with Figure*, 1947
Burra revived a view of watercolour as the proper medium for grand statements that had been dormant since the early 19th century. His mixture of satirical cynicism and lyrical naturalism in his later work suggests a desire to reconcile the ugliness and cruelty of the 20th century with the courage and warmth that he had seen in his fellow men during the war.

protest against the Spanish Civil War, *Guernica* (1937), exhibited in London the following year, provided a language in which many artists felt they could express their disgust with the world. Ceri Richards (1902–71), John Craxton (b. 1922) and Robert Colquhoun (1914–62) all reflected the powerful influence of Picasso in work that was often, on the surface, pastoral and lyrical, but which underneath was anything but.

An idiosyncratic member of this generation was Edward Burra (1905–76), a sufferer from arthritis from childhood who consequently preferred to work in watercolour, but did so on a large scale, displaying a vigorous feeling for sheer pattern-making. His figure subjects have a strong satirical bite and an almost medieval feeling for the grotesque, the macabre and the menacing; he could also paint landscapes of great breadth in which the ancient forms of the earth are combined with the structures of modern industry to create images of haunting poetry.

All these disturbing developments come to a climax in the paintings of Francis Bacon (1909–92). While nearly all the

'Neo-romantics' were draughtsmen, producing some of their most important work in the form of pen drawings or water-colours, Bacon was essentially a painter. The art of drawing, with its loving examination of form for its own sake, seems almost to contradict the passionate loathing of the human body that emerges from his work. Yet the body was also evidently a source of delight for him. He is one of a significant number of artists of the time who painted the male figure because it was, at least in part, an object of erotic interest.

When Bacon decided to base one of his pictures, *Two Figures* (1953), on a photograph by the experimental late 19th-century American photographer Eadweard Muybridge, he engaged with a tradition of serious study of the human body that had its roots in contemporary science. Muybridge took multiple sequential photographs recording the action of a horse or a

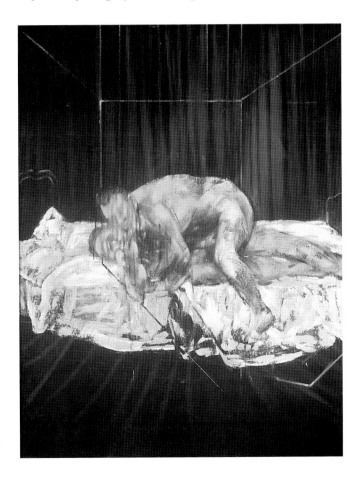

165. **Francis Bacon**, *Two Figures*, 1953

human being running, of men wrestling, and so on. Bacon picks up the quasi-cinematic aspects of Muybridge's procedure in his technique, which involves sweeps of a laden brush that blur and distort the forms, investing them with apparent motion rather as the Futurists had done in their consciously cinematic images. At the same time he transmutes the wrestling subject into one suggestive of an erotic encounter. Such images were familiar from the 'male physique' magazines of the time, which purveyed mildly homoerotic photographs in the guise of athletic activity.

Yet there is nothing mild about Bacon's picture. The two men wrestle – or make love – in a space that is projected on to their bed like a cage, so that they become imprisoned beasts, the surrounding darkness a threatening void. Often in the early pictures a single male figure appears in this cage, not necessarily naked but incongruously dressed in a neat dark suit with tightly knotted tie. This is the portrait of a real person – though we are not told who. Bacon treats historical characters in the same way. His series of studies after Velasquez's portrait of Pope Innocent X show the Pontiff seated, caged, in darkness that washes over him, as he clutches the arms of his throne and screams, mouth wide open. The claustrophobia is palpable, and one feels that the horror of the situation so vividly evoked is a psychological horror of self-loathing.

Bacon's own life was the reverse of saintly. He enjoyed the company of rough diamonds, drank copiously and lived in bohemian chaos, very urban, very London. Brought up a Catholic in Ireland he rejected Christianity, but was attracted to the form of the triptych altarpiece all his life. He found the Crucifixion an immensely satisfying subject, primarily because of its association with 'the slaughterhouse', the 'smell of death' – and, we must add, because of its archetypal presentation of the male nude as the victim of violence. In his *Three Studies for Figures at the Base of a Crucifixion* (1944) the mood of nightmare is conveyed with shocking authenticity: the indefinable emptiness, the impossibility of pinning down any precise detail save the sense of helpless suffering. Bacon's standing as a pre-eminent master of the late 20th century is rooted in his uncanny realization of what it has meant to be human in a terrible epoch.

166

166. **Francis Bacon**, central figure of *Three Studies for Figures at the Base of a Crucifixion*, 1944 Despite the reference in the title to a central element of Christian imagery, Bacon himself suggested that the three studies he exhibited to general shock in 1945 were 'sketches for the Eumenides'. The creatures he invents are indeed like the Furies of Greek myth, indescribably horrible yet faintly human in their blind screaming: vengeful victims of their own natures as much as persecutors of others.

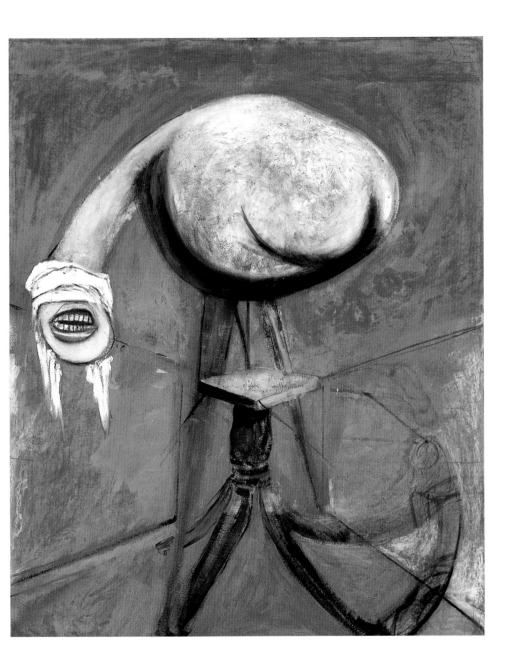

Chapter 9 A New Reality: since 1960

The Cold War between Western and Eastern Bloc powers, which lasted until 1989, ensured that the sense of anxiety that had underlain much of the painting of the 1940s and '50s continued to be felt through the ensuing decades. But the urgency of those early years of horror and disgust, reinforced by economic austerities, was bound to dissipate. The 1960s saw a great increase in national wealth, the spending power of the individual hugely enhanced. Air travel became available to everyone; gramophone records played for longer and every adolescent had the resources to buy them. War receded into the past, but its technological spin-offs were everywhere. The material world of the commercial artefact came to dominate everyone's perception of reality. Television was in most homes, and the commonplace images of daily life were more and more those provided by the news photographer, or invented by the advertising agent. Drug-taking, which had been common in bohemia for a century or more, became modish. The introduction of the contraceptive pill in 1963 rapidly rendered obsolete traditional constraints on sexual behaviour.

In all these matters, American life and culture came to represent a standard to be imitated. American servicemen, still stationed in Britain long after the War, helped to naturalize their way of life. American films were seen on television, American slang heard in the streets. Jimmy Porter, the anti-hero of John Osborne's play *Look Back in Anger* (1957), observes ruefully that he lives in 'the American age'. In the arts, that age was announced in the work of the 'Beat' poets and novelists round Jack Kerouac and William Burroughs, and the New York School of Abstract Expressionist painters, led by Mark Rothko and Jackson Pollock. Pollock's grand canvases, articulated with all-embracing gestures of the painting arm, often using bucketfuls of paint splashed and dripped in swirls and spirals, are perhaps Existentialist exercises like the less titanic work of his contemporaries in Europe. But they are also positive, assertions of the energy of creativity, or, in Rothko's case, of the spiritual heights and depths to be plumbed in the contemplation of a subtly coloured void.

This positive energy was something that appealed to Patrick Heron (1920–99), who is one of the few British painters to have been associated directly with the New York group. In the later 1950s he abandoned the figure subjects and still lifes inspired by Braque and Matisse that he had been painting and started to make large abstracts, often at first 'stripe paintings', tall piles of many-coloured brushstrokes, which were early reflections of the developments in New York; Heron himself claimed to have arrived at this point independently, and to have led the way for some of the Americans.

167

He lived for much of his life in or near St Ives, which had been home to many of the most perceptive landscape painters of the pre-war years, notably Ben Nicholson. His pictures of the late 1950s and early '60s are like blurred, strongly coloured reminiscences of Nicholson's neat geometries. They have something in common with the work of another painter associated with St Ives, William Scott (1913–89), who was preoccupied with the abstract implications of the still life: a pan or jug on a table is seen in plan, as if from the air, and becomes the basis of a much simplified arrangement of colours and shapes. Heron's abstractions became very large indeed in the 1970s and '80s. They consist of cheerfully coloured pink, blue or yellow patches floating in and out of each other, managing to graft their Americanness onto an unforced freshness and sense of natural beauty that is entirely English.

159

Many painters continued to find inspiration at St Ives, and developed a tradition of abstraction that deserves more recognition. Roger Hilton (1911–75) and Terry Frost (b. 1915) are among the distinguished artists to have worked there since the war. The ebullient *joie de vivre* that characterizes much of their work testifies to a mood of contentment, if not optimism, that pervades much St Ives painting. In Peter Lanyon (1918–64) the town had a native son, trained in Cornwall, who like Nicholson was happy to blend painting and sculpture in a free, expressive way that led him naturally to large abstract works drawing on the characteristics of the local landscape. He met Rothko in New York in 1957, and in scale and breadth his work has links with the New York artists. But his paintings typically have the colours of the English country and seaside – swirling greens and browns shot through with blue and white, the paint thick and energetically applied in big, open-air strokes. These pictures physically embody Lanyon's concern with the organic cycle of life, death and rebirth, and they evoke the outdoors, the rush of

168

167. **Patrick Heron**, *Various Blues in Indigo*, 1962
Heron's mature paintings are exultant celebrations of pure colour, often referring to landscape or, especially later in his career, to gardens.

168. **Peter Lanyon**, *Glide Path*, 1964

fresh wind. It is perhaps poetically appropriate that Lanyon died as the result of a gliding accident.

St Ives, with its white, slate-roofed cottages and narrow streets, intricately winding harbour front and wide bays, seems to have possessed an extraordinary capacity to lead artists forward in the search for a language to express their strong sense of these eloquent surroundings. The inspiration was crucial, since the question of abstraction had not been resolved. Was it an inevitable development, the goal to which every serious painter and sculptor must tend? Or was there always to be an underlying reference to that demanding reality outside? In St Ives it was possible to have it both ways. The place was a kind of abstraction of itself, asking to be drawn and painted. Victor Pasmore (1908–98) visited the town in 1950, and about that time broke decisively with representation, abandoning his delicately coloured, poetic Thames scenes and solidly modelled figure studies for pure abstraction, which he pursued with evangelical vigour as Director of Painting at the Art School of the University of Newcastle-upon-Tyne. He adopted the new international language of non-representational art, in which he was at once word perfect. But he deliberately allowed his pieces, whether paintings, collages or relief sculptures, to bear

169

169. **Victor Pasmore**, *Brown Development (Peat)*, 1966

the marks of 'do-it-yourself' construction – splintered edges, visible glueing – that are a stamp of authenticity running counter to the ostensibly 'mechanical' quality of these pared-down, ingenious exercises in pure composition.

Before this, in 1937, Pasmore had been a founder of the Euston Road School with William Coldstream (1908–87) and Claude Rogers (1907–79) in an attempt to get away from the uncertainty about abstraction and representation. Although they admired much of what had been achieved recently, they felt that painting should be comprehensible to the uninitiated. Coldstream was much affected by the social problems raised by the economic depression of the '30s. He felt that a truly left-wing art must be generally accessible, not the rarefied intellectuality of abstraction. 'I became convinced that art ought to be directed towards a wider public', Coldstream wrote. 'Whereas all ideas I had learned to be artistically revolutionary ran in the opposite direction.' His own method of dealing with the problem was to subject reality to a careful scrutiny, a measuring by eye, which was transferred to the canvas by means of a half-notional, half-real grid. The grid, which a Euston Road pupil, Lawrence Gowing (1918–91), referred to as a 'scan', gives the pictures a faintly mechanical look that perhaps helps to validate an appeal to modernity if not Modernism. Gowing talked of 'an aesthetic of verification', and it is apt that contemporary British philosophy was much taken up with 'Verificationism'. A pragmatic need to state only what is confirmably true permeates Euston Road pictures.

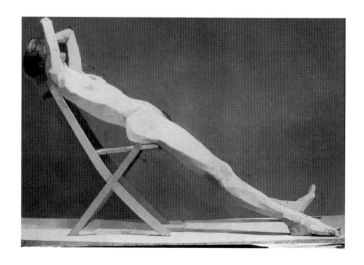

170. **Euan Uglow**, *The Diagonal*, 1977
Uglow takes to an extreme of concentration the Euston Road School's stress on drawing as a means of understanding the visible world. It is this imperative that dictates his spare compositions.

Another disciple of Euston Road, Euan Uglow (1930–2000), solved the problem by drawing the human body with a ruthlessly systematic objectivity. His 'scan' measures and partitions out head, limbs, torso as elements in a space which seems to imply that there is an exact answer to the question: how do all these parts relate to each other? There is no room for chance; the results are breathlessly balanced, ordained by an inexorable intellectual process. Despite the presence of the figure, this is essentially abstract painting.

The master who bestrode the modernist and traditional worlds was Stanley Spencer, and it isn't surprising that some artists found his example valuable in the struggle to forge a workable personal style. Norman Blamey (1914–2000) made Spencer's monumental figure compositions his starting-point, working out complex spatial designs in a bold, simplified language. He also followed on from Spencer's profound religious involvement. His life's work was dominated by a series of paintings recording the rituals of the High Anglican Church. His *Scene during the Deanery Mass at St Pancras Old Church, '. . . and* *was incarnate'* (1960) is a powerful example. Religious themes have not been by any means dead in 20th-century Britain. Vanessa Bell and Duncan Grant, in the latter part of their careers no longer avant-garde, made large-scale murals for Berwick church, near Charleston, their house under the Sussex Downs. In Kent, at the little country parish of Challock, John Ward (b. 1918) executed a lyrical series of *Scenes from the Life of Christ* (1958), set in the local countryside and with a cast of local

171. **Norman Blamey**, *Scene during the Deanery Mass at St Pancras Old Church, '. . . and was incarnate'*, 1960 Blamey's inspiration in the offices of the Anglo-Catholic church led him to the art of Byzantium, whose hieratic figures and ambiguous spatial settings he adapts, while recognizing the ingenious geometry and purity of form that are characteristic of the Italian quattrocento, especially as found in the work of artists like Piero della Francesca. In this picture, which records a specific moment in the Mass, he may have been inspired by Spencer's 'sacramental' war painting *Travoys* of 1919 (ill. 157), with its prostrate figures lying in parallel.

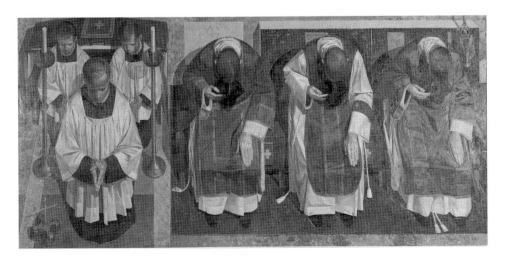

172. **David Hockney**, *Tea Painting in an Illusionistic Style*, 1961
The canvas takes the shape of the Ty-phoo tea packet, symbol of ordinary domesticity, a reminder of life at home with mother and father – characters who appear significantly often in Hockney's work. The imagery of the tea packet is an ironic echo of the glitzier advertising slogans that characterized paintings by American Pop artists at the same period.

people. For many years the walls of the Royal Academy showed paintings by Carel Weight (1908–97) which give voice to a more uneasy, late 20th-century spirituality, setting events of a vaguely transcendental nature in the drab landscapes of suburban London.

These artists found their respective voices very largely by opting out of the intellectual battles of the period, and by ignoring its glossy commercialism. For those who engaged in the debate it was this that provided the inspiration for a more complete grasp of reality. In the 1950s a 'Kitchen Sink' school had arisen which took Sickert's love of domestic squalor a stage further: the coarsely handled pictures of John Bratby (1928–92) and Jack Smith (b.1928) glory in the actuality of stub-filled ashtrays, bathroom fittings and messy kitchens. In both America and England a wealth of messages from the street – road signs, advertisements, newspaper photographs – was finding its way into the images of what quickly became known as Pop Art. Oil paint did not go out of fashion, but the new, industrially produced acrylic, with its clean, smooth texture and easy application, offered an appropriately shiny alternative.

In the mid-1950s Peter Blake (b.1932) began to incorporate postcards and magazine covers into his pictures, creating a hybrid of painting and collage – a technique that has its roots in Cubism. From the beginning Pop Art embodied the tensions of the new Anglo-American culture. Blake's *Girls and their Hero, 1959 (Elvis)*, painted in acrylic, records in images borrowed from newspapers and popular magazines the overwhelming British enthusiasm for American commercial music, Rock 'n' Roll and Elvis Presley. In *Self-portrait with Badges* (1961) Blake identified himself in terms of his current affiliations, interests and loyalties as affirmed by the collection of iconic tin badges he shows pinned on his clothes. The self-conscious youthfulness of artist and accoutrements is representative of the moment.

The Pop movement received a powerful impetus from the friendship of an English and an American artist. R. B. Kitaj (b. 1932) had come to London from the States in 1957 and entered the Royal College of Art where he met David Hockney (b. 1937). Hockney's student work was in a conscientious Euston Road vein. His adoption of a Pop manner towards the end of the decade was a striking transformation. Smeared surfaces like old urban walls, covered with random graffiti, become the backdrops to louche encounters, or sometimes constitute the entire picture. *Tea Painting in an Illusionistic Style* (1961) incorporates

173. **Peter Blake**, *Girls and their Hero, 1959 (Elvis)*, 1959
The format that Blake adopts here is part comic strip, part scrap-
book. His pictures are often composite images constructed from
photographs and found objects; but as in many early Pop art
images, there is a strong impulse towards the painted mark.

the homely Ty-phoo tea packet, placing this version of Pop, for all its Bacon-like ambiguities of space and image, unmistakably in a cosy lower middle-class England rather than in the nervy streets of Manhattan. Kitaj, by contrast, was a cosmopolitan, combining ideas taken from literature, philosophy and art history into kaleidoscopic satires on the modern world that are shot through nonetheless with human compassion. This sympathy warms his beautifully drawn and thoughtful portraits. Hockney too is a fine draughtsman and during the 1970s produced a succession of sensitive studies of his friends and their contrasting domestic surroundings in London and Los Angeles. He quickly succumbed to the attractions of American life and moved to California, where he made pictures that evoke with an entirely appropriate obviousness the sun-drenched, leisurely lifestyle of poolside and palm-lined boulevard. The transformation from muddy, slurred pigment to brilliant, primary-coloured clarity is a remarkable response to the changed environment.

The gentle irony of these artists gives way to a fiercer satire in the work of Allen Jones (b. 1937), who has been obsessed by the use of the female figure in commercial art and the sex industry. The obviously erotic purpose of these images is satirized in his sharp-breasted, fishnet-legged but often significantly

174. **David Hockney**, *Peter getting out of Nick's Pool*, 1966 Hockney quickly moved away from the gestural, vernacular art of his Pop phase to formulate an equally witty but more restrained response to the colourful, sybaritic lifestyle of Los Angeles, where he went to live in 1964. The surface gloss of that lifestyle becomes the medium through which he perceives his friends and their activities: forms are simplified and crisply defined as in the images of advertising.

faceless figures with their gaudy colour and slick outlines. There is irony, too, in the social comment of Richard Hamilton (b. 1922), whose images, often based on press photographs and advertisements, distil the ethos of the anti-Conservative satire that spread through the media in the 1960s. Patrick Caulfield (b. 1936) comments more suavely on the vernacular 'bad taste' and the monotony of the surroundings we have become used to in a world of mass-production.

'I love Sickert's London,' Kitaj has said. 'I could eat it up. I wish I were there (sometimes I am).' He added that he loved 'the lunacy of his late style too', and it is worth remembering that

175. **R. B. Kitaj**, *Kenneth Anger and Michael Powell*, 1973
Kitaj's paintings are replete with his current preoccupations, colourful jigsaws of his intellectual and emotional life, for which the characters he draws become surrogates. His portraits are often records not so much of likenesses as of the social and psychological ambience of the sitters. The two film-makers Kenneth Anger and Michael Powell are caught here in passing, accidental ingredients, as it were, in a vernacular scene which imposes its own rhythms on their existence, independent of their personalities or their creative achievements.

Sickert had pioneered the use of newspaper photographs as the 144 basis for pictures back in the 1930s. The identification of a recognizable 'London' quality in painting owes much to the presiding genius of Sickert, though the so-called 'School of London' that flourished in the '70s couldn't be said to have a single style or approach. Under its umbrella have been grouped many of the artists discussed in different places here according to their preoccupations. Perhaps the coarsely handled swimming-bath or tube-station scenes of Leon Kossoff (b. 1926), with their very heavy impasto and urgent spontaneity, continue to see London through Sickertian eyes. We encounter similarly dense paint in the work of Frank Auerbach (b. 1931), whose technique, like 176 Kossoff's, derives from the later style of Bomberg, who taught them both at the Borough Polytechnic. Like Kossoff too, he chooses London subjects – its people and its landscapes. It is a rewarding experience to penetrate the apparent confusion of Auerbach's contorted surfaces to discover the firm, tautly disciplined structures beneath, whether of a face or of a tree on

176. **Frank Auerbach**, *Primrose Hill*, 1967–68
Like many of the 'School of London' artists, Auerbach is concerned less with the surface appearance of the world around him than with its inherent or unseen structure. His paintings grapple with the problem of uncovering such structures, but are also, often, lyrically colourful and expressive of a real open air – this is not merely a formal landscape, but a place where Londoners take exercise and fly kites or model aeroplanes.

Hampstead Heath. Michael Andrews (1928–90) by contrast uses paint with great delicacy, specializing in the traditional subject matter of urban daily life, group portraiture and topographical landscape, albeit working on canvases that are sometimes very large.

All these developments had their parallels in the progress of abstraction. The careful scrutiny and measurement of Coldstream's studies of the everyday world are matched in the work of Kenneth Martin (1905–84) and his wife Mary (1907–69), whose paintings and reliefs are a development from Mondrian and Russian Constructivism. They built up their compositions by means of mathematical calculations, placing minimal marks – lines, blocks or spaces – on the canvas not as a consequence of aesthetic decisions but following a carefully planned sequence of 'sums'. The resulting patterns are cool and dry but, in Kenneth Martin's case, surprising and sometimes highly expressive in their understated way. They extend themselves naturally into three dimensions in the form of delicately balanced mobile sculptures. The paintings of Mary Martin, equally coolly calculated, possess a rare stillness and equilibrium.

Likewise, the bold, sassy commentaries of Pop Art on the imagery of commerce and the media found a counterpart in the abstractions of Bridget Riley (b.1931). Riley has been a single-minded exponent of the international Op Art movement that enjoyed its heyday in the 1960s and '70s. This was an approach to abstraction that concentrated on rigid but subtle geometry and optically startling colour combinations. Riley began painting in black and white alone, titillating the eye with finely modulated 177 stripes or dots that seem to flicker, fade or fold out of view as one looks. Her cool, hard objectivity took her so far as to employ assistants in the actual application of paint: the artist's personality, and all representational reference, are deliberately eliminated to an extent that has been unusual in British abstraction – compare Pasmore's anxiety to retain his personal imprint. Mondrian's grids lie at the root of Riley's approach, but it is interesting that when she attempted to make a copy of his *Broadway Boogie Woogie* she abandoned it, unable to feel her way into Mondrian's creative processes. Her own abstract language is, then, essentially different, and it is one of the most original of the post-war period.

At the opposite pole from Riley and the Martins is the lushly sensuous painting of Howard Hodgkin (b. 1932), who has 178 sustained the native tradition of abstraction founded on

representation: the nudes and still lifes of Matthew Smith and the watery landscapes of Hitchens all seem to have influenced him. He has painted portraits, interiors, landscapes, all transformed into glowing cauldrons of colour, variegated with polka dots and molten rainbows, in which the very glossiness of the paint contributes to the luxuriant effect. He has spent much time in India, and the brilliant patterns of Indian fabrics play an important part in his work. Even his frames are painted, extending the opulent breadth of his brushwork beyond the picture space and into the room. A younger exponent of the values of lusciously applied pigment is Therese Oulton (b. 1953), whose often large canvases are inundated by tides of rippling paint, floods of rich, sombre colour illuminated by intermittent flashes of fitful light.

Another abstractionist of Oulton's generation, Christopher Le Brun (b. 1951), reflected some of the preoccupations of the New York school in his large, brooding, loosely painted canvases; though his shadowy spaces usually evoke the transcendental in more concrete ways. Recently, especially, he has introduced strong representational elements, often taken from those Symbolist favourites Wagner and Dante. The abstract merges effortlessly into the musical expressionist.

177. **Bridget Riley**, *Loss*, 1964
In Riley's work the subtle evolution of a pattern of dots from one tonal level to another, or the slow modification of simple forms, is like the gradually changing motifs of some post-modern music, repetitive but endlessly different. With its denial of the brushstroke and of colour (the image is black on white), and its insistence on mathematical precision, this is an aesthetic of extreme refinement, the high point of the movement to pure abstraction.

178. **Howard Hodgkin**, *Chez Max*, 1996–97
Hodgkin has said that his subject matter 'is simple and
straightforward. It ranges from views through windows,
landscapes, even occasionally a still life, to memories of
holidays . . . and emotional situations of all kinds . . .
seen through the eyes of memory they must be
transformed into . . . pictures using the traditional
vocabulary of painting'.

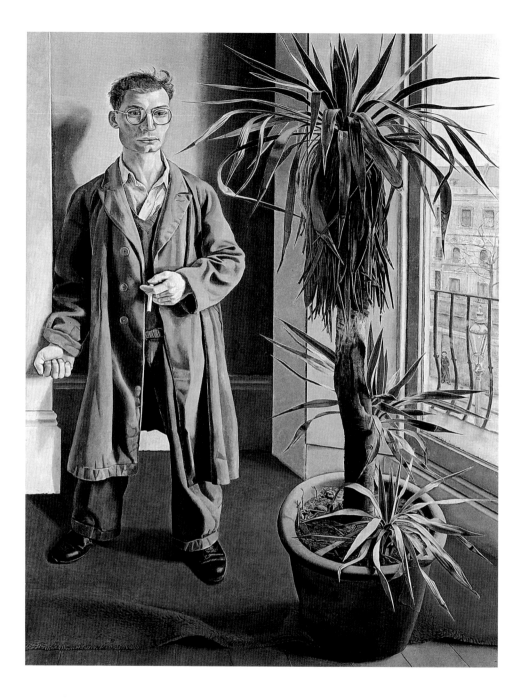

Le Brun's move away from the wholly abstract to a representational account of the more ineffable aspects of human longing, nostalgia or pain is symptomatic of an increasing plurality of approach in the last years of the century. Perhaps it is no accident that the presiding genius of painting in Britain at the end of the century is an older artist who has insisted repeatedly on the virtues of the art school – an institution that had seemed seriously threatened in the iconoclastic '60s and '70s. Lucian Freud (b. 1922) came from Vienna with his family in the 1930s, and his early work breathes Surrealism and *Neue Sachlichkeit*, shot through with the tense anxiety of the early post-war years. But already in his portraits of the 1950s there is an uncompromising fascination – obsession is not too strong a word – with the minute details of the human body. Over the years the scrutiny has become more microscopic, drawing remorseless attention to every vein and pore. We are sometimes

179

180

179. **Lucian Freud**, *Interior in Paddington*, 1951
The figure is a portrait of Freud's friend Harry Diamond, who later became a photographer. There is a surreal stillness in Freud's early paintings, but he came to feel that Surrealism and 'the rigid dogma of its irrationality, seemed unduly limiting. I could never put anything into a picture that wasn't actually there in front of me. That would be a pointless lie, a mere bit of artfulness.'

180. **Lucian Freud**, *Naked Girl with Egg*, 1980–81
In Freud's later studies of the nude, links with Spencer (ill. 156) are real, though Freud's involvement is not emotionally compromised, but is essentially that of the painter. Freud has said: 'I am only interested in painting the actual person; in doing a painting *of* them, not *using* them to some ulterior end of art. For me, to use someone doing something not native to them would be wrong.'

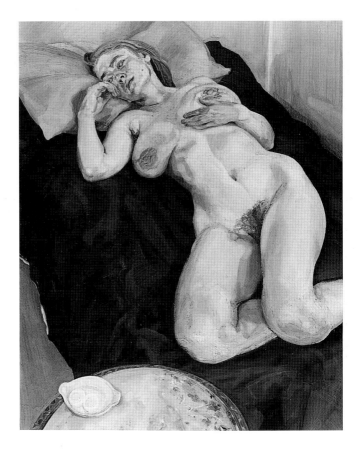

reminded of Spencer's earthy nudes, and of his explicit comparison of human with dead animal meat – not perhaps as far from the preoccupations of Bacon as might at first appear. In the long run it has never been necessary for Freud to leave the art school: all his materials are there. The willing model, candidly exposing him- or herself to the artist's intense observation, the significantly unimportant surroundings – a sofa, a roughly draped bed, bare boards. All of this is of ancient lineage, and Freud makes no attempt to dress his subject matter up as modern. Yet it is modern by the very nature of his gaze – uncensoring, unshockable, compassionate. These are the qualities on which we pride ourselves in the aftermath of a liberation that we are still trying fully to understand.

Freud has painted many portraits, though he is not a portrait painter in the old-fashioned sense: he does not cater to self-love, and wishes to flatter no one, least of all himself. It was his grandfather, Sigmund Freud, who made the métier of society portrait painter almost impossible in the 20th century. Now the painter of the human face is almost obliged to set forth his own psychology whatever his ostensible subject. The portraits of Auerbach with their tortured, heavily worked paint are a case in point. But for this reason we should give credit to the many artists who continue to fulfil the function of social portrait painter. They do so in a world that makes it increasingly difficult to respect the old agendas of power, status and wealth that dictated the parameters of portraiture. It is typical of British patronage of painting that portraiture remains a preference. The desire for a recognizable likeness is as strong as ever. Blamey and Ward are among those who have produced technically accomplished portraits for purposes of record, and Howard Morgan (b. 1949) has reworked the tradition of glossy flattery so effectively exploited by Lawrence and Sargent to create a style very much of its media-conscious moment.

Freud's example has stimulated a fresh interest in the figure, and indeed the last decades of the century saw a revival of subject painting, as in the enigmatic, often Surrealist landscapes and interiors of Stephen McKenna (b. 1939), and the fantasies of Ken Kiff (1935–2001), whose fairy-tale stories, some with a Grimm-like horror to them, some comic, are told in simple, childlike forms and vibrant, unmixed hues, often using a dense yet luminous watercolour. Something of the same love for children's tales has motivated Paula Rego, born in Lisbon in 1935, who trained at the Slade under Coldstream. She brings an

Iberian feeling for the macabre to her work. In her elaborate compositions large-scale figures enact the surreal dramas of private, often painful or squalid lives, and social misfits acquire a haunting beauty under her affectionate scrutiny.

We have seen how some 20th-century painting – by Nicholson, Martin and others – has tended to lead naturally to sculpture. In recent decades the boundaries between the various media have become increasingly blurred, many artists working in several together. The camera has played a more and more prominent role: still photography, film and video have all entered the arena of mixed-media creativity. Conceptual art has tended to steal the limelight, notably among the 'Britpack', a highly publicized group of *enfants terribles* who emerged in the 1990s, reinventing the old techniques of the avant-garde: bizarre incongruities, everyday objects or pornography are deployed to explore the increasingly diverse experience of

181. **Ken Kiff**, *Pink Landscape with Horse*, 1992–96
The story-book whimsy of Ken Kiff's work emerges from a strain in British painting that had been overlooked during the earnest years of the 20th century search for a higher truth in art. This is a return to the dream world of the Victorian painters of magic and fairyland (ill. 127), and to the legacy of the Edwardian illustrators of children's books. Yet it does not ignore the dark side of things: Kiff's fairy-tale landscapes are peopled with demons as well as enchanted beasts and blossoming trees.

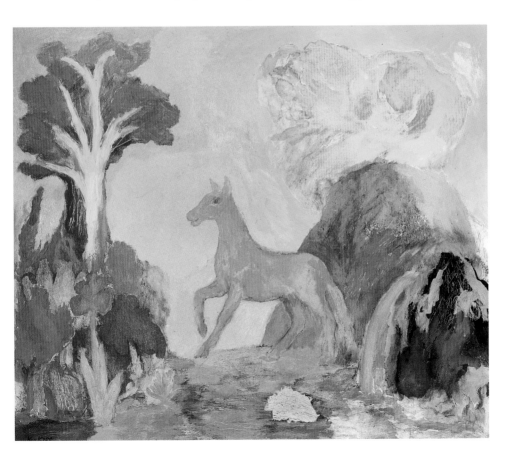

modern life. Yet despite this explosion of technical means, many younger artists have adopted painting as an appropriate medium for their reflections on the world. But the mood of the time has been shot through with a self-conscious awareness of the art of past epochs, and there is a steady undercurrent of ironic borrowing, a post-modern love of deconstructing traditional concepts and methods of working.

One of the more overtly traditional of these younger painters is Peter Doig (b. 1959), who reverts to the recognizable language of the landscape with figures, playing with the patterns of trees against snow (winter sports are a frequent theme), or the interrelationship of natural and architectural forms. Gary Hume (b.1962) revives some of the brasher aspects of the Pop movement in images that draw much of their effect from a boldly simplified abstraction, projected in the attention-grabbing colours and shapes of advertising.

The desire to offer a critique of recent art-history takes an interesting form in the abstractions of Fiona Rae (b. 1963). 182 Her compositions can be read as deconstructions of many

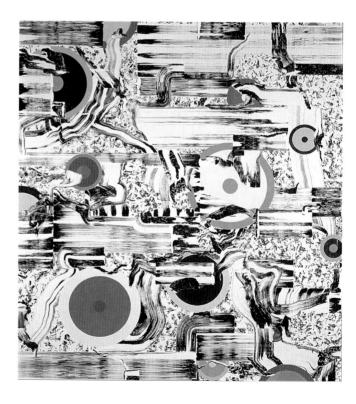

182. **Fiona Rae**, *Untitled (Sky Shout)*, 1997
In this canvas Rae's random vocabulary of abstract motifs is brought into balance by the combination of opposing elements: a bold, gestural texture is underpinned by a scattering of circles whose geometrical regularity can be read as ancient forms half eroded or concealed by subsequent convulsions.

183. **Jenny Saville**, *Fulcrum*, 1999
Saville approaches the female body with a blend of awe – reflected in the huge size of some of her canvases – and tenderness. She has explained: 'I want that child-like intimacy, as if you were in your mother's arms. Yet I also want the feeling of discomfort and anxiety living with contemporary flesh.'

20th-century movements, and allude variously to Picasso, to Bacon, to Pollock. They are built from motifs connected by what appears to be chance. The effect is of taking the possibilities of abstraction to their limit. As one commentator has said, 'Where are the words for such spaces, eruptions, such meandering transformations and clueless moments?. . . here is calligraphy shorn of useful meaning yet brimming with verve . . .' Starting from a very different position, Jenny Saville (b. 1970) takes Freud's anatomies of the human frame a step further, presenting her vast female nudes in Brobdingnagian close-up, distorted and sometimes deformed like mutants.

183

Despite the prophecies of its imminent demise that have been current for nearly a hundred and fifty years, painting is not yet dislodged from its unique position among the visual arts, and continues to attract serious practitioners while reflecting, with the due thoughtfulness of an older sibling, many of the innovations of contemporary multi-media art. Abstraction pursues its mission to probe the more ineffable aspects of thought and experience, while in a revitalized figurative tradition our humanity is once again examined in terms of individuals and their interaction. Things are rarely exactly what they seem: these artists draw attention to the oddness of life, and of the people who live it: of ourselves. A searching engagement with human reality is vital for the recharging of the batteries of art, and there can be no end to that encounter.

Select Bibliography

The place of publication is London unless otherwise stated. Many of the more recently published volumes contain bibliographies that will lead the reader to more specialized works.

NG National Gallery, London
NPG National Portrait Gallery, London
RA Royal Academy of Arts, London
Tate Tate Gallery, London

General

N. Alfrey and S. Daniels, eds, *Mapping the Landscape: Essays on Art and Cartography*, University Art Gallery, Nottingham, 1990

British Sporting Painting, exh. cat., Arts Council of Great Britain, 1974

M. Clarke, *The Tempting Prospect, A Social History of English Watercolours*, 1981

E. Croft-Murray, *Decorative Painting in England 1537–1837*, 1962, 1970

N. Everett, *The Tory View of Landscape*, New Haven/London, 1994

D. Foskett, *British Portrait Miniatures, a History*, 1963

R. Fry, *Reflections on British Painting*, 1934

M. Hardie, *Water-Colour Painting in Britain*, ed. D. Snelgrove with J. Mayne and B. Taylor, 1966–68

J. Harris, *The Artist and the Country House: A History of Country House and Garden View Painting in Britain 1540–1870*, 1979, rev. edn 1985

S. C. Hutchison, *A History of the Royal Academy 1768–1968*, 1968, rev. edn 1986

R. Hyde, *Panoramania!*, exh. cat., Museum of London, 1989

D. Macmillan, *Painting in Scotland: The Golden Age*, Oxford, 1986

L. Parris and C. Shields, *Landscape in Britain*, exh. cat., Tate, 1973

The Queen's Pictures: Royal Collectors through the Centuries, exh. cat., NG, 1991

M. Rosenthal, *British Landscape Painting*, Oxford, 1982

B. Taylor, *Animal Painting in England from Barlow to Landseer*, Harmondsworth, 1955

E. K. Waterhouse, *Painting in Britain 1530–1790*, 4th rev. edn, Harmondsworth, 1978

W. T. Whitley, *Artists and their Friends in England 1700–1799*, Cambridge 1928, New York/London, 1968

1 The Tudors

M. Aston, *England's Iconoclasts*, Oxford, 1988

E. Duffy, *The Stripping of the Altars: Traditional Religion in England 1400–1580*, 1992

M. Edmond, *Hilliard and Oliver: The Lives and Works of Two Great Miniaturists*, 1983

K. Hearn, ed., *Dynasties*, exh. cat., Tate, 1995

Holbein and the Court of Henry VIII, exh. cat., Queen's Gallery, London, 1978

K. T. Parker, *Drawings by Holbein at Windsor Castle*, 1945

J. Rowlands, *Holbein; The Paintings of Hans Holbein the Younger* (with cat. raisonné), Oxford, 1985

R. Strong, *Holbein and Henry VIII*, 1967
——, *The Cult of Elizabeth*, 1977

2 The Stuarts

C. Brown, *Van Dyck*, exh. cat., NG, 1999

D. Foskett, *Samuel Cooper 1609–1672*, 1974

R. Godfrey, *Wenceslaus Hollar*, exh. cat., British Museum, London, 1995

D. Howarth, *Lord Arundel and His Circle*, New Haven/London, 1985

O. Millar, *Sir Peter Lely 1618–80*, exh. cat., NPG, 1978

M. Rogers, *William Dobson 1611–46*, exh. cat., NPG, 1983

A. J. Wheelock Jr, S. J. Barnes and J. S. Held, *Anthony Van Dyck*, exh. cat., National Gallery of Art, Washington, D.C., 1990

3 The Age of Improvement

B. Allen, *Francis Hayman*, New Haven/London, 1987

F. Antal, *Hogarth and his Place in European Art*, 1962

D. Bindman, *Hogarth*, 1981

D. Cordingly, *The Art of the Van de Veldes, Paintings and Drawings by the Great Dutch Marine Artists and their English Followers*, exh. cat., National Maritime Museum, Greenwich, 1982

E. Einberg, *Manners and Morals*, exh. cat., Tate, 1990

W. Hogarth, *The Analysis of Beauty*, ed. J. Burke, Oxford, 1955

R. Paulson, *Hogarth, His Life, Art and Times*, New Haven/London, 1971

I. Pears, *The Discovery of Painting: The Growth of Interest in the Arts in England, 1680–1768*, New Haven/London, 1988

J. Richardson, *An Essay on the Theory of Painting*, 1715, 2nd edn 1725

D. Solkin, *Painting for Money: the Visual Arts and the Public Sphere*, New Haven/London, 1993

J. D. Stewart, *Sir Godfrey Kneller*, 1983

4 The Age of Industry

M. Andrews, *The Search for the Picturesque: Landscape Aesthetics and Tourism in Britain 1760–1800*, Aldershot/Stanford, 1989

M. Archer, *India and British Portraiture 1770–1825*, 1979

K.Baetger and J. G. Links, *Canaletto*, exh. cat., Metropolitan Museum of Art, New York, 1989

H. Collins Baker, *Crome*, 1921

J. Barrell, *The Political Theory of Painting from Reynolds to Hazlitt: 'The Body of the Public'*, New Haven/London, 1986

P. Bicknell, *Beauty, Horror and Immensity: Picturesque Landscape in Britain, 1750–1850*, exh. cat., Fitzwilliam Museum, Cambridge, 1981

D. Bindman, *Blake as an Artist*, 1977

M. Butlin, *The Paintings and Drawings of William Blake* (cat. raisonné), New Haven/London, 1981

J. Egerton, *George Stubbs 1724–1806*, exh. cat., Tate, 1984
——, *Joseph Wright of Derby*, exh. cat., Tate, 1990

Henry Fuseli 1741–1825, exh. cat., Tate, 1975

A. Gilchrist, *The Life of William Blake*,1863, Everyman edn 1942

F. Haskell and N. Penny, *Taste and the Antique*, 1971

F. Hawcroft, *Travels in Italy, 1776–1783: Based on the Memoirs of Thomas Jones*, exh. cat., Whitworth Art Gallery, Manchester, 1988

L. Herrmann, *British Landscape Painting of the Eighteenth Century*, 1973
——, *Paul and Thomas Sandby*, 1986

D. Mannings, *The Paintings of Sir Joshua Reynolds* (cat. raisonné), New Haven/London, 2000

B. Nicolson, *Joseph Wright of Derby: Painter of Light* (with cat. raisonné), 1968

N. Penny, ed., *Reynolds*, exh. cat., RA, 1986

W. L. Pressly, *James Barry*, New Haven/London, 1981

Sir J. Reynolds, *Discourses on Art*, ed. R. R. Wark, New Haven/London, 1975

M. Rosenthal, *Gainsborough*, New Haven/London, 1999

W. W. Roworth, ed., *Angelica Kauffman: A Continental Artist in Georgian London*, 1992

A. Smart, *Allan Ramsay: Painter, Essayist and Man of the Enlightenment*, 1992

D. Solkin, *Richard Wilson: the Landscape of Reaction*, exh. cat., Tate, 1982

E. Waterhouse, *Gainsborough*, 1958, new edn 1966
——, *Reynolds*, 1973

5 Romantic Virtuosos

E. Adams, *Francis Danby: Varieties of Poetic Landscape*, New Haven/London, 1973

A. Bailey, *Standing in the Sun: A Life of J. M. W. Turner*, 1997

M. Butlin and E. Joll, *The Paintings of J. M. W. Turner* (cat. raisonné), New Haven/London, 2nd edn 1982

D. Farr, *William Etty*, 1958

J. Gage, *A Wonderful Range of Mind*, 1987

K. Garlick, *Sir Thomas Lawrence: A Complete Catalogue of the Oil Paintings*, Oxford, 1989

Benjamin Robert Haydon 1786–1846 Painter and Writer, Friend of Wordsworth and Keats, exh. cat., The Wordsworth Trust, 1996

K. M. Heleniak, *William Mulready*, New Haven/London, 1980

E. Joll, M. Butlin, and L. Herrmann, eds, *The Oxford Companion to J. M. W. Turner*, 2001

C. R. Leslie, *Memoirs of the Life of John Constable, composed chiefly of his Letters*, 1843, 2nd edn 1845; modern edn ed. J. Mayne 1951

H. A. D. Miles and D. B. Brown, *Sir David Wilkie of Scotland (1785–1841)*, exh. cat., North Carolina Museum of Art, Raleigh, N.C., 1987

P. Noon, *Richard Parkes Bonington 'On the Pleasure of Painting'*, exh. cat., Paris/New Haven, 1991

W. B. Pope, ed., *The Diary of Benjamin Robert Haydon*, Cambridge, Mass., 1960–63

M. Rajnai, *John Sell Cotman 1782–1842*, exh. cat., Arts Council of Great Britain, 1982

G. Reynolds, *The Paintings of John Constable*, New Haven/London, 1984, 1996

D. Thomson, ed., *The Art of Henry Raeburn 1756–1823*, exh. cat., Royal Scottish Academy, Edinburgh/NPG, 1997

W. Vaughan, *German Romanticism and English Art*, New Haven/London 1979

W. T Whitley, *Art in England 1800–1820*, Cambridge, 1928

——, *Art in England 1821–1837*, Cambridge, 1930

S. Wildman, *David Cox 1783–1859*, exh. cat., Birmingham Museums and Art Gallery, 1983

A. Wilton, *J. M. W. Turner, His Life and Art*, Fribourg, 1979

——, *Turner in his Time*, 1987

6 Middle-class Moralities

P. Allderidge, *The Late Richard Dadd 1817–1886*, exh. cat., Tate, 1974

Burne-Jones, exh. cat., Metropolitan Museum of Art, New York, 1998

G. Burne-Jones ('GBJ'), *Memorials of Edward Burne-Jones*, 1904

E. T. Cook and A. Wedderburn, eds, *The Works of John Ruskin*, 1903–12

W. P. Frith, *My Autobiography and Reminiscences*, 1887

T. Hilton, *John Ruskin: The Early Years 1819–1859*, 1985; *The Later Years*, 2000

W. Holman Hunt, *Pre-Raphaelitism and the Pre-Raphaelite Brotherhood*, 1905

R. Ironside and J. Gere, *Pre-Raphaelite Painters*, 1948

J. Maas, *Victorian Painters*, 1969

Daniel Maclise 1806–1870, exh. cat., Arts Council of Great Britain, 1972

J. G. Millais, *The Life and Letters of Sir John Everett Millais, Bt.*, 1899

R. Ormond, *Sir Edwin Landseer*, exh. cat., Tate, 1982

—— and C. Blackett-Ord, *Franz Xaver Winterhalter and the Courts of Europe 1830–70*, exh. cat., NPG, 1987

M. Pointon, *William Dyce 1806–1864*, Oxford, 1979

M. H. Port, *The Houses of Parliament*, New Haven/London, 1976

The Pre-Raphaelites, exh. cat., Tate, 1984, rev. edn ed. L. Parris, 1994

A. Staley, *The Pre-Raphaelite Landscape*, Oxford, 1973

7 The Apogee of Empire

A. L. Baldry, *Albert Moore: His Life and Works*, 1894

E. Becker and others, eds, *Sir Lawrence Alma-Tadema*, exh. cat., Van Gogh Museum, Amsterdam, and Walker Art Gallery, Liverpool, n.d.

W. Blunt, *'England's Michelangelo': A Biography of George Frederic Watts O.M., R.A.*, 1975

J. Christian, *The Last Romantics*, exh. cat., Barbican Art Gallery, London, 1989

E. Kilmurray and R. Ormond, eds., *John Singer Sargent*, exh. cat., Tate, 1998

Frederic Leighton 1830–1896, exh. cat., RA, 1996

A. McLaren Young, M. Macdonald and R. Spencer, with the assistance of H. Miles, *The Paintings of James McNeill Whistler* (cat. raisonné), New Haven/London, 1980

C. Newall, *The Grosvenor Gallery Exhibitions*, 1995

Watts: Symbolism in Britain, exh. cat., Tate, 1997

A. Wilton and R. Upstone, eds, *The Age of Rossetti, Burne-Jones and Watts: Symbolism in Britain*, exh. cat., Tate, 1997

8 The Great Debate

W. Baron, *The Camden Town Group*, 1979

——, *Sickert*, 1973

C. Bell, *Art*, 1914

R. K. Bell, *Stanley Spencer, A Complete Catalogue of the Paintings*, 1992

L. Browse, *William Nicholson*, 1956

R. Cork, *David Bomberg*, exh. cat., Tate, 1988

M. Eates, *Paul Nash The Master of the Image 1889–1946*, 1973

R. Fry, *Vision and Design*, 1920

C. Harrison, *English Art and Modernism, 1900–1939*, London/Indiana, 1981

C. Langdale, *Gwen John* (with cat. raisonné of paintings), New Haven/London, 1987

J. Lewison, *Ben Nicholson*, exh. cat., Tate, 1993

D. S. McColl, *Life, Work and Setting of Philip Wilson Steer* (with cat. of paintings and list of watercolours in public collections by A. Yockney), 1945

K. McConkey, *Impressionism in Britain*, exh. cat., Barbican Art Gallery, London, 1995

D. Mellor, ed., *A Paradise Lost, The Neo-Romantic Imagination in Britain 1935–55*, exh. cat., Barbican Art Gallery, London, 1987

W. Michel, *Wyndham Lewis's Paintings and Drawings*, 1971

R. Shone, *The Art of Bloomsbury: Roger Fry, Vanessa Bell and Duncan Grant*, exh. cat., Tate, 1999

Stanley Spencer, exh. cat., Tate, 2001

L. Tickner, *Modern Life and Modern Subjects: British Art in the early Twentieth Century*, New Haven/London, 2000

9 A New Reality

B. Bernard and D. Birdsall, eds, *Lucian Freud*, 1996

A. Bowness and L. Lambertini, *Victor Pasmore* (with cat. raisonné), 1980

Patrick Caulfield, exh. cat., Hayward Gallery, London, 1998

L. Checketts, *Norman Blamey*, exh. cat., Norwich Institute of Art and Design, 1992

A. Graham-Dixon, *Howard Hodgkin*, 2000

R. Kudielka, ed., *The Eye's Mind: Bridget Riley Collected Writings 1965–1999*, 1999

R. Morphet, ed., *R. B. Kitaj: A Retrospective*, exh. cat., Tate, 1994

Sensation: Young British Artists from the Saatchi Collection, exh. cat., RA, 1997

M. Tuchman and S. Barron, eds, *David Hockney: A Retrospective*, exh. cat., Los Angeles County Museum of Art, 1988

T. Wilcox, ed., *The Pursuit of the Real, British figurative painting from Sickert to Bacon*, exh. cat., Manchester City Art Galleries, 1990

List of Illustrations

Artists, titles and dates are given in the captions.
All works are in oil on canvas unless otherwise indicated.
Measurements are given in inches and centimetres (the latter in brackets), height preceding width.

BM British Museum, London
NG National Gallery, London
NPG National Portrait Gallery, London
Tate © Tate, London 2001
V&A Victoria and Albert Museum, London

1 Tabley House Collection, University of Manchester; 55¾ × 47 (142 × 120) **2** Kupferstichkabinett der Öffentliche Kunstsammlungen, Basel; pen, 15¼ × 20¾ (38.8 × 52.4) **3** Fundación Colección Thyssen-Bornemisza, Madrid; oil on panel, 10¾ × 7¾ (27.3 × 19.7) **4** V&A; gouache on vellum on playing card, diam. 1¾ (4.5) **5** Tate; oil on panel, 18¼ × 16¼ (47 × 41) **6** Her Majesty The Queen; 65¾ × 35¾ (167 × 90.8) **7** NG; oil on panel, 82 × 82¼ (208 × 209) **8** NPG; 87½ × 86½ (222.4 × 221.9) **9** Her Majesty The Queen; oil on panel, 27¾ × 33¼ (70.8 × 84.5) **10** NPG; 95 × 60 (241.3 × 152.4) **11** Tate; 90¼ × 59¼ (230.5 × 150.8) **12** Private collection; 23¾ × 19¾ (56.4 × 49.6) **13** V&A; watercolour on vellum, 5¾ × 2¾ (13.6 × 6) **14** V&A; watercolour on vellum, 2¾ × 2¼ (6.9 × 5.5) **15** Rt Hon The Earl of Powis; vellum mounted on card, 9 × 7¼ (23 × 18) **16** The Suffolk Collection, Ranger's House, Blackheath, London (English Heritage); 81¼ × 48¼ (206.4 × 122.3) **17** NPG; 81¼ × 50 (207 × 127) **18** Her Majesty The Queen; 104 × 46¼ (259 × 117) **19** The Metropolitan Museum of Art, New York Purchase, Joseph Pulitzer Bequest, 1944 (44.272); 79¼ × 58 (201.9 × 147.3) **20** Private collection; 81¼ × 60½ (206.4 × 153.7) **21** Tate; 59½ × 97¼ (151 × 246.7) **22** Archiepiscopal Castle and Gardens, Kroměříž, Czech Republic; 44¾ × 64¼ (113.5 × 163) **23** National Gallery of Victoria, Melbourne, Felton Bequest; 87¼ × 51¼ (223.2 × 130.3) **24** Museo del Prado, Madrid; 43¼ × 44¼ (110 × 114) **25** The Earl of Pembroke, Wilton House; 11 × 17 ft (335 × 518) **26** Tate; 24 × 18 (61 × 45.7) **27** Estate of the Duke of Buccleuch and Queensberry, K.T.; watercolour, 3½ × 2¾ (8.9 × 7.3) **28** Now at Clandon Park, Guildford,

Surrey. Photo The National Trust Photograph Library; 35¾ × 140 (90 × 355.5) **29** Yale Center for British Art, New Haven, Paul Mellon Collection. Photo Bridgeman Art Library; 75¼ × 54¼ (191.8 × 138.4) **30** Courtesy of the Worshipful Company of Painter-Stainers, London; 100 × 69 (254 × 175.3) **31** The Earl of Clarendon, on loan to Plymouth Museum and Art Gallery; 56 × 71½ (142.2 × 180.5) **32** Her Majesty The Queen; 49¼ × 40 (125.1 × 101.6) **33** Dulwich Picture Gallery, London; 41¾ × 32¾ (106.3 × 82.9) **34** Tate; 21¼ × 18¼ (53.5 × 46) **35** Private collection; 52¾ × 77 (134.5 × 195.6) **36** His Grace the Duke of Atholl, Blair Castle, Perthshire; 96 × 66 (240.4 × 167.5) **37** NPG; 36 × 28 (91.5 × 71) **38** Her Majesty The Queen; 91⅝ × 56½ (232.5 × 143.5) **39** The Earl of Shaftesbury 93½ × 57 (237.5 × 144.8) **40** Private collection 66 × 48 (167.5 × 122) **41** Former Royal Naval Hospital, Greenwich, London **42** Syndics of the Fitzwilliam Museum, Cambridge; c. 25 × 30 (63 × 76) **43** NG; c 28 × 36 (70 × 90.8) **44** Private collection; 51¾ × 57¾ (131 × 146.7) **45** Yale Center for British Art, New Haven, Paul Mellon Collection; 52 × 60½ (132 × 153.6) **46** Tate; 31 × 37¼ (78.7 × 94.6) **47** Thomas Coram Foundation for Children, London; 94 × 58 (239 × 147.5) **48** Tate; 35¾ × 71 (90.8 × 180.4) **49** National Maritime Museum, Greenwich; 27 × 27 (68.5 × 68.5) **50** NG; 27¼ × 47 (69.8 × 119.4) **51** Tate; 54 × 95 (139 × 241.5) **52** NPG; 39 × 29¼ (99 × 74) **53** Board of Trustees of the National Museums and Galleries on Merseyside, Walker Art Gallery, Liverpool; 49¼ × 40 (125.7 × 102) **54** NPG; 24¾ × 29¼ (63 × 74) **55** Devonshire Collection, Chatsworth. Reproduced by Permission of the Duke of Devonshire and the Chatsworth Settlement Trustees. Photo: Photographic Survey, Courtauld Institute of Art; 44½ × 55¼ (113 × 140) **56** The Metropolitan Museum of Art, New York, Bequest of William K. Vanderbilt, 1920 (20.155.3); 101¾ × 57¼ (258.1 × 145.4) **57** City Art Gallery, York; 110½ × 72 (281 × 183) **58** Iveagh Bequest, Kenwood, London (English Heritage); diam. 24 (61) **59** Abbot Hall Art Gallery, Kendal; 80 × 91¼ (203 × 232) **60** Manchester City Art Galleries; 71¾ × 107¾ (186.7 × 273.4) **61** Yale Center for British Art, New Haven, Paul Mellon Collection; 30¼ × 40¼ (77 × 102) **62** Tate; 44¾ × 59 (113.5 × 149.8) **63** Mount

Stewart, County Down. National Trust Photo Library/Felix Aprahamian; 82¼ × 144¾ (209 × 367.3) **64** The J. Paul Getty Museum, Los Angeles; 39½ × 49¼ (100.5 × 125.5) **65** The Garrick Club, London; 48 × 40 (121.9 × 101.6) **66** Tate; 48 × 52 (121.3 × 132) **67** NG; 72 × 96 (183 × 244) **68** Narodni Galerie, Prague; 57 × 80¾ (145 × 205) **69** Ipswich Borough Council Museums and Galleries (Christchurch Mansion, Ipswich); 50 × 39¾ (127 × 101) **70** Her Majesty The Queen; 62¼ × 74 (158.1 × 188) **71** Frick Collection, New York; 92¼ × 61¼ (234.3 × 155.2) **72** Toledo Museum of Art, Toledo, Ohio; 47¾ × 67 (121.3 × 170.2) **73** BM; aquatint, 9½ × 12¼ (24 × 31.5) **74** National Museum of Wales, Cardiff; 38 × 53 (96.5 × 134.6) **75** City of Nottingham Museums, Castle Museum and Art Gallery, Nottingham; 41 × 50 (104.1 × 127) **76** V&A; outline etching with grey wash, 17¾ × 11¼ (44.5 × 28.6) **77** The Goodwood Collection, Goodwood House, Sussex; 41¾ × 46½ (106 × 117.4) **78** NG; oil on paper laid down on board, 4¾ × 6¼ (12.1 × 15.8) **79** National Maritime Museum, Greenwich; oil on panel, 9½ × 18¼ (24.1 × 46.4) **80** Royal Society of Arts, London; 142 × 182 (360 × 462) **81** BM; pen and wash, 10¾ × 15½ (27.5 × 39.5) **82** Norfolk Museums Service (Norwich Castle Museum); 28 × 39½ (71.1 × 100.3) **83** National Gallery of Canada, Ottawa; 59½ × 84 (151.1 × 213.4) **84** Tate; 97 × 144 (246.4 × 365.8) **85** Tate; pen and ink and watercolour on paper, 20¾ × 14¼ (52.7 × 36.8) **86** V&A; watercolour, 16¾ × 12¼ (41.5 × 31.1) **87** Tate; colour-printed monotype, 21½ × 30 (54.5 × 76) **88** Private collection, on loan to the NG; 64 × 87½ (162.5 × 222) **89** Tate; 67 × 94 (170.2 × 238.8) **90** V&A; oil on paper laid on canvas, 10¼ × 12¼ (26 × 31) **91** Tate; 40 × 50 (101.7 × 127) **92** Guildhall Art Gallery, City of London; 53½ × 74 (135.8 × 188) **93** Royal Academy of Arts, London; 56 × 73¾ (142.2 × 187.3) **94** NG; 35¾ × 48 (91 × 121.8) **95** Whitworth Art Gallery, University of Manchester; 14¼ × 20¾ (36 × 52.8) **96** BM; watercolour, 9½ × 21¼ (24 × 54) **97** BM; pencil and watercolour, 13 × 9¼ (33 × 23) **98** Manchester City Art Galleries; 18 × 25 (45.8 × 63.5) **99** Usher Art Gallery, Lincoln; watercolour, 11½ × 16½ (29 × 42) **100** The Rt Hon the Earl of Mansfield, Scone Palace; 22½ × 29½ (57.2 × 75) **101** Apsley House (V&A), London; 38¼ × 62¼ (97 × 158) **102** Private

collection, on loan to the NG; 48 × 40 (122 × 101.6) **103** NG; 94⅜ × 58 (239.5 × 147) **104** Her Majesty The Queen; 107 × 71½ (271.8 × 181.6) **105** National Galleries of Scotland, Edinburgh; 95 × 59 (241.3 × 149.9) **106** Staatliche Museen zu Berlin – Preussischer Kulturbesitz, Gemäldegalerie. Photo Jorg P. Anders; 72 × 57¾ (183 × 147) **107** Wallace Collection, London; 21¼ × 25⅜ (54 × 64.4) **108** Tate; 32 1/2 × 33 (82.5 × 83.8) **109** Musée du Louvre, Paris © RMN-Arnaudet: J Schormans; 17⅛ × 21½ (43.5 × 54.5) **110** United Grand Lodge of England, London; 58 × 88 (147.3 × 223.5) **111** V&A; 66⅛ × 92¾ (168 × 235.4) **112** V&A; 24¾ × 32 (62.8 × 81.2) **113** Tate; 131 × 166 (332.7 × 421.6) **114** Ashmolean Museum, Oxford; brown ink and gum arabic, 7⅒ × 9⅖ (18 × 23.8) **115** House of Lords, Palace of Westminster, London; fresco, 82¼ × 63½ (209 × 161.3) **116** Her Majesty The Queen; 44⅝ × 56 (113.3 × 142.2) **117** Manchester City Art Galleries; 53⅛ × 77¹⅒ (137 × 197.3) **118** Tate; 30 × 22 (72.6 × 55.9) **119** Board of Trustees of the National Museums and Galleries on Merseyside, Lady Lever Art Gallery, Port Sunlight; 33¾ × 54½ (85.7 × 138.5) **120** Tate; 28½ × 16½ (72.4 × 41.9) **121** Tate; 34 × 55 (86.4 × 139.7) **122** Tate; 30 × 44 (76.2 × 111.8) **123** Private collection, on loan to the NG; 34½ × 26¾ (87.6 × 68) **124** Tate; 25 × 35 (63.5 × 88.9) **125** Royal Holloway College, Egham, Surrey; 46 × 101 (116.7 × 256.4) **126** Whitworth Art Gallery, University of Manchester; oil on panel, 12 × 8 (30.5 × 20.3) **127** Private collection, on loan to the NG; 24 × 29½ (61 × 75) **128** Tate; 34 × 26 (86.4 × 66) **129** Birmingham Museums and Art Gallery; 39½ × 30¼ (99.4 × 76.6) **130** Watts Gallery, Compton, Surrey; 59⅝ × 49½ (151.5 × 125.5) **131** Tate; 51½ × 35½ (136.4 × 91.8) **132** Manchester City Art Galleries; 77½ × 160¼ (197 × 407) **133** Tate; 46 × 77¾ (116.8 × 197.5) **134** Hugh Lane Municipal Gallery of Modern Art, Dublin; 78 × 39½ (198.1 × 100.3) **135** City Museum and Art Gallery, Plymouth; 47¾ × 61 (121.3 × 154.9) **136** National Gallery of Art, Washington, D.C., Harris Whittemore Collection; 84½ × 42½ (214.6 × 108) **137** The Detroit Institute of Arts; 23¾ × 18¾ (60.3 × 46.6) **138** Glasgow Museum and Art Gallery, Glasgow; 67⅜ × 56½ (171.1 × 143.5) **139** Private collection, on loan to the NG; 79⅜ × 52¾ (201.4 × 134) **140** NPG;

67¼ × 43½ (170.8 × 110.5) **141** Private collection, on loan to the NG; 57½ × 90 (146 × 228.5) **142** Board of Trustees of the National Museums and Galleries on Merseyside, Walker Art Gallery, Liverpool. © Estate of Walter R. Sickert 2001. All rights reserved, DACS; 30 × 23¾ (76.2 × 60.4) **143** Yale Center for British Art, New Haven, Paul Mellon Fund. Photo Bridgeman Art Library © Estate of Walter R. Sickert 2001. All rights reserved, DACS; 24 × 16 (61 × 40.6) **144** Her Majesty Queen Elizabeth the Queen Mother. © Estate of Walter R. Sickert 2001. All rights reserved, DACS; 18½ × 18½ (47 × 47) **145** Board of Trustees of the National Museums and Galleries on Merseyside, Walker Art Gallery, Liverpool; 13 × 7 (33 × 17.8) **146** The Metropolitan Museum of Art, New York, Bequest of Joan Whitney Payson. © Estate of Gwen John 2001. All rights reserved, DACS; 13¾ × 10½ (34.9 × 26.7) **147** The British Council, London; 40 × 30 (101.5 × 76.2) **148** Tate. © Courtesy of the Artist's estate/ Bridgeman Art Library; 73½ × 65 (186.7 × 165.1) **149** Private collection, on loan to the NG; 85 × 47 (216 × 119.5) **150** Wadsworth Atheneum, Hartford, Conn., Ella Gallup Sumner and Mary Catlin Sumner Collection. © Estate of Mrs G. A. Wyndham Lewis. By Permission; pencil, pen, ink and watercolour, 56 × 38 (142.2 × 96.5) **151** Tate; 60 × 88¾ (152.4 × 224.2) **152** Tate; 74½ × 56 (189.2 × 142.2) **153** Tate; 20 × 16 (50.8 × 40.6) **154** Imperial War Museum, London; 72 × 86 (182 × 218) **155** Tate; 108 × 216 (274.3 × 548.6) **156** Syndics of the Fitzwilliam Museum, Cambridge. © Estate of Stanley Spencer 2001. All rights reserved, DACS; 61 × 91.5 (154.9 × 232.4) **157** Museum of Modern Art, New York, The Joan and Lester Arnet Collection. © 1961 The Estate of Vanessa Bell. Courtesy Henrietta Garnett; 21¾ × 17¼ (55.1 × 43.7) **158** Tate. © Angela Verren-Taunt 2001. All rights reserved, DACS; 21¾ × 24 (55 × 61) **159** City Museum and Art Gallery, Bristol © Angela Verren-Taunt 2001. All rights reserved, DACS; oil and pencil on board, 19¾ × 26 (50 × 66) **160** Imperial War Museum, London; 28 × 36 (71 × 91.4) **161** Tate; 18 × 26 (45.7 × 66) **162** Tate. © The Artist's family; 23 × 61½ (58.5 × 156.2) **163** The British Council, London; 50 × 40 (127 × 101.5) **164** The Trustees of the Cecil Higgins Art Gallery, Bedford. © Alex Reid and Lefevre, London; watercolour, 34¾ × 43¾ (88.3 × 110.2) **165** Private

collection. © Estate of Francis Bacon/ARS, N.Y. and DACS, London 2001; 60 × 46 (152.4 × 116.8) **166** Tate; 37 × 29 (94 × 73.7) **167** National Museum of Wales, Cardiff. © Estate of Patrick Heron 2001. All rights reserved, DACS; 40 × 60 (101.6 × 152.4) **168** Whitworth Art Gallery, University of Manchester. © S. M. Lanyon; 60 × 47⅞ (152.5 × 121.7) **169** University of Liverpool Collection. Permission granted by the Estate of the Artist; oil on board, 66 × 66 (167 × 167) **170** Browse and Derby Gallery, London; 46⅞ × 65⅜ (118 × 167) **171** The Beaverbrook Art Gallery, Fredericton, New Brunswick, Canada, Gift of the Sir James Dunn Foundation. © Stephen Blamey; oil on masonite, 48 × 96 (122 × 243.8) **172** Tate. © David Hockney; 78 × 30 (198 × 76.2) **173** Yale Center for British Art, New Haven, The St John Wilson Trust. © Peter Blake 2001. All rights reserved, DACS; cryla on board, 52¾ × 41½ (134 × 105.1) **174** Board of Trustees of the National Museums and Galleries on Merseyside, Walker Art Gallery, Liverpool. © David Hockney; 59½ × 59½ (152 × 152) **175** On loan to the Musée national d'art moderne, Centre Georges Pompidou, Paris, from the Ludwig Collection, Aachen; 95⅝ × 29½ (243 × 76) **176** Tate; 48 × 57¾ (121.9 × 146.7) **177** Private collection. © the Artist; 46 × 46 (116.8 × 116.8) **178** Private collection. © Howard Hodgkin. Photo Prudence Cuming; oil on wood, diam. 69½ (176.5) **179** Board of Trustees of the National Museums and Galleries on Merseyside, Walker Art Gallery, Liverpool. © the Artist; 60 × 45 (152.4 × 114.3) **180** The British Council, London. © the Artist; 29½ × 23¾ (75 × 60.5) **181** Marlborough Fine Art. © Estate of Ken Kiff; acrylic on board, 25 × 29½ (63.5 × 75) **182** The Saatchi Gallery, London; oil and acrylic on canvas, 108 × 96 (274.3 × 243.8) **183** The Saatchi Gallery, London. Photo Robert McKeever; 103 × 193 (261.6 × 487.6)

Index